FIGURE
PAINTING
IN OIL

FIGURE PAINTING IN OIL

Douglas R. Graves

WATSON-GUPTILL PUBLICATIONS/NEW YORK

With love to Bea

Paperback Edition
First Printing, 1979

First published 1973 in the United States and Canada by Watson-Guptill Publications,
a division of Billboard Publications, Inc.,
1515 Broadway, New York, N.Y. 10036

Library of Congress Catalog Card Number: 72-12676
ISBN 0-8230-1702-8
ISBN 0-8230-1703-6 pbk.

Distributed in the United Kingdom by Phaidon Press Ltd.,
Musterlin House, Jordan Hill Road, Oxford OX2 8DP

Manufactured in Japan.

1 2 3 4 5 6/93 92 91 90 89

ACKNOWLEDGMENTS

As I worked on this book my morale often sagged and my words seemed to create a muddle. For coming to my rescue I want to thank my editor, Diane Casella Hines, as well as Heather Meredith-Owens, and always hovering in the background, Wendon Blake.

CONTENTS

INTRODUCTION

"Of all kinds of painting, figure painting is the most difficult; then comes landscape painting, and next dogs and horses. High towers and pavilions are definite things; they are difficult to execute, but easy to handle since they do not demand insight." *The Spirit of the Brush*, Ku K'ai-Chih, 344–406 A.D.

Why should you paint the nude figure? Is some lofty motive involved, like the search for illusory perfection? Or is it simply the supreme training ground for painting people or, for that matter, any subject? Certainly, the nude is an integral part of art history; as Kenneth Clark in his book on the nude has said, "It may have suffered some curious transformations, but it remains our chief link with the classic disciplines."

The importance of the nude figure in the contemporary art scene is difficult for me, or anyone, to determine. However, taken as an instrument of learning, I'm convinced that studying and painting the nude figure has no substitute. What subject matter offers the kind of challenge that the tonal values and subtle colors of the human body present? Where else can you find the grace and movement, as well as the dynamic action, inherent in the human form? The technical problems that painting the nude presents force you to carefully observe tonal values and color while seeking their solutions.

While working through the projects in this book, you'll become adept in using the medium of oil paint. I've chosen oil because it meets the demands of figure painting; it's a responsive medium that can be manipulated, changed, and reworked.

By painting the nude you become knowledgeable about the human figure, and you learn to accurately judge and reproduce its anatomical proportions. This might seem to indicate that there are precise measurements for the figure. Though painters and sculptors throughout the centuries have presented us with many versions of the "correct" bodily proportions, all these versions differ slightly from one another.

However, even the layman has a strong mental picture of what constitutes a well-formed female figure. This intuitive sense for proportion must be combined with study. Only with study will you improve your observation, and gain proficiency in your painting techniques.

Whether or not your goal as a painter is to portray beauty through the nude, the study of the female figure is indispensable to the education and experience of the artist.

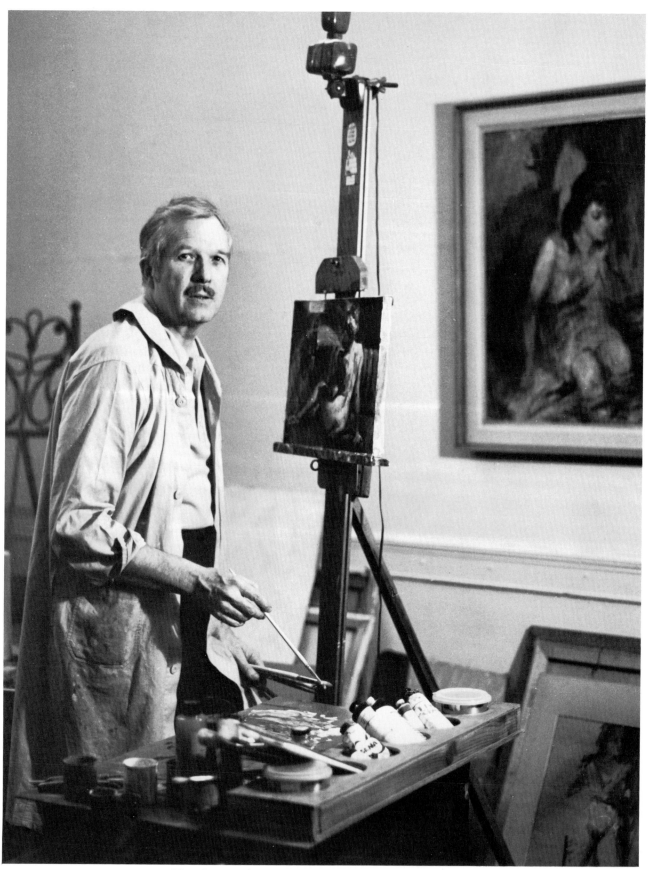

Here I am working on a painting that's reproduced on page 120. You can get a glimpse of my studio in the background. Notice in the foreground on the taboret my large "pound" tubes of paint.

MATERIALS AND TECHNIQUES

The variety of supplies in an art store is always fascinating, but when you begin to select your oil painting materials, it's easy to be perplexed by the vast number of choices available. There'll be several racks of oil color tubes, consisting of two or three brands that total approximately 100 colors. Racks or drawers full of brushes stare you in the face. Which ones should you choose? At first, the best course is to follow the recommendations of a professional painter who can give you the benefit of his experience. You'll unquestionably veer off from there, finding materials more suitable to your needs. But to start somewhere, let's talk about paint.

Painting in Black and White

For black and white painting, white is the workhorse. You can usually get white in one pound tubes; a good brand is Permalba white, made by F. Weber. This white is a combination of titanium and zinc oxides and has a buttery consistency that's easy to manipulate. The other colors you'll need are Mars black, because it dries faster and more evenly than other blacks, and burnt sienna, a luminous red-brown to mix with the black. (I'll discuss this when I start the demonstrations.)

Palette for Full Color Painting

In painting the figure, flesh is your primary concern, so the range of colors you'll need for your palette is narrowed. However, it's not as simple as using a tube of color called Flesh Number 1. You'll soon discover that the human skin, bathed in different kinds of light, has a multitude of hues, and these hues can be captured only with various mixtures of colors.

The first paint you buy should be pound (Figure 1) tubes of the colors most often used: white, yellow ochre, cadmium red light, alizarin crimson, viridian green, and ultramarine blue. Be extravagant with pigment; oil paint is now being packed in one pound tubes just to make it easy for you to do this. A brand called Dana, manufactured by Permanent Pigments, sells paint in these big tubes. If you can't obtain these, get the largest tubes available. You'll also need the following colors: cadmium orange, cadmium yellow light, Mars red, cadmium red light, Mars yellow, Mars yellow, terra rosa, Mars violet, burnt sienna, burnt sienna deep (made by Blockx in Belgium and obtainable from Lloyd's Art Co., 517 Lyons, Irvington, New Jersey), raw umber, burnt umber, phthalocyanine (hereafter called thalo) green, cobalt blue, cadmium green and Mars black.

Don't buy student grade colors. You may think that you'll save money; but student grade paints contain extenders—like putting sawdust in hamburger! I know that the prices of the professional grades will make you hesitate, especially over the expensive cadmium colors, but a little bit of these paints will go a long way.

In each color demonstration, I'll select a different group of colors which will make up the particular palette necessary for that painting.

Some Characteristics of Oil Paint

The most favorable aspect of oil paint, in terms of manipulation, is its slow drying property. You fon't

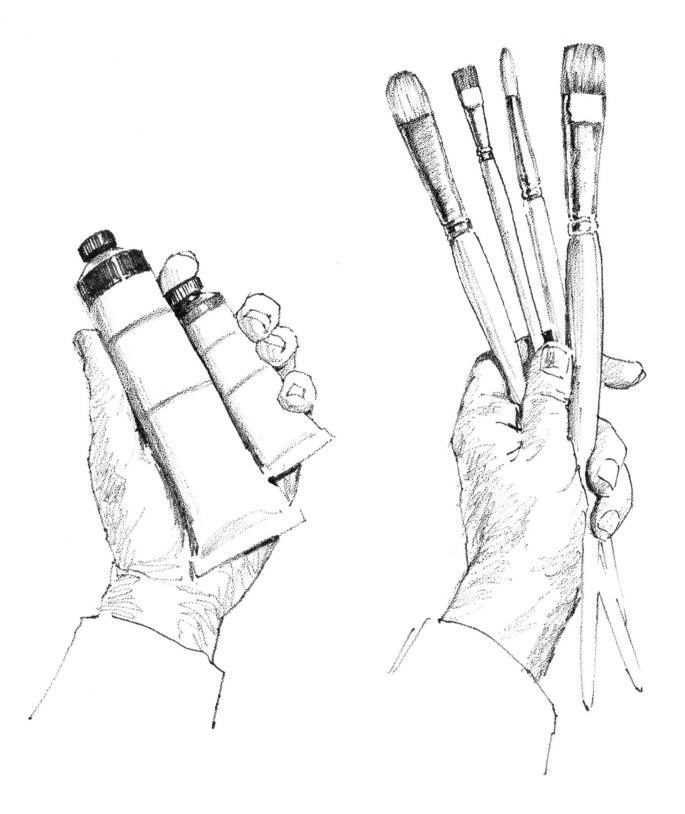

Figure 1. I recommend buying colors in the larger tube, called the pound tube. It actually carries about 155 cc. of paint, compared to the studio tube which should contain 37 cc. of paint. Thus, you get over four times as much paint at about half the price of three studio tubes.

Figure 2. Here are the four basic types of brushes you'll be using in this book. Left to right they are: filbert, sable, round, and bright.

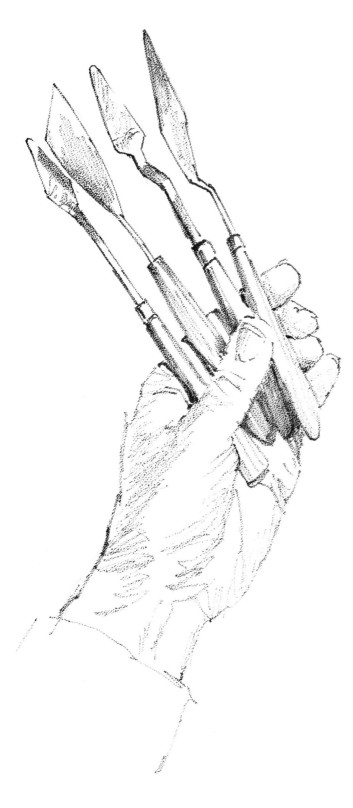

have to adjust your technique to any capriciousness of your media; it doesn't suddenly dry out. Mistakes (if you'll excuse the expression) aren't covered up but simply removed.

A hazard of painting in oil is the tendency of getting the oil paint dirty. At the very beginning, you should develop habits to prevent this. First, I suggest that you use paper towels instead of rags. The sections of paper towels can be discarded at once; whereas with rags, there's an inclination to keep wiping with the same rag, thereby contaminating your brushes. Also, as soon as a brush starts to get dirty, discard it for another. Use brushes in pairs; keep some exclusively for your light colors, others for your dark ones.

Oil paint has a vitality that is easily destroyed. It is a lustrous and rich color, but this quality can be lost by overbrushing it. Don't stroke back and forth as if you were painting your kitchen. Instead lay on the oil paint as if each stroke were precious. You should always be aware of how you're applying the paint. For example, you might be trying to get too much paint out of one brushload. Van Gogh must have dipped for each stroke, because every one is as juicy as the next.

Using Enough Paint

Now I'm going to present an idea which will help you get over a hang-up I've had: painting with too little pigment. Here's the way I worked it out.

I bought some small cooking pans, enough for the basic colors like white, yellow ochre, cadmium red, viridian green, ultramarine blue, and burnt sienna. I squeeze into these pans one half (or more) of a pound tube of paint. In the case of cadmium red, I use less. Then I add a teaspoon of Copal Painting Medium Light to the paint; again, less in the red. (The amount of medium can vary according to what kind of mixture you prefer.) I mix this as thoroughly as possible. Now I have nice big pots of color to dip into. When I'm through painting for the day, I cover the paint with water! When I'm ready to start again, I pour off the water and go at it. I disregard any stray drops of water; they just evaporate. Paint won't dry in these pans; no skin will form over the top of the paint if you keep it covered with water when you're not painting.

Let me stress that the whole procedure mentioned should be regarded as a temporary measure to help overcome the problem.

Figure 3. This is a handful of typical painting knives. I would use these four as follows. The small one at the left would be useful for small dots or dabs of bright colored highlights. The next, with its angled cut, would be used to lay in broad geometric shapes. The next would serve for short fine lines or slightly larger dabs of paint. The last would be used for applying larger passages of paint or for achieving a longer line.

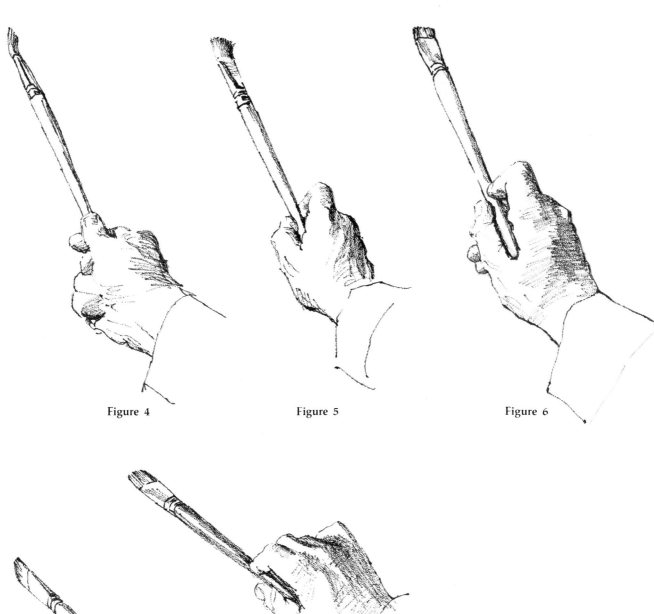

Figure 4 Figure 5 Figure 6

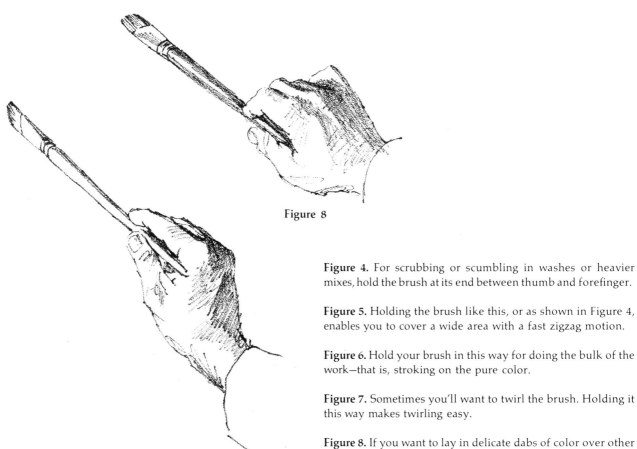

Figure 8

Figure 7

Figure 4. For scrubbing or scumbling in washes or heavier mixes, hold the brush at its end between thumb and forefinger.

Figure 5. Holding the brush like this, or as shown in Figure 4, enables you to cover a wide area with a fast zigzag motion.

Figure 6. Hold your brush in this way for doing the bulk of the work—that is, stroking on the pure color.

Figure 7. Sometimes you'll want to twirl the brush. Holding it this way makes twirling easy.

Figure 8. If you want to lay in delicate dabs of color over other colors, hold the brush like this.

Brushes and Knives

There are a number of different types of brushes (Figure 2), but the brushes most often used in oil painting are the bristles. These are made of stiff, springy hair and there are four types: brights, flats, filberts, and rounds. Brights are short and square, giving you broad, sharp-edged strokes. Brights don't bend much, so you have to apply the paint in delicate dabs or in strokes which lack expressive motion. Flats are long and squarish; they're springier than brights and make a softer stroke. Filberts are flat brushes with round tips; the bristles are longer than those of the brights, more yielding, and the strokes have softer edges. Rounds are cylindrical and pointed; they permit very free manipulation and leave soft-edged strokes.

If you get frustrated with not getting enough pigment on the canvas, you can use painting knives (Figure 3). Painting knives have the added advantages of keeping color mixtures pure and providing clean, concise strokes.

Sable brushes are made of fine, soft hair and come in round and flat shapes. The round sables are used for drawing lines and the flats can be used to "slick" or smooth the paint. Use one, at least, for smoothing and softening when your painting requires such effects (Figure 2).

The way you hold your brush when you're painting will affect the surface texture of the paint itself. Different textures require you to hold the brush in specific ways. I've illustrated some of the proper hand positions in Figures 4, 5, 6, 7, and 8. For most painting purposes, hold the brush almost, if not completely, at the end farthest from the bristles. Your control will be just as good, if not better, than if you grip it near the ferrule.

Painting on Canvas

The traditional surface for painting is canvas woven with either cotton or linen fibers. You can save some money by using cotton duck canvas at first. Cotton canvas is a fair surface to paint on; it tends to be more regular in texture than linen. Cotton fibers are inherently just as permanent as linen, but the cotton canvas is more cheaply made and may, therefore, be less durable. Optimal durability in your canvas isn't important at first, but when you think you're at a stage when your paintings are destined for posterity, you may want to start using linen canvas.

Cotton canvas can be bought in some art stores pre-primed and stretched in a variety of sizes. Most canvas is now primed with an acrylic ground which hasn't yet been proven absolutely compatible with oil. If you find this fact inhibiting, you may want to prime your canvas by the "old-fashioned" method. In that case, buy some linen "raw" canvas, a quantity of rabbit skin glue and a can of white lead (called white lead in oil), and get busy.

In brief, here's how the process works, although for more complete instructions I'd advise you to consult such books as the *Artist's Handbook* by Ralph Mayer or *The Painter's Dictionary* by Frederic Taubes. First you stretch the raw canvas on the usual wooden frame. Then you soak the powdered rabbit skin glue in cold water until it forms a kind of jelly. The jelly must then be liquefied by heating it in a double boiler. To apply the warm glue to the canvas, use a housepainter's brush. When the wet glue dries, the canvas will shrink as tight as a drum and it will be sealed against any oil seeping into its fibers and causing it to disintegrate over the years. On top of this, spread white lead (which you can buy in cans at a paint store) with a putty knife or spatula, pressing the paint into the fibers of the canvas. Scrape off any excess, so that the weave of the canvas still shows through.

Stretching Canvas

Stretching primed canvas is easy, provided you take care to observe a strict procedure. The stretcher strips (that form the wooden frame) should be assembled and checked to make sure they're square by placing a triangle in the corners (Figure 9). To make certain the corners stay that way, especially on large-sized frames, I place two small brads on these corners (Figure 10). Be sure that the corners are closed tight. Cut your canvas to go 1¼" beyond the edges of the stretchers. A heavy-duty tacking or staple gun can simplify the tacking procedure. If you don't have strong fingers, use stretching pliers which you can buy in an art supply store (Figure 11).

Start in the center of each wooden stretcher strip, putting one staple through the canvas on each of the four sides. As you staple, pull the canvas tight across the stretcher bars. If the canvas is heavy, you'll have to staple temporarily the tightly pulled canvas at the corners to keep it from rippling (Figure 12). Continue to work out from the center staple, putting a few staples at a time on each side (Figure 13). When you near the corner, remove the temporary staples (Figure 14). Finally, the corners

Figure 9. Adjust the assembled stretchers until all corners are square. It may take a little time, but your framer will be happy.

Figure 10. Sometimes when you're tugging on the canvas the stretcher strips don't *stay* square at the corners. Often they don't fit tightly enough, so they start to slip out. If you put brads (two) on each corner, the stretchers can't turn.

Figure 11. A staple gun (left) and stretching pliers (right) will simplify the stretching procedure.

should be folded under and stapled down (Figure 15). I believe in stretching the canvas so tight that it thrums when you snap your finger on it (Figure 16). It shouldn't be necessary to put keys in the corners if the canvas is as tight as a drum. Keys should be the last resort because they often cause wrinkles.

The gripping selvage of the canvas should be turned around in back and stapled in a few places (Figure 17). The selvage should be left on in case you have to restretch the canvas at some future time.

For practice work or studies, use thumbtacks to mount the canvas, but follow the same stretching procedure.

Textures

Canvas textures are something you'll become aware of later. At first, I'd advise a medium rough texture. It will keep you from wanting to be too detailed and your paintings will have a broader, more painterly look to them. It will "eat" more paint, but don't start getting uptight about how much paint you're using.

Painting on Board

Masonite is a brownish hardboard which you can get from any lumberyard. It makes a novel change from canvas. Use the untempered variety only and work on the smooth side. It can be safely primed with acrylic gesso. Wash the board with ammonia first and sand it lightly with fine grade sandpaper before applying the gesso. Give it at least three coats. If you want a texture, paint the gesso on thickly, leaving the imprint of the brush. If you want a smooth finish, brush the gesso thinly and sand it after each coat.

You can also prepare Masonite with rabbit skin glue and white lead, the way you prime canvas, but apply the white lead with a brush, not with a spatula.

Painting Mediums

As it comes in the tube, oil paint is simply powdered color blended with a vegetable oil called linseed oil. If you use oil paint straight from the tube, the paint will be fairly stiff—not particularly fluid. You can use it this way, if you like, but many painters like to modify the handling qualities of tube color by adding a medium.

Whether to use a medium or not continues to be

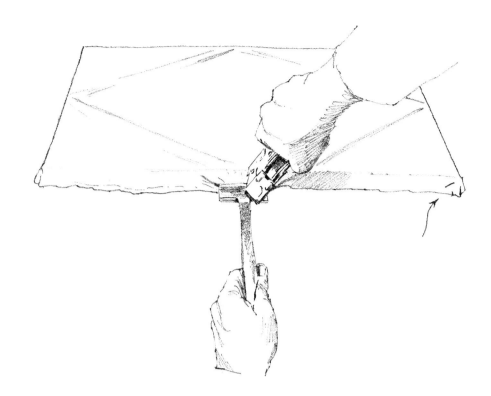

Figure 12. Starting in the center of each strip, place one tack on each side. Then pull all the sides until the canvas pulls into a diamond shape. Be sure to point one of the side edges toward the light and sight down across the canvas. This enables you to see the ridges.

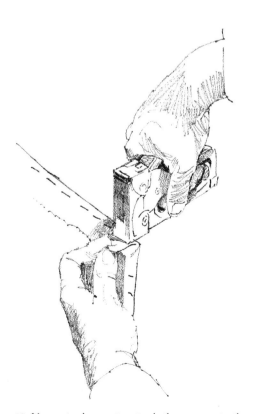

Figure 13. Use a staple gun to attach the canvas to the edge of the frame.

Figure 14. Remove the temporary staples. Fold the corners neatly over the top of the edge and onto the back of the frame.

Figure 15. Make sure the canvas is folded snugly so that it will fit into a frame.

Figure 16. The canvas should be so tight that you don't have to use keys in the back. It should thrumm when you tap it with your fingertips.

Figure 17. Staple the canvas down on the back side in a few places all the way around the frame. Don't cut this extra canvas off.

a subject for argument and debate among artists. I'll confess that I've been swayed by arguments on both sides, but the final decision will ultimately be yours. I once had an instructor who was abrupt and direct with his answers to students. I remember asking him what I should mix with my paint, and his terse reply was "brains."

Normally, a medium is a mixture of damar or copal varnish and linseed oil—either in its raw form, or heat processed so that it becomes thicker and more flowing (then it's called sun-thickened oil or stand oil). A medium can be made thinner by adding turpentine or mineral spirits. The most immediate and obvious benefit of adding a medium to paint is the improvement of its brushing quality. The medium makes the tube paint "long"; it softens the paint so that it will brush out better and more smoothly. However, too much medium will make the paint "soupy." A medium will also add luminosity to your paint and make the paint dry to a tougher, more durable film. In glazing techniques—thin, transparent painting—I'd certainly recommend the use of a medium.

You'll find helpful discussions of different mediums and their use in both *The Artist's Handbook* by Ralph Mayer and *The Painter's Dictionary* by Frederic Taubes. Mr. Taubes has developed a number of painting mediums which are manufacturered by Permanent Pigments of Cincinnati, Ohio. These are excellent products.

Choosing the right medium is a matter of taste and experience. It also depends on how you want your painting to look. I'd advise you to try out several mediums until you find one which suits your purpose.

Regardless of whether you decide to use a medium or not, it's essential to use a thinning agent such as turpentine or mineral spirits (without a medium) for your first lay-in. A thinning agent does two things: the most important is that a thinning agent makes the pigment penetrate the pores of the canvas. You'll also find that you'll be able to cover the canvas more quickly. Many times, the original lay-in wash has fascinating patterns and colors that are too good to cover. However, if you just thin the paint with turpentine, the paint film won't be very durable; you should paint over the original layer with a more substantial paint film.

Turpentine evaporates from your painting in an hour or so, and you'll notice that as it does so, dark colors lose their depth and richness; the use of a medium prevents this loss.

To Restore and Protect

The subject of varnish is important. I said previously that diluting pigments with turpentine caused them to become dull and lifeless when they dried. *Most* colors, even without dilution, will change as they dry. The light tones will become slightly darker; the dark colors will come up in value from the ones you originally planned. To restore these to the value they had when they were wet, give the painting a coat of retouching varnish, which is a diluted form of damar picture varnish. This thin-bodied retouching varnish can be sprayed on fairly soon after the painting is dry to the touch; it can even be applied between layers, provided that the paint is dry.

A final varnish should be applied a number of months after the painting has been completed, when the paint is bone dry. The varnish to use in this case is a heavier fluid, called picture varnish, and it's applied with a soft brush, usually oxhair. If you brush it on, use a light touch, and be careful not to dissolve or lift any tacky paint. Alizarin crimson will be the most vulnerable because it dries so slowly. Varnish can be obtained in either a glossy or a matte (dull) finish.

The finish coat of varnish is important for the protection of the painting. Don't use any substitute for a good picture varnish. Use either damar or copal. I grew several gray hairs quickly when one of my portrait clients asked me whether he should *shellac* his portrait!

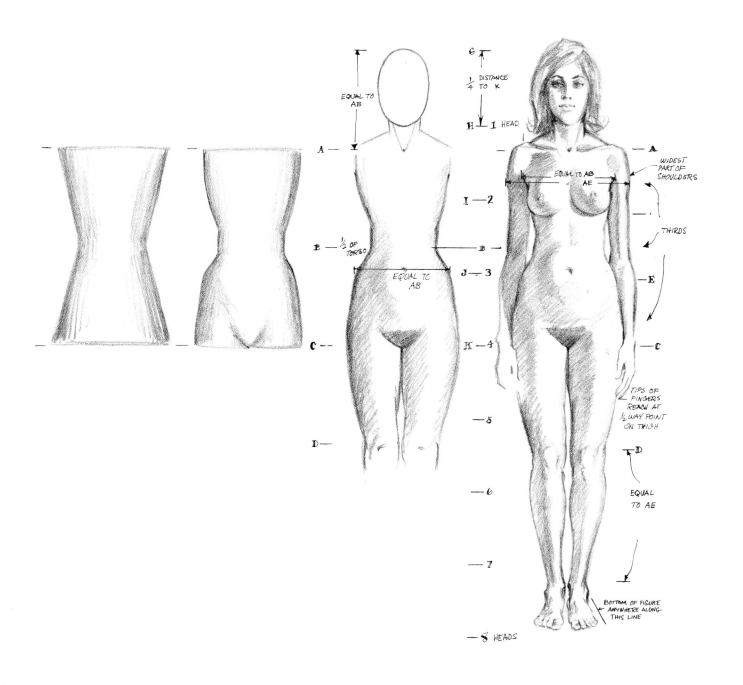

Figure 18. (Left) The drawing on the left shows the torso as a cylindrical shape—a tube squeezed in at its midpoint. The drawing on the right shows this basic torso shape slightly sculptured with an indentation for the crotch and some roundness in the hip area where the thighs will attach to the body

Figure 19. (Center) The distance between point A (the base of the neck) and point B (the waist) is equal to the distance between point B (the waist) and point C (the crotch). In addition, the width of the body at the top of the hips also equals the distance between either points A and B and/or B and C. The distance between the top of the skull and the pit of the neck is also equal to the distance between A and B, just as the distance between the top of the knee and the crotch equals that between A and B.

Figure 20. (Right) Here's the complete figure. The length of the head can be used to find proportions to the crotch. The distance from the top of the head, point G, to the chin, point H, is the equivalent of the distance between the chin and the nipples (H and I), the distance between the nipples and navel (I and J), and the distance between the navel and the crotch (J and K).

BASIC FIGURE PROPORTIONS

What you should know about the figure depends upon the kind of painting procedure you're going to use in painting the nude. You could paint by the *à la prima* method, transmitting an accurate visual impression of the model directly to the canvas; you wouldn't be concerned with the undersurface or the anatomy of the figure, except where they affected your visual impression. Chances are if your eye is well trained and you are skillful enough to duplicate the color and tonal masses in their proper positions, you might pull off a pretty good painting. This would be a visceral type of painting, that is, painting by sensation rather than by intellectualization. You'd skip the slow building process of figure construction, the laborious drafting of the anatomical base. However, most people don't have the detachment to think of the figure in this way or the total control to paint in this fashion.

It takes a tremendous amount of knowledge of anatomy and experience in figure drawing to construct the human body without the benefit of either good "copy" or a live model. Even when you're able to put together a figure without reference to a model, it often lacks a convincing, lifelike quality. Invariably you wind up faking parts you don't remember or actions you haven't seen or understood.

Artistic Anatomy

A good way to pursue figure painting is with a three-pronged attack. First, paint as much as possible from the live model. Next, as you're painting, think about the anatomy of the figure—that is, the various bones and muscles that form the shapes and contours you see. When you have a question about the attachment or proportion of these muscles and bones, look up the answer in a good anatomy book. Finally, learn basic proportions; train your eye to pick out the important points, or landmarks, in the

anatomical landscape that can help you relate the size of one part of the body to another part.

As for a great deal of artistic anatomy, I believe a book should give you all of it, or nothing. Books like *Artistic Anatomy* by Dr. Paul Richer (translated by Robert Beverly Hale) or *Art Students' Anatomy* by Edmond J. Farris do an excellent job. So rather than enlarge this book to a monstrous size with information on artistic anatomy, I'll only give you some of the important anatomical points to help you construct the human body.

Seeing Large, Basic Shapes

A simple method of constructing a figure is to first visualize it as a composite of large shapes, either as simplified, geometric, three-dimensional forms or other familiar shapes. At the same time, try to relate the size of one large shape to another. Next, find the smaller shapes that make up each large mass. Analyze each smaller shape and relate their size to the other smaller shapes and the large mass which contains them. This process of working from large down to small with the corresponding relation of the size of each part to another can be carried down to the smallest bodily detail.

The Torso

The largest chunk of the body is the torso. It's the central hub of the body with all of the body's movable parts attached to it. Let's start there and use it as the standard of measurement for the total figure. Conventional methods of measuring use the size of the head as a basic unit, but no one can decide whether the average figure is seven or eight heads in length. Besides, there are only a few places on the body where the head measurement is applicable in terms of size. The torso as the basic unit of meas-

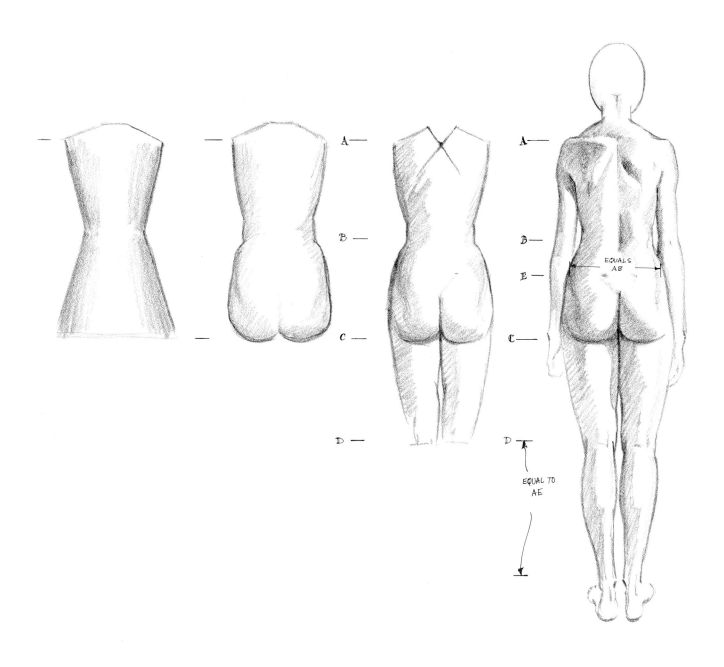

Figure 21. (Left) Starting with the same kind of an hourglass shape as in the front view, I'll develop the rear view of the standing figure. However, here the top is slightly pyramided for the shoulders. In the drawing on the right the shape is molded to show the buttocks and the hips.

Figure 22. (Center) In a back view the torso divides into two equal parts at the waist, from point A at the shoulders to point B at the waist, and from point B to point C at the base of the buttocks. Each of these proportions is equal to the distance between point C at the base of the buttocks and the back of the knee, point D. This point is slightly above the crossbar of the "H."

Figure 23. (Right) The width of the figure across the back at the top of the hips is equal to the distance between point A and point B at the waist. The distance between the knee and the ankle bone also equals the distance between points A and E.

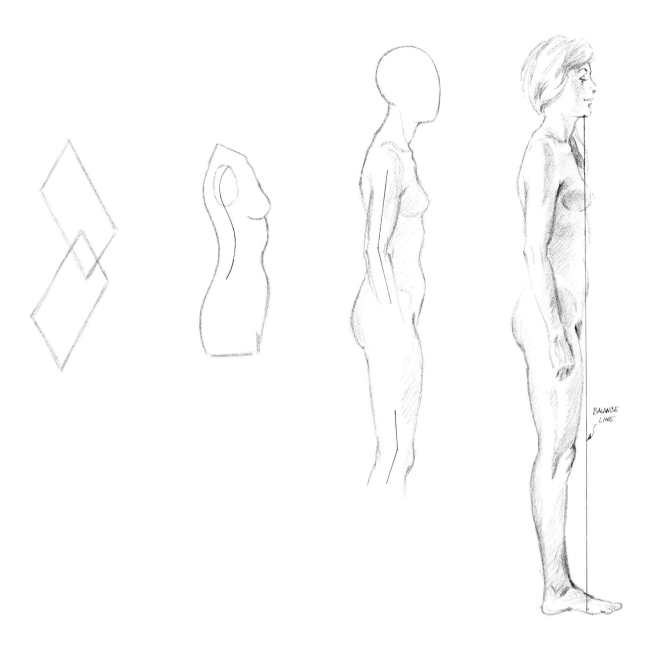

BALANCE
LINE

Figure 24. (Left) The side view of the standing figure's torso can't be related to any well known object, so I think of it as two overlapping parallelograms. In the drawing on the right, I develop the torso by rounding out the geometric shapes. It helps to visualize the action of the spine as a flat "S" shape.

Figure 25. (Center) In this figure the arms are in repose. The upper arm angles back a bit; the forearm then bends forward. The thigh falls in a gentle curve as it narrows. The knee area (known as the knee pan) takes a jog backward.

Figure 26. (Right) The side view of the complete figure shows the gentle curving thrusts the body takes. Note the head jutting forward. The feet come out from the body to fall directly under the head for balance.

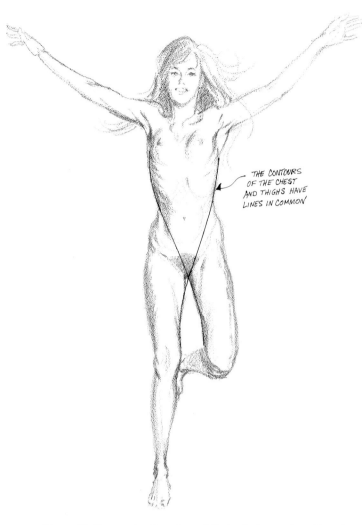

THE CONTOURS OF THE CHEST AND THIGHS HAVE LINES IN COMMON

Figure 27. Even a standing, immobile body has various thrusts and changes of direction that form its "action line." "Movement," however, is actual physical exertion. In this case the jumping motion that the figure is performing doesn't give the forms as much interest as a carefully posed model.

urement has more mathematical relationships.

The torso can be visualized as a cylindrical form (Figure 18). First, let's divide the torso mass in half at the waist; this point I'll call point B (Figure 19). I locate point A at the pit of the neck (suprasternal notch), while point C is located at the crotch. These divisions give us equal lengths from the pit of the neck to the waist and again from the waist to the crotch. Using either division, you can determine three more proportions: the width of the body at the top of the hips (pelvis) is equal to the distance between the pit of the neck and the waist; the same distance up from the pit of the neck locates the top of the skull; and the top of the knee is likewise the same distance (that is, the distance between the neck and the waist or waist and the crotch) from the crotch (Figure 19).

Proportions for the Front

As you go through these proportions, think of the larger divisions first—finding halves, then thirds, next fourths, and finally the eight parts of the body. In Figure 19 the torso—from the pit of the neck to the crotch—was halved. Now let's divide the torso into thirds (Figure 20). These one-third divisions are from the neck to the bottom of the breasts, and from there to the hip line, or iliac crest (point E). The distance between points A and E is equal to the distance between the knees and the ankle bone. It doesn't make any sense to attempt measurements to the bottom of the foot. I've tried, unsuccessfully, to establish where that reference point falls. Because of the perspective involved when viewing the foot, you can't get a fix on a bottom point. Therefore, a better landmark is the inside ankle bone. Notice that the inside ankle bone is higher than the outside ankle bone.

To determine the length of the head itself, divide the area between the top of the head and the crotch into four equal parts (Figure 20). Each part will equal the length of the head. Dividing the figure with head measurements is useless on the remainder of the figure, because the divisions don't fall at any specific point.

Proportions for the Back

Now let's view the figure from the rear and determine proportions (Figure 21). Once again, the torso can be divided in half at the waist. The cleavage of the buttocks ends about halfway between the waist and the bottom of the buttocks. A small diamond

shape at the top of that cleavage represents the sacrum bone. This bone creates dimples that make it easy to locate.

At the top of the back is an "X" configuration (Figure 22). The center of this X is located on the shoulder line. This configuration helps to locate (roughly) the inner boundaries of the shoulder blades as well as the point on the rise of the trapezius muscle at which the neck terminates. The proportions for the back of the legs are the same as those for the front; the bend line of the leg is directly opposite the knee cap on the front.

With the back view the lower point on the leg is again the ankle bone which is the same distance from the knee as in the front view (Figure 23). Estimating the head length is more difficult with a back view, because the chin isn't visible. Notice how the hanging arm in Figure 23 tends to follow the curve of the body, throwing the lower arm out at a slight angle. From the back, the vertical center line of the body is obvious since it follows the spine.

Thrusts of the Body

Even when the body is in repose, the shapes that comprise the figure aren't static; the various body parts thrust out at different angles from the torso. In Figures 24, 25, and 26 you can see the side view of a single standing figure. In Figure 48, the body's main action line is indicated in black. By "action line" I mean the line that indicates the direction or flow of the body. In art, "action" and movement" are not the same. "Action," as I've said, refers to the thrust, or the direction of the body which is inherent even in a figure standing still (Figure 25). "Movement" refers to physical exertions such as running, jumping, etc. (Figure 27).

The human body isn't ramrod straight. It has a natural curvature—the spine; in other words it has a "set" curved action. Some of the main thrusts of the body are: the angle of the neck jutting out from the shoulder plateau; the forward thrust of the chest and corresponding backward thrust from the base of the chest to the top end of the thigh bone; the slightly forward thrust of the thigh and backward thrust of the knee; and the slight forward arc of the lower leg from the knee to the foot.

Placement of the Head and Neck

One of the glaring faults in a beginner's drawing of the figure is his placement of the head on the body. There's confusion about how the neck and shoul-

Figure 28. The length of the hand can be used as a measurement for proportioning the head.

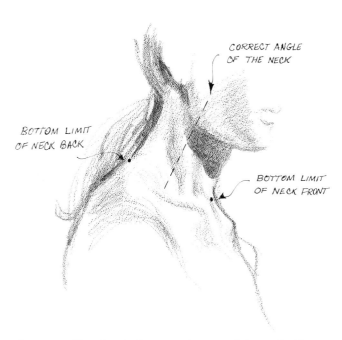

Figure 29. This sketch shows a side view of the neck. Notice how it rises at an angle from the shoulder plateau (which slants down and forward.)

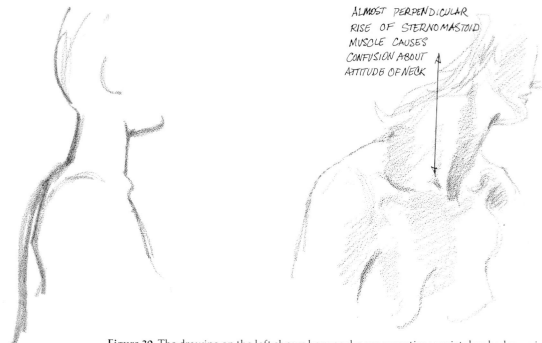

ALMOST PERPENDICULAR
RISE OF STERNOMASTOID
MUSCLE CAUSES
CONFUSION ABOUT
ATTITUDE OF NECK

Figure 30. The drawing on the left shows how necks are sometimes mistakenly drawn in a side view. The mistake is caused by an illusion created by the almost perpendicular rise of the sternomastoid muscles which run from behind the ears down to the collarbone. These straight muscles seem to create the direction of the neck itself. The corrected neck angle is seen on the right.

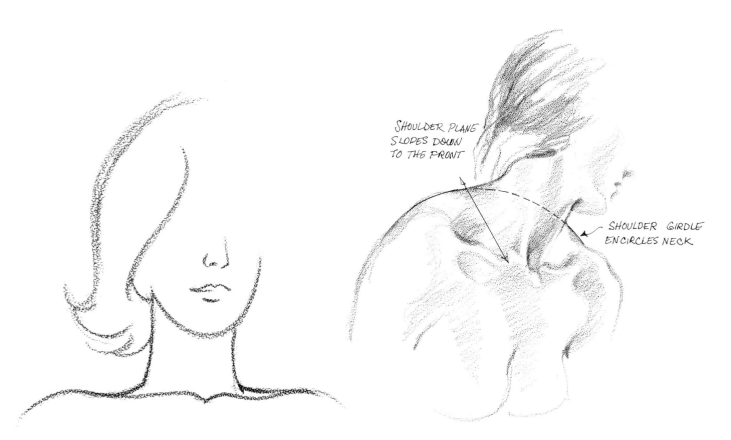

SHOULDER PLANE
SLOPES DOWN
TO THE FRONT

SHOULDER GIRDLE
ENCIRCLES NECK

Figure 31. On the left is an example of an error often made in constructing a front view of the neck and shoulders. It appears that the shoulder plateau is level, instead of pitched forward as it should be. In the corrected drawing on the right, notice how the shoulder girdle encircles the neck in a continuous line. This is even more noticeable when the figure is slumped over a little.

ders are constructed. In order to visualize the size of the head, compare it to the length of your hand (Figure 28).

The neck doesn't grow straight out of the body like a tree; actually it's perpendicular to the shoulder plateau. The shoulder plateau slants forward, jutting the neck out at an angle. This, in turn, thrusts the head forward and away from the body. The long, straight muscles (the sternomastoid muscles) that attach behind the ear and drop straight down to the collarbone obscure this jutting angle of the neck and make the neck appear to rise straight out of the shoulders (Figures 29, 30, 31, and 32).

Proportions of the Leg

The construction of the leg is peculiar in that the front and side views of the leg can be visualized so differently. In the front, the leg can be viewed as a series of angular tapers (Figure 33); while with a side view the leg can be visualized as long, overlapping ovals (Figure 34).

In a front view, the leg breaks at the knee, but in a side view the flow of the leg is unbroken. The long sweep of the curved thigh bone continues into the curve of the back part, or calf, of the lower part. The front of the lower leg has a slight, almost imperceptible, forward arc to it.

Proportions of the Arms

The length of the arm is equal to one-half the length of the entire figure. If this surprises you, it's because you seldom view a person (at least, for very long) with his arms hanging in repose at his sides. Generally people are using their arms, thrusting them backward or forward. In such cases the arms appear to be shorter or longer, and that's when foreshortening ("body perspective") enters your picture. I'll discuss foreshortening a little later.

Figures 35 through 39 show the arm in a variety of positions. The arm is composed of a series of forms that alternately change direction. A group of muscles—one called the supinators and the other called the flexors—twist the hand outward from the body and inward, respectively (Figure 40).

Movements of the Spine, Shoulders, and Hips

The spine is usually straight, but it can curve slightly to the left or right through the central region (Figure 41). At the points where the shoulders and hips cross the spine, they form right angles to it.

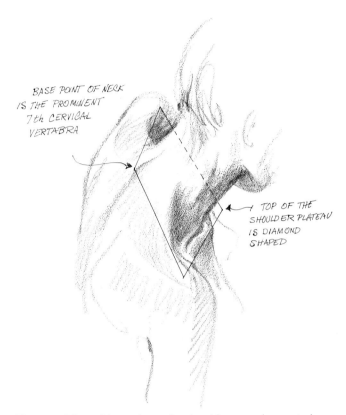

BASE POINT OF NECK IS THE PROMINENT 7th CERVICAL VERTABRA

TOP OF THE SHOULDER PLATEAU IS DIAMOND SHAPED

Figure 32. Viewed from above, the shoulder area also encircles the neck in a diamond configuration. The large trapezius muscles of the back create another plane, a rolling edge, viewed from this perspective. At the sides of the body these muscles appear as small saddles dropping to meet the ends of the collarbones.

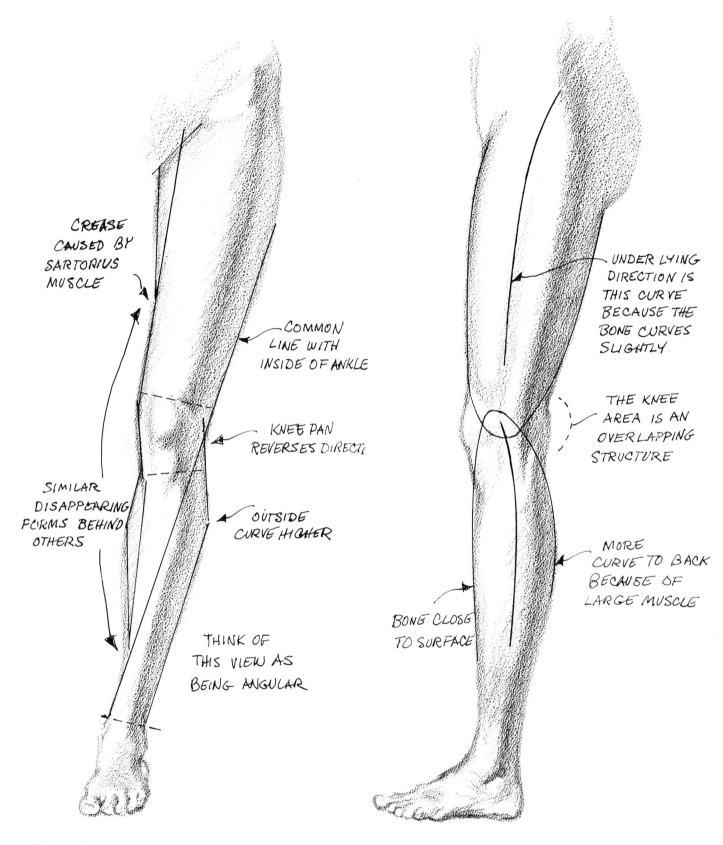

CREASE
CAUSED BY
SARTORIUS
MUSCLE

COMMON
LINE WITH
INSIDE OF ANKLE

KNEE PAN
REVERSES DIRECT.

SIMILAR
DISAPPEARING
FORMS BEHIND
OTHERS

OUTSIDE
CURVE HIGHER

THINK OF
THIS VIEW AS
BEING ANGULAR

UNDER LYING
DIRECTION IS
THIS CURVE
BECAUSE THE
BONE CURVES
SLIGHTLY

THE KNEE
AREA IS AN
OVERLAPPING
STRUCTURE

MORE
CURVE TO BACK
BECAUSE OF
LARGE MUSCLE

BONE CLOSE
TO SURFACE

Figure 33. When painting or drawing the leg, it's important to capture the change of direction that takes place in the knee area. Notice the tapering angular segment as well as the line of the outside thigh contour crossing the lower leg to the inside ankle.

Figure 34. The lower leg doesn't fall directly under the thigh but jogs backward at the knee. In a side view, as well as a frontal view, there's a reverse in direction at the knee pan. From the hip the thigh falls forward, but the knee thrusts backward and causes the lower leg to arc slightly forward. Note that you never make the back of the knee concave; it puffs out.

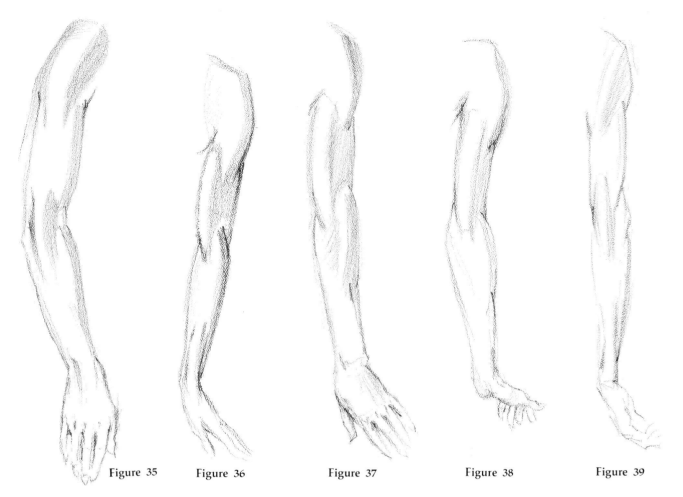

Figure 35 Figure 36 Figure 37 Figure 38 Figure 39

Figure 35. The arm in a straightened position is the hardest to construct. The sketches in Figures 35 to 39 all have exaggerated muscles so you can visualize them as a series of blocky forms that alternate in direction down the length of the arm.

Figure 36. See how these changes of form are almost at right angles to each other and are interwoven. In addition, the arm tapers gracefully.

Figure 37. Even as the wrist turns the hand, the arm still has these alternating formations. The sections starting at the top of the arm are the shoulder muscle (deltoid), the biceps-triceps area, the supinators and flexors which twist the lower arm, and finally the bony part near the wrist.

Figure 38. The arm turned in this position with the hand outward from the body is in the "supinated" position.

Figure 39. When the hand is turned into the body the arm is "pronated." Here the deltoid muscle twists around but the rest of the forms follow in their usual alternating directions.

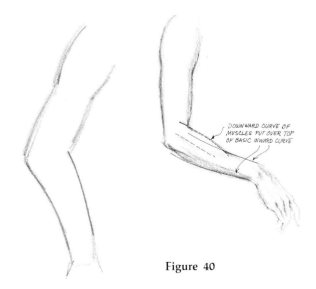

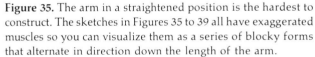

DOWNWARD CURVE OF
MUSCLES PUT OVER TOP
OF BASIC INWARD CURVE

Figure 40

Figure 40. A beginner often makes the lower arm in the manner shown in the drawing on the left. This is due to faulty observation. The supinator muscles attach to the upper arm and insert into the lower arm in such a way as to cause it to appear to bend in the wrong direction. In the corrected drawing on the right, the forearm has a slight bend in toward the body. The supinator group is added after the underlying basic curve of the arm is established.

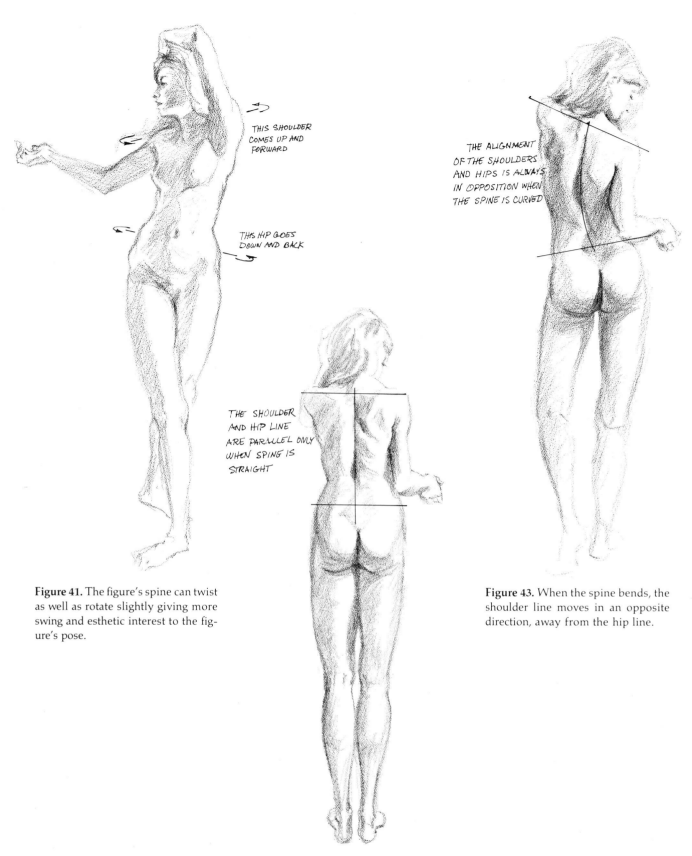

THIS SHOULDER
COMES UP AND
FORWARD

THIS HIP GOES
DOWN AND BACK

THE ALIGNMENT
OF THE SHOULDERS
AND HIPS IS ALWAYS
IN OPPOSITION WHEN
THE SPINE IS CURVED

THE SHOULDER
AND HIP LINE
ARE PARALLEL ONLY
WHEN SPINE IS
STRAIGHT

Figure 41. The figure's spine can twist as well as rotate slightly giving more swing and esthetic interest to the figure's pose.

Figure 43. When the spine bends, the shoulder line moves in an opposite direction, away from the hip line.

Figure 42. These two lines can never be parallel unless the spine is absolutely straight as it is in this pose.

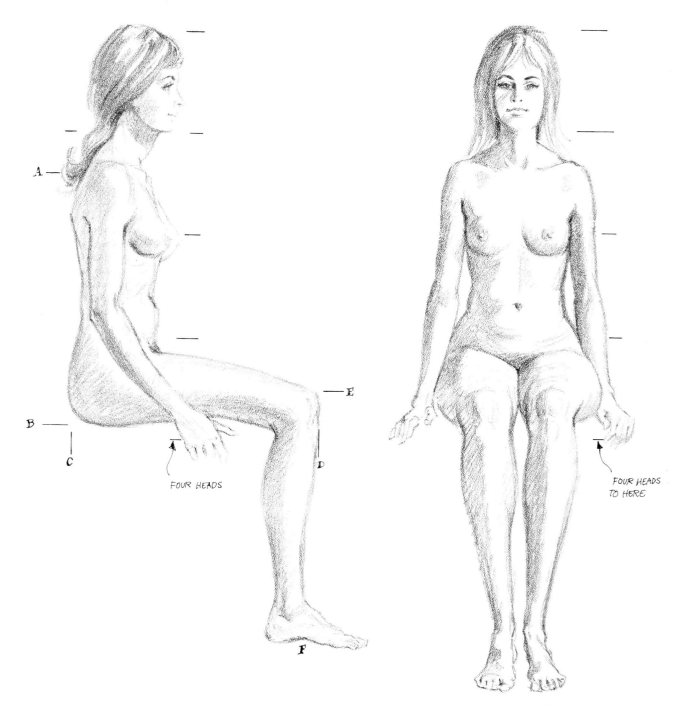

FOUR HEADS

FOUR HEADS
TO HERE

Figure 44. The seated figure can be measured from the side view with three equal units: AB equals CD equals EF. The angle of the thigh slopes downward so that the thigh starts to flatten near the edge of the object on which the figure is seated. All other measurements are the same as those for the standing figure.

Figure 45. In a front view of the seated figure the lower legs are longer in proportion to the rest of the body, because they're closer to you. No set measurements can be given since the comparison of torso to legs will vary depending on your distance from the model.

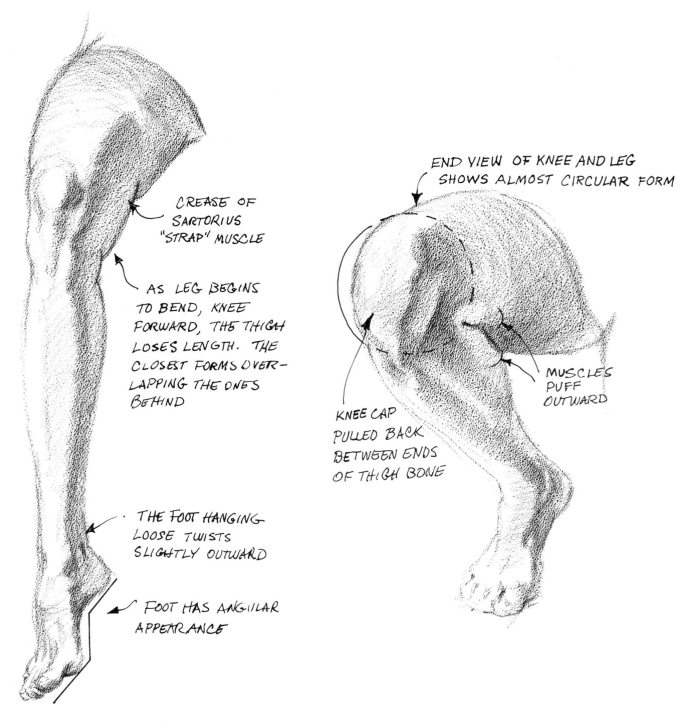

CREASE OF
SARTORIUS
"STRAP" MUSCLE

AS LEG BEGINS
TO BEND, KNEE
FORWARD, THE THIGH
LOSES LENGTH. THE
CLOSEST FORMS OVER-
LAPPING THE ONES
BEHIND

THE FOOT HANGING
LOOSE TWISTS
SLIGHTLY OUTWARD

FOOT HAS ANGULAR
APPEARANCE

END VIEW OF KNEE AND LEG
SHOWS ALMOST CIRCULAR FORM

KNEE CAP
PULLED BACK
BETWEEN ENDS
OF THIGH BONE

MUSCLES
PUFF
OUTWARD

Figure 46. This front view of the bent leg shows how fore-shortening is beginning to create the loss of length in the thigh.

Figure 47. With a leg that's almost completely bent you become aware of its width. The muscles press together causing outward bulges. The knee cap retreats in-between the condoyles of the thigh (femur) bone.

Therefore, the only time the shoulder and hip lines are parallel to each other is when the spine is straight (Figure 42). Whenever the center section of the backbone bends, the lines of the shoulders and hips always swing into opposite directions, away from each other (Figure 43).

Foreshortening

When you talk about perspective, you refer to the visual illusion that makes objects that are further away from you "appear" to diminish in size, while those closer to you appear to be larger.

The body is also affected by perspective; the various appendages that are closer to you—that thrust forward—appear larger than those that move backward and are further away from you.

However, remember that perspective isn't a scientific phenomenon, it's a visual illusion; therefore, you should concentrate on what you actually see in the model before you, not what you "think" a leg or arm should look like, physically.

Foreshortening and the Seated Figure

With a side view of the seated figure, foreshortening isn't seen and some measurements can be given (Figure 44). The distance between the pit of the neck to the bottom of the thighs is the same distance found between the back of the thighs and the front of the knees. The distance from the top of the knees to the bottom of the feet is also equal to the two previous measurements.

However, when the seated figure is viewed from the front, no measurements can accurately be given because foreshortening takes place (Figure 45). The thigh flattens out and appears to lose most of its length (Figures 46 and 47). Arms are also subject to foreshortening. An arm generally equals one half the length of the total figure, but if it moves backward, or away from you, it will appear to be much shorter. Likewise, if the model thrusts either an arm or leg forward at you, it will appear to be much shorter than it is physically (Figure 48).

Training the Eye and Hand

There are an infinite number of procedures for measuring the figure, and some are more helpful than others. However, don't rely exclusively on a set of memorized rules for proportions. It is far better to train your eye to judge proportions and to adjust your drawing to what you observe in the model before you.

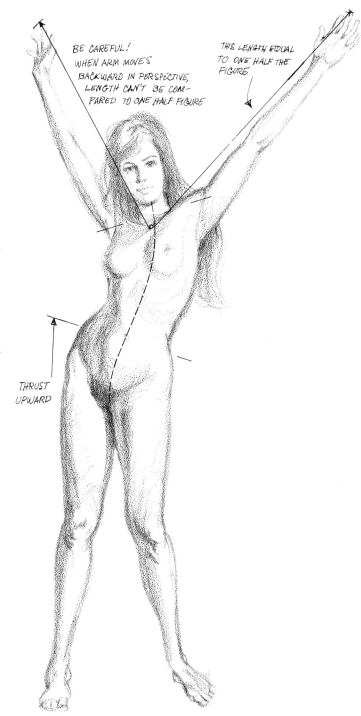

Figure 48. The action of this pose is caused by the curve of the spine and the extreme opposition of the shoulder line to the hip line. Notice the foreshortening taking place in the position of the arms. The dotted line indicates the action line of this pose. Think of it as a flattened "S."

Project 1

WORKING FROM A PLASTER CAST

To get the feel of general figure proportions, you'll use a white plaster cast figure rather than a model for your first experience with oil paint. Plaster casts have been used as copy for a long time with beginning art students. The advantages of using such a cast outweigh the frustration the beginner may feel, because he isn't working from the living model. The main advantage in using a white plaster cast figure as copy is the absence of color.

Hues, Tones, and Values

When you're learning to paint, you have three things that concern you all at the same time: drawing, value, and color. It's like trying to play a guitar, piano, and drums at the same time! All three factors may be related (and can be mastered) but in the beginning learning can be simplified when at least one of these three components is eliminated, such as color. The white plaster cast serves this purpose, because it has no color to confuse you.

Perhaps this is the time to define a few simple terms. Color, or *hue*, refers to the surface pigmentation of an object. *Tone*, on the other hand, refers to the amount of light reflected off an object. Objects reflect or absorb light according to their substance and shape as well as their position in the light. When the light and shade of an object varies in clearly defined areas, it's said to have planes. If there's no discernible boundary between light and shade on the object, it is assumed to have a rounded shape.

The Gray Tonal Scale

In addition, tones of an object have *values*. That is, some tones are darker than others; these are said to have darker or *lower* values. Some are lighter; these are said to have lighter or *higher* values. These tonal values can be compared when placed side-by-side to form a spectrum, or gray scale, with white at one extremity and black at the other.

In the black and white demonstrations of this book, I'll use numbers to refer to the tones I use. I've painted a gray tonal scale which contains eight tonal values between the extremities of white on the left and black on the right avd have assigned a number to each tone (Figure 49). Eight seems to be the greatest number of tones that the eye can distinguish between.

Control of color, or hue, isn't as vital as control of tonal value. Graduations of tone explain the form and dimension of objects in light. Tones painted correctly—that is, in the right value, shape, and position—create light and dark patterns which define an object and make it recognizable. When you paint from life, the effect of light (and the subsequent creation of light and shadow patterns) is of prime concern. The first 17 projects in this book will be done with the gray scale so that you can gain control of tonal values before you start painting with a full color palette.

How to Begin

You'll need the following materials for this project:

12" x 16" canvas board
2 Number 8 filbert bristle brushes
2 Number 6 filbert bristle brushes
titanium white
Mars black
burnt sienna
turpentine

Begin by setting up the cast figure. Illuminate the figure with one light, but not the one over your easel. Hang a light gray drape in back of the cast. On the opposite side from the light, hang a black drape to eliminate any reflected light. By keeping the lighting simple, the problem of correct values is also simplified. By using as few values as possible—four or five—you can produce a study with strength and cohesiveness.

Toning Your Canvas

Once you have gathered together your materials, you should tone your canvas. Why, you may ask, can't you paint on the plain white canvas? Starting with a white canvas, you're faced with a formidable area to cover. Whether you're painting a figure or a tree, you soon realize that very little of it will be white. Eventually you'll have to put some kind of tone over most of the canvas. So why not begin by covering your surface with a medium gray or middle tone, the tone that will be central to the dark and light pattern of your painting? In this way, you're starting from the middle and working out to either extreme of the tonal scale: middle tone to white or lightest tone; middle tone to black or darkest tone.

To cover your canvas with a middle tone, squeeze out about a quarter of an inch of Mars black and half that amount of burnt sienna directly on to the canvas. Pour a couple of tablespoons of turpentine onto the canvas and rub both paint and turpentine together; smear this mixture over the entire surface. You'll now have an overall middle tone to work with.

You'll notice that when you mix white with black the grays take on a ghastly bluish cast. You can overcome this by mixing equal amounts of Mars black with burnt sienna. Use your palette knife for mixing. The burnt sienna helps to "warm up" the black so that when you mix white into this new black color, the resulting grays will also be warmer.

For all of the black and white projects, I mixed a full studio tube of black with a full tube of burnt sienna and put the mixture in one of those pans I discussed in the "Materials" chapter. In this way, you'll always be able to get the same warm shade of gray with just the addition of white.

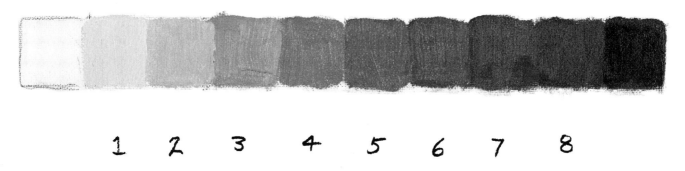

Figure 49. These are the graduated values of the gray tonal scale I'll be using in the black and white demonstrations. Eight or nine seems to be the maximum number of values that are visually different from one another between the extremes of black and white.

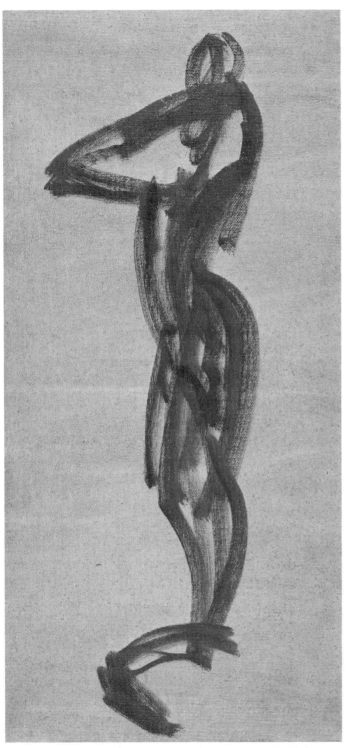 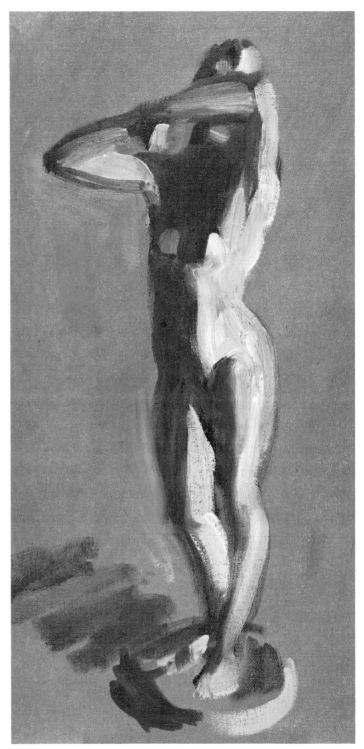

Step 1. Prior to this step, I covered my canvas with a light gray tone. Now I'm concerned with establishing the correct placement and the general attitude of the figure. I accomplish both objectives by capturing the gesture of the cast figure with a simple "stick" configuration. I sketch in this stick figure with a Number 6 filbert brush and a dark, about a Number 7, gray tone.

Step 2. Next, I take a larger, Number 8 filbert brush and pick up a generous quantity of white paint. Actually I want a tone slightly darker than pure white, but the white will pick up enough gray from the paint that I put down in Step 1 to lower the tonal value of the pure white to about a Number 1 gray. With my Number 6 filbert brush, I paint in all the areas of the body that are in shadow, as well as the cast shadow that the figure itself creates; this cast shadow sets down the plaster cast on a surface.

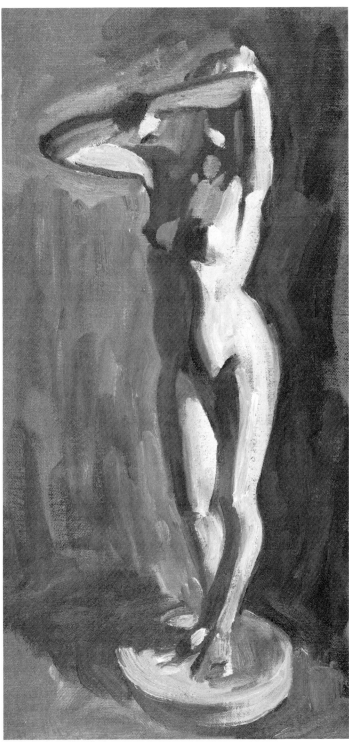

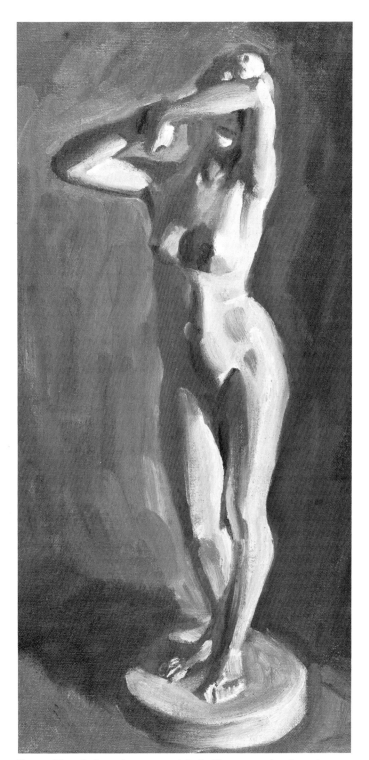

Step 3. Undoubtedly, some of the contours of my figure must be corrected. On the light side of the figure I darken the background and at the same time correct and define the body's contours. For this background definition I use a Number 8 filbert and about a Number 7 gray. Such a dark background tone used on the figure's light side makes those light areas even brighter. I use a Number 3 gray on the shadow side of the figure to shape contours. I use this same tone on the right side of the figure's chest which is a middle tone area; the undersides of the forearms are also middle tone areas.

Step 4. Here I place the more subtle halftones on the figure's chest and breast; these tones give an appearance of roundness and depth. With tone I indicate a small flat plane on the light side between the figure's hip and abdomen which helps to thrust the abdomen outward. The original highlight, which I positioned in Step 2, I leave untouched to indicate the bony area of the pelvis. With a Number 7 gray I place the cast shadow of the breast, the thighs, and between the legs. By simply indicating detailed areas, such as the bend of the left arm, with highlights, rather than carefully delineating them with individual strokes, bodily components are defined.

Project 2

THE HEAD

First attempts at painting the full figure result in frustration, because you discover you've spent most of the time trying to paint the figure's head and have failed. Soon you give up the head and bash out the rest of the figure, having achieved neither a portrait nor a good figure painting.

I think it's important to have spent many hours drawing the figure in charcoal to develop both your powers of observation and drafting skills. When you start to paint, use casts of figures to make yourself see the larger tonal arrangements. At some point, however, you'll need to conceive of how each of the elements of the figure is constructed. Then it's time to analyze each part of the figure separately. Painting the head is such a tussle, because of its subtleties of form (which give the figure life). Therefore, you should confront the study of the head first.

The Egg Configuration

Construction of the head can start with several basic geometric shapes. The head has been visualized in many ways, both two and three dimensional: for instance, trapezoids, circles on circles, squares, cubes, spheres and combinations of these. But since we're talking about beginning something, the egg is a natural thought. It can be turned to simulate the form of the head in different positions. I'll demonstrate three positions in this project: the direct front view (an egg standing upright on its small end); a side view (egg flat, small end forward with jaw annexed to the front lower side); and an almost three-quarter view from slightly above (the egg with small end down, axis at an angle).

Basic Shapes

Within the overall egg shape of the head are the forms that comprise the features. The eyes are located at the halfway point between the top of the head and the chin. The sockets of the eyes, the actual openings in the skull, obtain their characteristic shape from the top rim of the opening which points and droops toward the outside. Although the bottom rim on the socket also droops it isn't as influential.

The placement of the nose is in the middle third of the head, measuring from the hairline to the jaw. The nose is mostly composed of cartilage and has an elongated wedge shape. That is, it has a distinct top plane, two side planes, and a front end.

The mouth area or muzzle, rounds out both horizontally and vertically as a protruding ball shape. The chin juts slightly from the facial plane—just a step back from the lower lip. The sides of the face taper down to meet the chin.

Alignments of Facial Features

The coherent beauty of the facial features is due to their alignments. As checkpoints these alignments can assist you in knitting the parts of the face together in the straight front view, which is the most difficult view to compose. I'm not suggesting that all faces are cast from the same exact proportions, because a slight deviation from this ideal is the basis for character and individuality.

To establish the proportions between the eye and the eyebrow, as well as showing the curve of the eyeball in relationship to the larger curve of the head, imagine a sideways "X" shape placed over

the eyes with its center at a point over the bridge of the nose (line AB in Figure 50). When the eyes are open, the inner part of the eyebrow is on the same line as the outer curve of the eyeball of the opposite eye.

The arch of the eyebrow is generally straight above the outer corner of the eye (line C, Figure 50).

A line can be drawn straight down from the eyebrow's inner end to the tear duct corner of the eye, down to the outer edge of the nostril, terminating at the point of the chin (see line DE in Figure 50). Another plumb line from the inner edge of the iris meets the outer corner of the mouth (line F, Figure 50). This alignment is based on a model who is staring at you from some distance away. The irises would cross the lines as the model moved closer to you.

An angling line can align the outer corner of the eye, the mouth, and end at the point of the chin (line B in Figure 50).

The length of the ear falls within a space that's equal to the distance between the eyebrow and the end of the nose (lines H and I, Figure 50). Lines extending from along the ridges of the philtrum below the nose cut through the two peaks on the upper lip, through the outer corners of the lower lip and end at the points of the chin (lines J and K in Figure 50).

Manipulating the Paint

You'll need the following materials for this project:

3 10" x 14" canvas boards

2 Number 4 round bristle brushes

2 Number 8 round bristle brushes

titanium white

Mars black

burnt sienna

There'll be three demonstrations in this project. In two of these demonstrations, I've roughly completed the shapes in each step. I suggest you paint the head that way once or twice to understand what the underlying forms are. It's important that in the final stage of painting the head, the basic ovoid form is not lost even though changes occur in its shape, particularly at the jaw.

In this project I'll use a canvas board toned with a dark gray. The dark-toned canvas makes the forms of the head in the light more apparent. In this project I'll also suggest that you use round brushes, because they'll make soft edges, provided you don't stroke the pigment on with too much pressure.

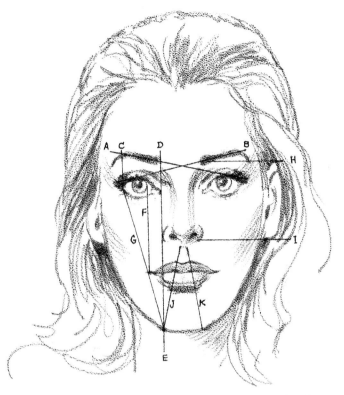

Figure 50. Some basic alignments, or checkpoints, for the placement of facial features can aid you in assembling the front view of the head. For an explanation of the various alignments see page 38.

Also, if you hold the brush at right angles to the canvas so that the bristles spread somewhat, the varied length of the bristles will help eliminate pressure, leaving a soft-edged brushstroke.

A round brush can also produce a sharper edge if you desire. By flattening the angle of the brush toward the canvas, you can draw it along so that part of the paint comes off the sides of the bristles. By rolling the brush slowly, it will stay pointed which will keep the edges of the stroke clean. See the "Materials" chapter (Figure 7) on how to hold the brush for the rolling stroke.

Blending Tones

A painting which has freedom of expression with its juicy flowing brushstrokes and a rich interplay of edges calls for the wet-in-wet technique. Using this technique, you pick up wet color from underneath with a new, wet color; this technique helps you blend edges. Let's say you have an area about an inch wide that turns from white to black. Thin your black pigment and brush it on first. Use another, clean brush and load it with white. Start where the light area is and stroke lightly into the black tone, lifting the brush as you get into the black. Try not to dig into that black tone; you can only take about two strokes like this before your brush picks up the undertone (black). Wipe your brush off with a clean paper towel. (Avoid rinsing in turpentine. This seems to soak the paint deeper into the bristles; whereas if you *wipe* the brush dry, most of the dirtying color comes off.) Now dip that brush back into your white paint and lay more overlapping brushstrokes into the dark value. Hold your brush so that you're laying the light tones on top, more or less. Now, using your brush reserved for black mix a dark, Number 7 gray and stroke it on from the black side in a fraction, back toward the white.

You'll discover that you work up the value scale farther with the "dark-color" brush than you come down in value with the "white" brush, because you must keep your "white" brush as clean as possible. Don't use it for any tone darker than a Number 3 gray, if possible. If you should forget and dip your "white" brush into a darker color, put your dirty brush into the wash bottle and reach for a clean one.

If the dark tone begins to overpower or go too far into the white, switch back to the white brush and come back into the dark tones again. With practice you should be able to paint lights and darks into each other to get a blended edge that is not slick; instead, the tones will be fused and brushy.

In the projects that follow I'll demonstrate in detail how to paint each feature of the face. But in this project, I'll begin by constructing all the facial components from large masses to show you how the whole head develops.

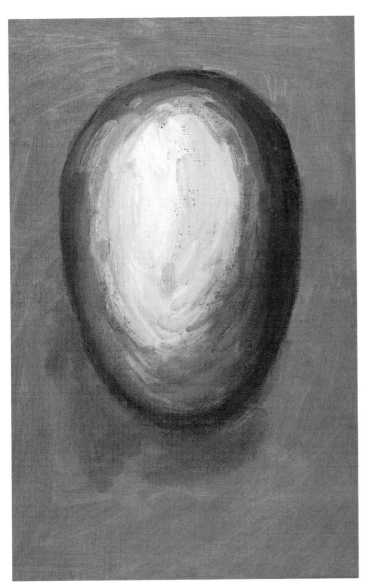

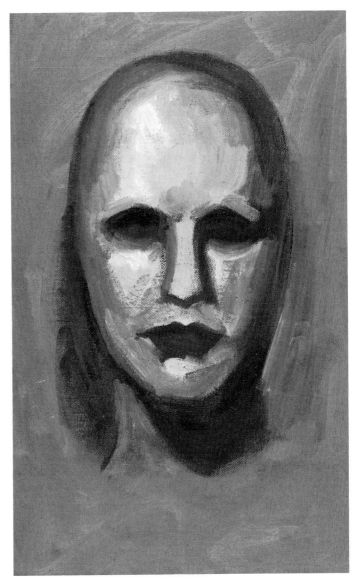

Step 1. On a canvas board toned with a dark gray, I paint a simple egg shape with a single light coming from above and to the left front. The highlight should be pure white; then I can blend the values around it to get Number 7 grays. This area around the highlight has a tonal transition. Using Number 2 round bristle brushes, I paint long strokes of graduating values parallel to one another. I start at the dark edge of the oval shape and using the Number 8 gray, I'll paint increasingly lighter strokes following the curved shape until the tone is about a Number 4 gray. I change to my light brush and at the highlight area paint on pure white; then I gradually darken each adjacent stroke until I reach the darker values. The soft edges of each of the strokes in the oval shape should overlap. This mixes them together and creates halftones.

Step 2. At a halfway point between the top of the head and the chin, I locate eye sockets with a Number 5 gray. They're the actual shape of the openings in the skull. The outward-projecting form of the nose I place halfway down between the eyes and the chin. I paint the nose with a heavy line around it to define its two side planes and its bottom plane. I make this line thicker and heavier on the nose's shadow side—the right side. I block in the lips as one mass using a Number 5 gray. It will help at this point to imagine that you're sculpturing the head rather than painting it. The jaw line and mouth planes emerge, showing the projection of the mouth and chin. I flatten the sides of the head form in between the nose's tip and the top of the temples.

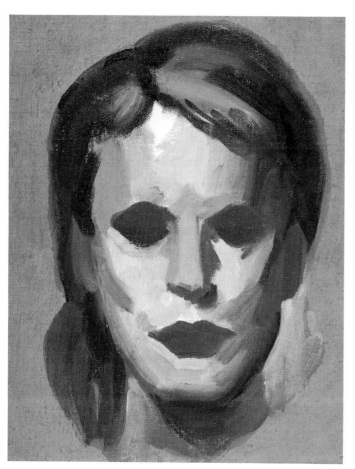

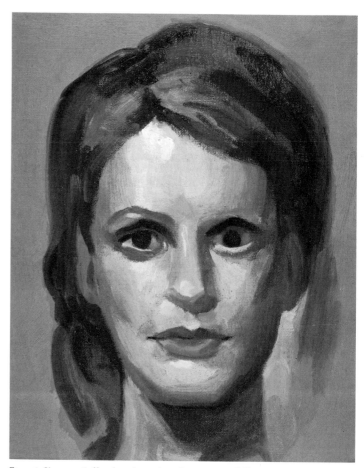

Step 3. I cover the head with a hairdo that follows the skull's roundness. While I'm doing that I also block in the ears being certain that they're a tone darker than the face because they have to stay back around the sides of the head. In addition, their florid local color will translate into a darker gray, about a Number 6. I bring the left side of the nose into correct value by lightening it, since this is the light half of the face. I blend tones softly into the cheeks on both sides of the nose. The underside of the nose should be angled back under more. I place a cast shadow with a Number 5 gray which gives more dimension, or depth, to the nose.

Step 4. I've partially developed each eye to a different stage to explain their difficult construction. First, the black dots representing the irises should always be painted on *both* eyes. For them, I use a Number 6 filbert brush with pure black paint. Surrounding the irises is the white of the eyes which isn't pure white but several light gray values. Arched over the right eyeball is a heavy stroke of Number 8 gray. This will be the basis for creases of flesh around the top eyelid. Next, I paint the top of the lower lid. *This* is the area of the eye you're aware of as being so light. I abandon the right eye at that stage so that you can refer back to it for its underlying procedures. I continue developing her left eye, and I put in a black stroke for the upper lashes. Now using about a Number 4 gray, I paint a tone on the lower lid. I lay in the path of eyebrow hairs with a base tone of Number 4 gray. Lips take shape by the addition of lighter tones. Some separation of the two lips plus their corners are shown with black lines.

Step 5. (Right) I darken the eyebrow hairs toward the center of the eyebrows. Her right eyebrow is all darker because it's on the shadow side of the face. I light up the upper lids with a Number 3 gray that I stroke on in a sideways fashion with a smaller filbert brush. Be very sure that the widest part of the eyebrow is directly over the eyeball. On her right eye (the one on our left), notice that as the lid drops toward the inside it gets just slightly darker and then, around the tear duct, quite light again. That path of the lid is influenced by the base of the nose turning out toward the light. I finish by adding nostril holes. I flick a bit of cast shadow under the nostril on the right side and soften the shadows on the upper lip. The edges of the mouth are considerably softer.

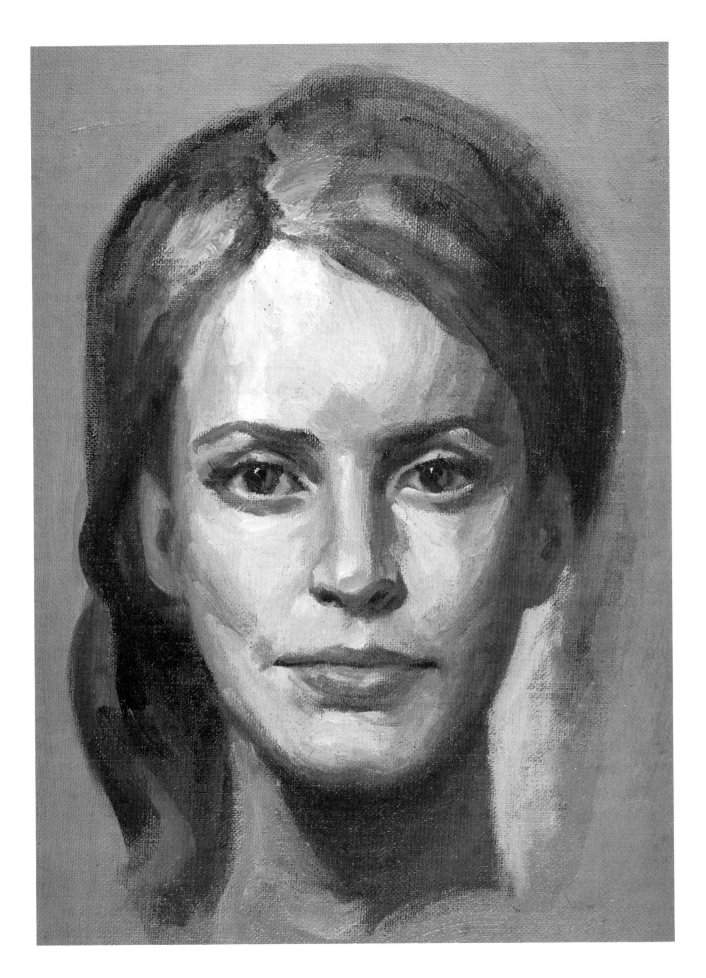

Demonstration of a Side View

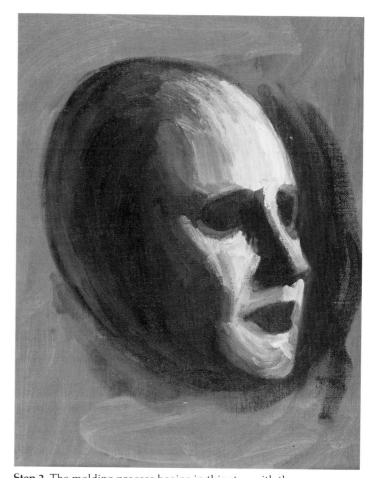

Step 1. On a canvas toned dark gray I start again with the complete egg shape. The large part of the egg is at the back and top; the rest of it slants down toward the chin. The light is above and directly in front of the head which will give this viewpoint strong contrasts of light and shadow. After placing white for the lightness, I use about a Number 8 gray and work from the back shadow area. As I come forward toward the light, I blend wet-in-wet tones.

Step 2. The molding process begins in this step with the same hollows of the eye sockets; I use about a Number 8 gray for them. Here you see how they angle back from the form of the nose. The side dimension of the nose is striking in this position. You can see how the nose is welded into the head by the keystone formation at its top, as well as the blending of its side plane into the cheek. One tone, a Number 8 gray, has been used to unite the shadow of the side of the nose and the cast shadow. The mouth is painted with a Number 7 gray in one mass; notice the foreshortening that's involved with the mouth. The shadow plane of the side of the head is evident. It curves around at the chin to follow the oval contour but then goes up-right because it dips into the depression of the cheek, slanting up along the cheekbone to join the shadow beside the eye.

Step 3. (Right) It is less work to complete this side view of the head than to complete a front view. Here I add a simple hair shape. I do some softening and blending of her hair near her forehead. The details of the features are developed much as I did the demonstration of the front view. This head position can be difficult because so little of the far, or right, side of the face is visible, but it's more interesting than a complete profile.

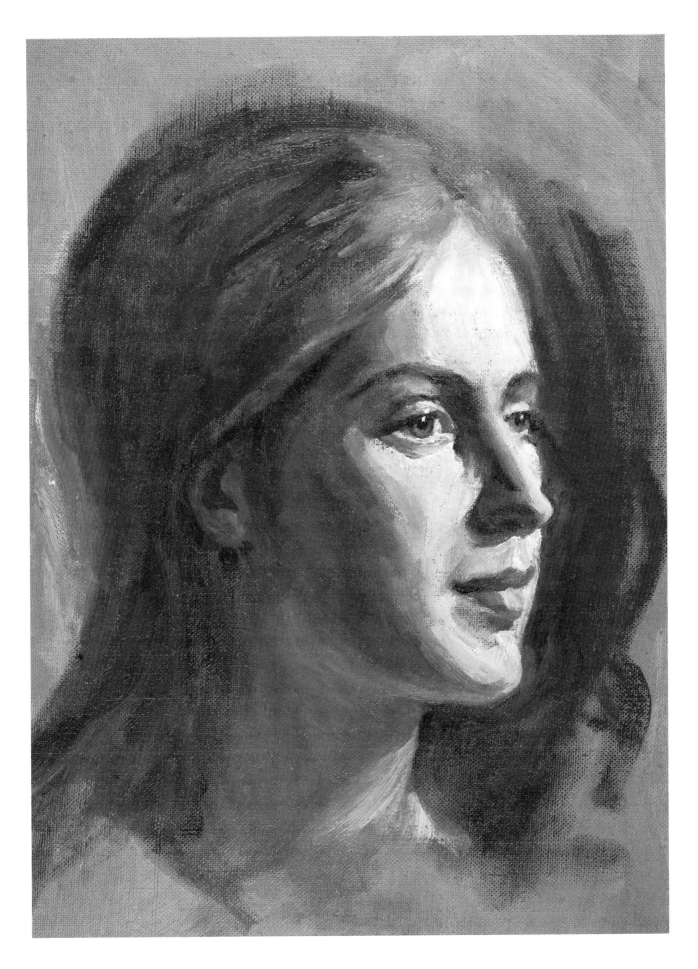

Demonstration of a Three-Quarter View

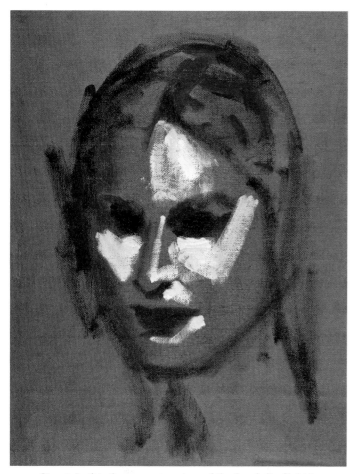 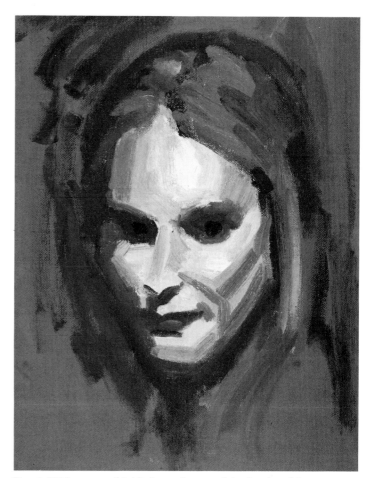

Step 1. In this three-quarter view of the head, the light is coming from the upper right and above. If you have established in your mind the large, basic egg shape it isn't necessary to paint it completely. I sketch in a vague linear representation of it. However, I indicate the strongest areas of light—the forehead and the cheek planes—with white pigment. A highlight runs down the nose and across the top of the right nostril defining its form on that side. A highlight shows the projection of the muzzle area. The strongest light is near and under the mouth. With a Number 7 gray I lightly position the eye sockets and a darker tone within them positions the irises. The shadow side of the nose is contoured and its underside is located with a Number 7 gray. The total area of the mouth is painted again with the same gray. I roughly indicate the hair masses.

Step 2. With a strong highlight on the top of the forehead, I emphasize its rounded contour. However, down farther, the forehead breaks up into planes going around the front and sides of the face into the temples. This view demonstrates quite well the plane of the cheek that slopes toward the front. I have purposely exaggerated this cheek plane to emphasize the importance of this form around the eyes. Only when that form is fixed can the eyes themselves be developed. *Never* paint the lids of the eyes first and try to put the eyeball inside, because the eyelid placement depends on the curve and position of the eyeball. I use a Number 2 gray for the side planes of the nose. The cast shadow under the nose follows the contour of the septum on the upper lip. The cheek is pulled up in a slight smile; that line does not touch the mouth.

Step 3. (Right) In Step 2 I showed how the head is formed by positioning large masses of dark and light paint. Here I simply refine these large tonal masses, breaking them down into smaller tones thereby creating facial details and defining features. I develop the eyes basically as I did in Demonstration 1 of this project. The cast shadow under the nose is extended almost into the left side of the mouth. I also use a lighter tone of gray as I extend this shadow; a cast shadow is always darkest where it joins the object that's casting it and lightens up as it moves farther away. I also lighten up the right side of the lower lip with a Number 3 gray, emphasizing its roundness. A tiny spot of white on the lower lip creates a highlight.

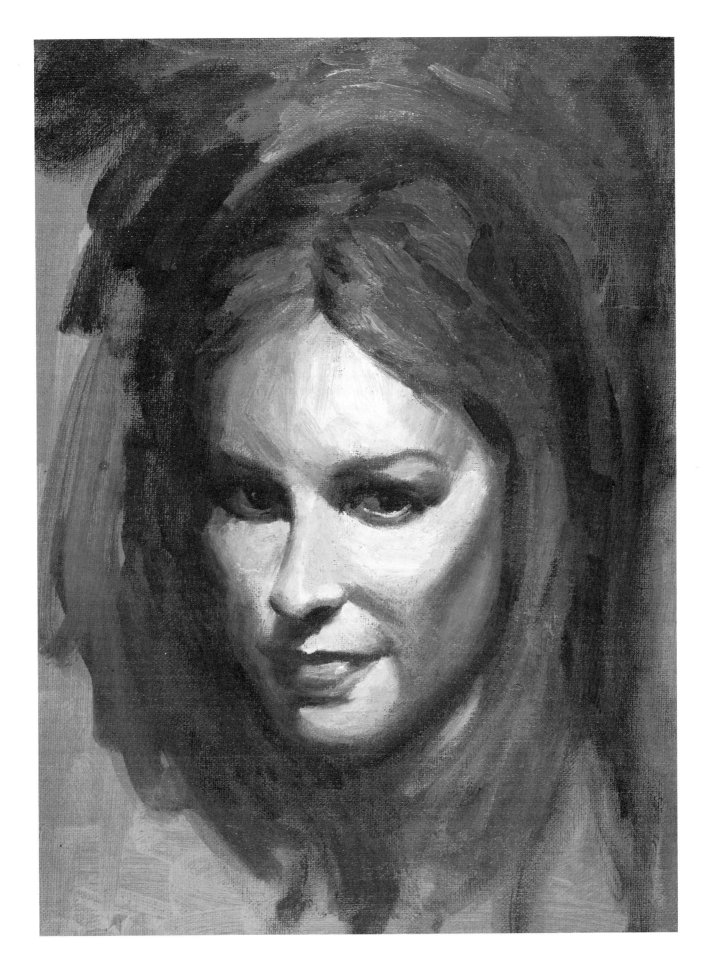

Project 3
THE EYE

Before I begin this project, let me point out that painting the individual features of the face usually is done at an advanced stage in the overall painting of the figure—usually after you have laid in the entire figure with a wash and have determined all of its proportions correctly. Yet, I'm going to demonstrate how to paint the individual features early on in this book simply because it's a logical extension of any discussion of painting the head. Therefore, since most beginners are *mistakenly* overconcerned with painting the head first anyway, I felt I might just as well begin at the top of the body and work my way down, part by part—from head to facial features to torso, arms, legs, feet, etc. Then we'll put together all the components and paint complete figures.

The eyeball is recessed from its surroundings; it presents a convex shape which protrudes from the concave form of the socket. It's often difficult to see this, because other smaller modulations of the eye hide the eyeball's underlying form. However, unless you paint the concave and convex configurations of the eye correctly, you might as well put in circles like Orphan Annie eyes. Concentrate your efforts on learning to paint the forms *around* the eyeball. Sparkling highlights and long lashes are easy to render, but they won't save a poorly constructed eye.

Developing Structure

You'll need the following materials for the straight-on view of the eye in this project:

8" x 10" canvas board
Number 1 filbert bristle brush
Number 6 bright bristle brush

2 Number 6 filbert bristle brushes
titanium white
Mars black

I haven't toned the canvas boards for this demonstration, because I don't need a surrounding atmosphere. Start with a Number 6 tone and paint a shape to resemble the eye socket—somewhat pointed at the top, slanting down, curving around the outside and bottom, and turning back up next to the nose. Next, spot in the iris using a clean Number 6 bright bristle brush. (See Figure 51 for a completed eyeball.) Aim the brush loaded with pure black straight into the canvas. Twirl it slowly. The iris should be very black and round. If your brush picks up too much of the light color underneath, wipe the brush clean and repeat with more black.

Note: it's essential that both eyes should be painted at the same time when you're doing a complete head, because this is the only way you can achieve correct tracking—both eyes looking in the same direction—of the eyes. Irises should be placed in their exact position after all the basic forms of the facial features have been blocked in. Even with just two spots for the eyes, you'll be surprised how believable the gaze is.

The "White" of the Eye

In black and white tones, the so-called "white" of the eye is only pure white at its shiniest part. In full color this area of the eye is *never* white; in fact, it's nearly flesh color. Paint the "white" around the sides of the iris as well as above and below it. It isn't necessary to paint the complete eyeball as in Figure 51, unless you want to do it for a study.

Lower Eyelid

There's a recess above the eye caused by the upper fold of the skin between the brow and upper lid. It's better painting procedure to paint dark recesses first and work the lighter tones into them. Use a fairly wide stroke for this upper recess arching around where the periphery of the eyeball would be. Place a dark accent for the tear duct corner.

The next thing to attend to is the top rim of the lower lid. This rim is very light. The reason for putting this light tone in first is that you can't always watch or control both edges of the brush at once. If you get the bottom edge painted incorrectly you can come back in with a dark tone later. In this view of the eye, the lower lid just misses the bottom of the iris. At the outer corner the lower lid disappears under the upper one. The top rim of the lower lid is visible, reflecting its light pink color. It should be lighter than the "white" of the eyeball over on the shadow side. Keep in mind that what often appears to be the lightest part of the eye is not the "white" of the eye but that top rim of the lower lid.

Upper Eyelid

To paint the top lid, start next to the nose and stroke up over the eyeball so that you're cutting off the top of the black iris; the lid should be the widest above the iris. Again, watch the shape of the top edge. Coming to the outside, twist your brush so that the lid thins out and curves down around the eyeball. Where that lid approaches the nose, take pure white and make the curving path around the tear duct, widening into the cheek area and the lower lid. The cheek tones will blend back into this.

Eye Creases and Shadows

Back to the lower lid. It does not terminate in a definite line below. It covers the lower part of the eyeball and then softens into surplus folds of skin that merge at the lower rim of the eye socket into the cheeks. The surplus folds of the lower eyelid stretch up when the eyes raise. These are not noticeable in young people. If you want to idealize the female face, underplay them.

Eyebrows

The eyebrows have a pecular path—a reverse twist. They start slightly above the root of the nose, follow the underside of the brow prominence, and curve

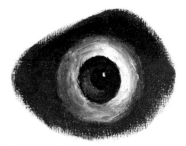

Figure 51. The eyeball is suspended in the center of the eye's socket. The eyeball's diameter is about an inch and it occupies half the orbital cavity. The iris is one-half the diameter of the eyeball.

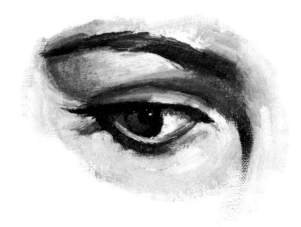

Figure 52. This view of the eye is seen from slightly above. It shows further evidence of how the eyeball protrudes out from the eye's socket. This view also shows the lids and how they set in the recessed assembly of the socket. From this perspective the lower parts of the eye are seen as deep circles, while the top lateral lines of the lid and lashes begin to flatten out. The shadow of the lashes on the cheek gives a feeling of third dimension or depth.

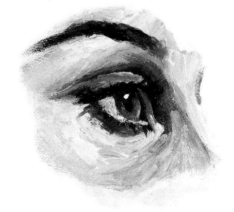

Figure 53. This three-quarter view of the eye is seen from a bit below. The light has shifted around a bit, but the depth of the recessed eye socket still causes a darker area around the lid, especially next to the nose. The thickness of the eyelids, visible here, is important to note, because the beginner often makes the eyeball flush with the lids. The rim of the lower lid has a small bit of moisture which gives the whole eye luster. Note how the light on the eyeball passes throught the transparent cornea and lightens the side of the iris further away from it.

around to a point over the eyeball. There they change direction and cut straight up across the edge of the bone opening. The edge of this boney prominence and the eyebrows form a flat "X."

The eyebrow hairs are a study in edges. Retracing their path, they start at the nose with ultra softness blending completely into the flesh. Then they get very dark; their top edge becomes sharp, and their underside becomes soft. This immediately switches at the arch of the eyebrow and the top edge becomes soft and jagged while the underside is dark and sharp. This is in sharp contrast to the highlight along their drooping outer edge. From here out to the end they're lighter and fade somewhat.

Final Touches

If you need more sparkle or femininity in an eye, you can thicken its lashes with black. For these lashes, stroke toward the outside. Directly above the irises start flipping the brush up in short strokes out to the corner. There are a few dark lashes on the very outer edge of the lower lid.

To indicate the local color of the iris, dab in a spot of light gray tone on the side *opposite* from the highlight on the pupil. The light striking the shiny transparent cornea of the eyeball creates this sparkling highlight and continues on to light up the iris on the other side. Pull a pointed glob of pure white from your palette with your brush. Just touch this point of paint to the edge of the pupil. Zingo! You have a lifelike eye.

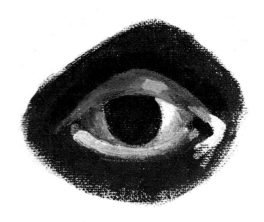

Step 1. I paint a shape that simulates the opening of the skull, or eye socket described in Project 2, using a Number 6 gray. In the center of this shape, I paint the iris by twirling slowly a Number 6 bright bristle loaded with pure black. I put in the tones of the eyeball that will show between the lids. I graduate these tones so that the eyeball looks round. With a Number 8 gray, I paint the heavy dark crease above the upper lid. Using the Number 1 filbert brush, I stroke in the top of the lower lid with white and bring the stroke around from the shadow side to the tear duct where there should be a dark dab in the corner. With my Number 6 filbert brush, I start painting in the upper lid at the tear duct corner with a Number 3 value. I stroke up and over the black circle of the iris. At that point the upper lid widens and then narrows down; I twist the brush to achieve the narrower stroke. On the highlight side of the eye, I brush a dab of Number 2 gray on the lid. In the corner next to the nose, I bring the upper lid down around the tear duct with pure white; the tag end will blend with the facial tone.

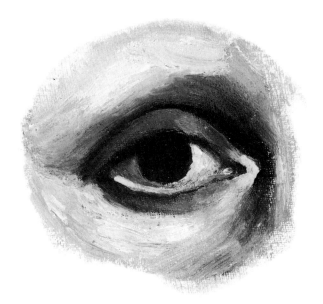 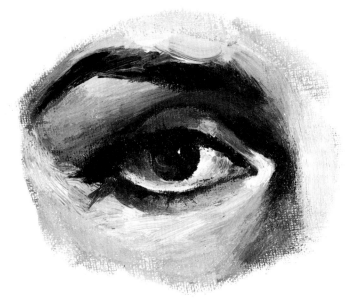

Step 2. Now is the time to work the eye formation out into the face. I use light values such as a Number 1 gray and some white to blend the face values into the dark tones of the sockets. If the rim of the lower lid gets too fuzzy, I cut back into the underside of it with a Number 6 value. Then I blend the light path around the the tear duct into the underside of the lower lid, so that this light tone gradually gets darker toward the eye's outer corner. I put in the cast shadow of the upper lid by starting at the nose corner with a middle (Number 5) gray. Just before the iris, I make the shadow black all the way across, but thin it at the outer corner. This line should be soft on both edges. (I use the small filbert brush, stroking it flat side forward.) In this light, the outer edge of the face from the corner of the eye dips in slightly; very subtle grays can define this contour. Some of the side plane of the nose is painted. The dark recess next to this side plane begins to lighten as it comes down farther. A final touch is a spot of light in the tear duct to show moisture.

Step 3. This is the time to paint in things you were dying to do at the beginning. The path of the eyebrows should be gone over twice. The first time, I use a Number 5 gray to establish the route and placement of the brows. The second time, I put in the variations of their character. On this second pass, I make the fine, soft hairs of the eyebrow's inner end blend completely. Over the eyeball, these hairs get darker, heavier, and have a sharp edge on top and a soft one underneath. As the eyebrows cross the prominence of the brow bone, the light catches them. Here the top of the hairs fold over, so they become soft-edged on top and gather together to sharpen the under edge. At the outer, downward curve the hairs are lighter, sparse, and come to a point. I don't paint individual hairs, but rather I get the effect of bunches of hair with heavy paint. I use the Number 6 filbert brush, alternately turning the brush to produce wide and thin strokes. I thicken the upper lashes with black. Only a few lashes on the lower lid are necessary. The upper lashes cast a shadow on the face. I indicate the local color of the iris by dabbing in a spot of Number 6 gray on the side of the iris opposite from the highlight on the pupil. The pupil's highlight is a pinpoint of pure white paint.

Project 4

THE NOSE

Unlike the eyes with their expressive movements, the nose is simply a rigid, vertical fixture made of bone and cartilage. What muscles it does have can only make it wiggle up and down at the top. Observe then, the three fundamental parts of the nose: the upper wedge at the bridge, the main pyramid shape, and the wings, or nostrils, flaring out on each side.

Learning Basic Forms

Straying from an ideally shaped nose will quickly change the face both in age and character. The termination of the bone half way down the main body of the nose is usually evident. When you paint a young pretty face that termination should be glossed over (Figure 54). You'll need the following materials for this project:

8" x 10" canvas board
2 Number 6 filbert brushes
titanium white
Mars black

The Front View

Painting a front view of the nose is actually harder than painting it at an angle, because in this view only subtle tonal changes can describe its form. (See the demonstration at the end of this project.) Start by laying in a flat middle tone in a configuration that includes the bridge, the sides, the front, and what will be the nose's underside. At this point avoid using any thinner, like turpentine. If your paint isn't soupy enough, use a painting medium. The two planes slanting back to the face from the

nose are done with darker tones; the one on the shadow (right) side is much darker. The tone on the shadow side should extend down and out from the base of the right nostril to produce a cast shadow. The tones on both sides of the nose rise up to blend in with the darkness around the eye sockets.

With light coming from the left side, you can show the slight camber of the nose's front surface by painting in a Number 3 tone along the left half of the nose. Down near the nose's tip, this tone stops; this leaves a subtle shade across the top of the nose, making it appear to turn up slightly. On the lower half of the tip, brush some Number 3 gray in a triangular shape. While you're using that tone, rough in some of it above the bridge. Each side plane turns into the front of the face very gradually. Brush in a Number 4 gray at a downward angle to underscore that effect.

Nostrils

The dramatic changes in the nose occur when the wings or nostrils of the nose are completed. There are light values which form a sharp junction around the nostrils. Paint these with Number 1 and Number 2 grays. With the left nostril, a light gray tone cuts around underneath it with a knife-sharp edge; then this tone blends into a halftone that travels up into the nostril (see the demonstration). The two nostril openings, like tilted commas, are very dark, about a Number 8 gray. The front surface of the nostrils are subtle tones. The nostril on the right has a dab of Number 4 gray; the left one has a value only a halftone lighter. Very judicious use of white is used for highlights in the demonstration, because the light is flat and soft.

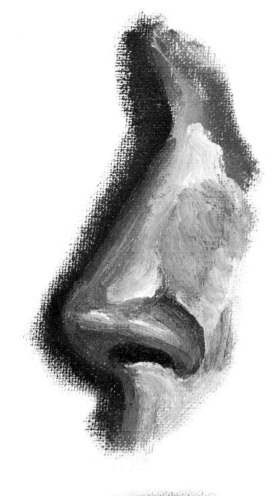

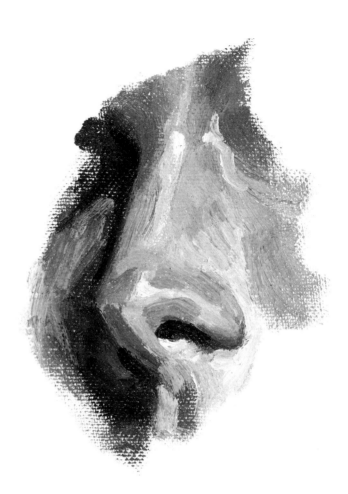

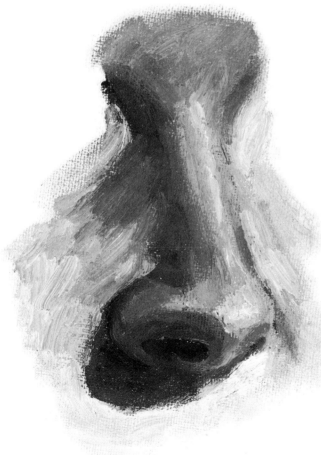

Figure 54. (Above Left) This profile view idealizes the shape of the nose. Intentionally, there's no bump halfway down its top slope to show where the bone ends and the cartilage continues. Most any view of the nose seems to make the nostril opening look like this reclining comma. Here you see how the point of the comma at the base of the nose is farther forward than the indentation of the nose's bridge. The back part of the nostril that meets the cheek is nearly always sharply defined.

Figure 55. (Above Right) This oblique view of the nose has the light coming from the upper right and shows the side plane of the nose blending into the cheek. From this view you can also see the outward slope of the nose along its top plane with its tip turning out still more. At the tip there's a wide highlight of pure white. The underplane of the nostril flares up slightly and back at an angle revealing its elongated opening. This opening is lit by reflected light from below, making it a tone lighter than the cast shadow created by the nostril.

Figure 56. (Left) This is another oblique view. Here the light is coming from the right. You can see that the center of the cartilage of the nose tip is part of the septum. Note how the septum picks up the light just before it blends into the shadow of the nostril's opening. In this view the highlights are on the edge of the nose closest to the light. The line of the highlight continues, in a lesser degree, out along the top of the nostril. The far nostril, in shadows, has mostly soft edges which make it recede.

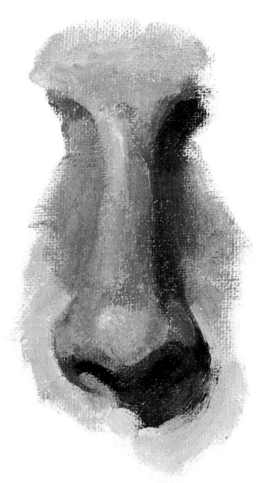

Step 1. (Above Left) I paint the basic nose configuration with a middle tone, about a Number 4 gray. It's basically a short necktie shape. The "keystone" shape at the top forms the bridge of the nose while the main chunk of the nose widens down to the tip. This shape incorporates the basic planes of the nose: its top, its two sides, and its bottom tip which turns up from the face.

Step 2. (Above Right) I define the side planes of the nose with graduating tones that range from Number 6 to 8 grays on its shadow (right) side. The bulk of this shadow and the nose's cast shadow are about Number 7 and Number 8 tones. On the light side of the nose (left) I use Number 4 and 5 grays. I brush out two angled strokes from either side; these act as attachments to the facial tones. With a Number 3 gray, I add the facial tones above the bridge of the nose. Loading my brush with some more of the Number 3 gray, I stroke down the light half of the top of the nose and stop short of its tip. I use more of that tone to round out under the nose's tip.

Step 3. (Left) I cut sharply around the nostrils of the nose with the light tones composed of Number 1 and Number 2 grays. These edges are not only a sharp contrast, but they are just the opposite of how the planes blend softly into the face at the bridge. Down below the nose, I shape the cast shadow so that the depression under the septum is evident. A halftone made from a Number 3 gray lights the bottom of the nostril opening. The shadowy openings of the nostrils are very dark—almost pure black. The tops of the nostrils I paint with one dab. The nostril on the light side is only a shade lighter than its base. I underplay the highlight here, blending it softly into the undertones.

THE MOUTH

The mouth and its surrounding muscles contribute the most to facial expressions. It has a flexibility and movement of its total shape that neither the eyes nor the nose have. All of the features move, more or less together, to produce changes of facial expression, but none of them change their shape so completely as the mouth. The majority of faces I'll be painting have serious countenances with their mouths in repose. Most everyone is familiar with the lip shape in that position, that is the mouth with its lips closed and in repose. That shape of the mouth in its various three-dimensional aspects is all I'll be concerned about now.

You'll need the following materials:

8" x 10" canvas board
2 Number 6 filbert bristle brushes
titanium white
Mars black

The Front View

The forms that encircle the mouth are so subtle that it isn't feasible to use them to begin painting the mouth's contours. Therefore, it's easier to start a mouth by using thinly painted dark tones on bare canvas and work the lighter impasto tones into it.

In repose, the red margins of both lips present a very clearly defined mass. Paint this mass first. Use a dark tone like a Number 6 gray and paint this mass solidly. (See the demonstration at the end of this project.) Once this is done, you can paint the light tones surrounding the solid lip shape. The upper lip covers the teeth; from each cheek the upper lip slants forward to the center depression called the philtrum.

The furrow under the rim of the lower lip is very dark. Notice how the furrow arches upward, pushing the lower lip up in the center.

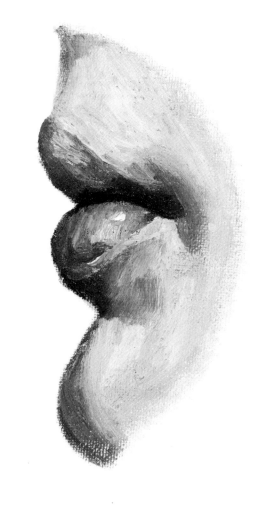

Figure 57. The sharp outline of the mouth seen in profile is painted by starting with a dark shape similar to a heart symbol placed on its side. Next, the facial forms around the mouth are painted, in this case with very light tones. They blend into darker shades as they reach the edges of the lips. At the corner of the mouth the facial tone blends into a middle gray to meet the very black corner of the lip. There are two places on the periphery of the lips that lose their edges and blend into surrounding flesh. Such edges will keep your lips from looking as though they're pasted on.

Major Parts

The lips protrude from the face and have several planes. Of course, they're divided; the upper part is less than half of the lip mass. The top lip slants back on each side from a pointed center. As mentioned, the center is actually a crescent-shaped tubercle; it forms a center part to which the two sloping side parts of the upper lip attach. The protruding lower lip has three planes: two side planes and a long front plane that rolls forward.

The chin is a ball that gets lighter as it comes forward until it's almost pure white next to the dark furrow just below the lower lip. At the sides of this furrow the face gets lighter as it goes up toward the corners of the mouth. Details can be added here by darkening the corners of the mouth and blending them up into the cheek tones. The whole study of the mouth can be polished by softening the tones on the upper lip and being more definite with the planes underneath the mouth.

Highlights can be added along the rim of the upper lip at its peaks and along the valley of the philtrum. On the protruding part of the lower lip, there's a lighter path of adjacent flesh all around it. This light area can be painted with lighter tones to show how they surround the lips. Finally, you can add some very thick white to show the moistness of the lower lip. Also, you can accentuate the separation of the lips and the corners of the mouth with pure black.

Step 1. In this front view of the mouth, I begin by painting the lips as a flat solid shape, using a Number 6 gray. If your edges are a little ragged and brushy like mine, it doesn't matter, because you'll be painting into them. Notice that I use bare canvas; eventually I'll work light impasto tones into the dark masses of the lips to create contours.

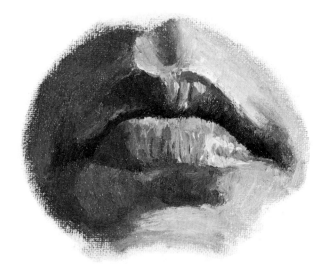

Figure 58. From a viewpoint below the mouth (looking up at it), the three planes of each lip are emphasized. This view especially shows the forward slant of the whole upper lip and the dipping of its center tubercle. The overhang of the lower lip is obvious, with reflected light hitting it under its left side. A variety of lost and found edges are used here.

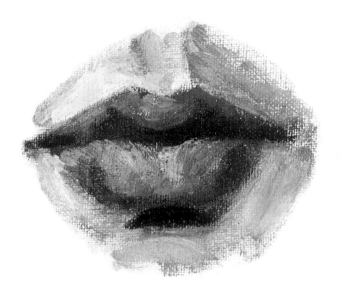
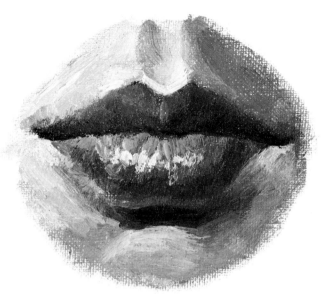

Step 2. Here I rough in the forms surrounding the mouth using a Number 2 gray. A Number 4 gray indicates the upper lip on the shadow (or right) side; this is somewhat of a receding plane. Some of that tone pushes in the part under the shadow of the mouth. I paint the depressed valley of the philtrum on the upper lip. For the side of the philtrum in the light I'll use a tone between pure white and a Number 1 gray. The shadow side of the philtrum is about two or three shades darker. I paint the upper part of the tubercle on the upper lip with a Number 4 gray. On the underneath part of the tubercle I use a Number 7 gray to show its crescent shape. I rough in more dark paint to indicate how the lips roll under as they taper to their corners. By painting the long front plane of the lower lip with a Number 4 gray and stroking from the separation line down, I define all three of its planes. A Number 3 gray hints at the slight vertical crease down the center of the lower lip. There's a deep furrow under the lower lip that humps up slightly. This is painted very dark, about a Number 8 gray.

Step 3. To tighten up the painting, I smooth out the forms around the lips. On the upper lip, the side close to the light is mostly Number 1 gray. On the rim between the two peaks of the upper lip, a pure white highlight makes them turn outward. I soften all of the philtrum edges at the upper lip and blend the tones that form its center tubercle. I add a very black dividing line between the lips. Under the corners of this black demarcation, you should lighten the flesh part. These parts are often painted with strong highlights. Combined with the shaded part above the corner they impart a pleasant expression to the face. The forms below the mouth funnel into a short, dark furrow with a Number 8 gray blending up and around the shadow side. I start with a pure white under this dark accent and paint the ball-like shape of the chin. This white will lighten the dark gray tone already present to a Number 3 gray. The finishing touches are the moist highlights on the lower lip which I put in with white paint, and, once more, black touches in the corners of the mouth.

Project 6
THE EAR

It would be hard to describe an ear in any simple way. It's neither oval nor round. It's a conglomeration of crinkled pieces that appear to have no rhyme or reason, but they do, of course. The forms of the ear almost have to be discussed in anatomical terms. As a painter, you need some logical way to put the various ear forms together. Even looking at an ear, you can be confused.

Simplified Ear Structure

I had a cartoonist friend who gave me a clue for simplifying the structure of an ear. He said to look for the letters "C" and "S." The letter "C" is the general shape of the outside contour of the ear. The letter "S" shape forms the interior core upon which the other ear parts are based. The two letters face in opposite directions from each other, depending on the side of the head you're looking at. On the *left* side of the head, the "C" is backward and the "S" is correct. On the *right* side of the head the "C" is correct and the "S" backward. This may seem a bit artless, but I'm all for finding an easy way to do things—and this works!

You'll need the following materials for this project:

8" x 10" canvas board
2 Number 6 filbert bristle brushes
titanium white
Mars black

The Side View

To paint the left ear you can start with an undertone of a Number 6 gray filling in the letter "C" shape (see the demonstration at the end of the project). With a brush full of black paint you can swish in the letter "S." Remember with a left ear the "S" is facing in the correct direction. You should widen your stroke at the bottom of the "S"; the bottom of the "S" is also a smaller curl. From this foundation you go on to make all of the anatomical adjustments.

The outer rim of the ear is called the helix. This helix is separated from the inside bulging shape called the antihelix by continuing the upper curl of the "S" around. The antihelix rises and splits into another letter shape, a "U," and disappears in under the shadow of the helix rim.

Continuing down the antihelix, it narrows and forms a lump at the bottom of the ear which is called the antitragus. Directly above the antitragus and across the black tone of the concha is the tragus, a protecting flap of cartilage that covers the ear hole. The earlobe is puffy, so it can be painted in lighter grays. The helix swings around in front and disappears into the concha.

The final step in painting an ear is to round out and add highlights to all of the parts. The shapes are somewhat shiny and may have slight twists and turns according to the individual ear. Most paintings of females have no ears or only parts showing. However, you never know; a future hair style for women may be a crew cut!

Figure 59. (Above Left) If you change your viewpoint around to the front slightly, the ear looks the same except for the antihelix which begins to show itself protruding out near the bottom. Also from this view the whole ear appears to be much narrower.

Figure 60. (Above Right) Even in a direct view from the front, the underlying "S" shape of the ear is evident. Can you see it? All of the parts of the ear angle out from the head. The upper rim has a flatness. The antihelix swings out and back to the antitragus.

Figure 61. (Left) Seen from the rear, an entirely different set of shapes are apparent in the ear. Next to the mastoid bone you can see the outside of the concha wall. The depression below this is lit because of the lowered position of the head. You see the rear of the lobe connecting to the helix, which rises in bumps and turns, flattens, and dips back into the side of the head. Here again, you could say the ear's outside rim forms a very slender "S."

Step 1. (Above Left) First, I paint in a flat tone in the shape of a letter "C." I use a Number 6 gray for this. For the left ear the letter "C" is reversed. Inside of the "C" configuration with a stroke of black paint, I paint the letter "S" facing in the correct direction. This "S" shape widens toward the bottom and the curl of the bottom is smaller than the one at the top of the "S."

Step 2. (Above Right) I bring the upper point of the "S" down to form the recess between the outer rim (helix) and the antihelix. I use a Number 4 gray to give some of the parts depth and shape: for example, the front flap of the tragus, which rises up from the antitragus to cover the ear opening, and the earlobe.

Step 3. (Left) All of the shapes are now molded, softened, and highlighted. The parts that turn into the light, which is coming from the left, are painted with Number 1 and Number 2 grays. The ear hole is in the center behind the tragus. The floor of the concha, below the tragus, is very dark in this type of lighting situation. The two fingers of the antihelix go into shadow above so I change the value from the black of the original "S" line in those two spots.

HAIR

If any form exists at all in hair it's due to a particular styling plus its flow around the skull, neck, and shoulder shapes. In terms of what interests a painter pattern is the best description of how hair masses arrange themselves. The artist can forget completely about individual hairs and observe, instead, hair that clings together in either narrow strands or larger sections. These sections of hair separate slightly and each has its own light and shadow arrangement. Even though two segments or sections might hang next to each other, their highlights and shadows are out of step, either higher or lower than those adjacent to them. Therefore, hair has a patchwork look to it.

Softness and Edges

The first thing I'd stress, emphatically, is a prudent treatment of edges when painting hair. Hair can be a study of a variety of edges. A few edges might have a hint of sharpness but generally they range from soft to very, very soft. If you're in doubt about how to handle a certain edge—make it softer. This is an absolute where the hair lines are concerned (see Figure 63).

Style and Movement

Hair forms are not bounded by any anatomical configurations but are the result of either an individual hair "style," or the haphazard disarray caused by breezes or movement. The arrangement of hair is, naturally, fragile especially at the ends. Painting hair from a live model should be completed in one twenty-minute session, because it won't have the same form in the next session. (Hair spray should only be used in a studio for fixing drawings!)

Background

When you paint the hair, you produce a blend of color which fuses hair tones and background tones together. The background must be absolutely stark and flat in order for the colors and values surrounding the head to produce a third dimension and softness to the hair. For instance, some hair edges can be absolutely lost into the mist of the atmosphere, while against other edges the background can be in strong contrast to make the head come forward from it. Contrary to restrictions imposed by other parts of the body, hair gives you freedom to paint "loose" and to *design* its colors and shapes.

Color

In black and white painting it's not easy to tell the hue of the hair unless it's extremely black or blond. In a black and white painting, white can either mean gray or blond hair. Later, in a full color painting it will be possible to show how hair—though labeled red, blond, or brown—can have many colors in it.

Lighting

Some of the most beautiful paintings of hair were done by portraitists like John Singer Sargent, Thomas Eakins, and Velásquez. They painted hair simply, with just a hint of one light. Perhaps their studios were the legendary ones with just a single shaft of soft light from a skylight. Today we are attuned to multiple light sources blasting from all directions, like those used in movies and TV. The samples I've painted reflect this influence. Though I've endeavored to keep one area of major contrast,

Figure 63. Unlike dark hair which shouldn't have extreme tonal contrasts, blond hair often does have a wide range of values. On the shadow side of any object, even bright ones, there's a certain amount of darkness, so regardless of whether hair is blond or dark, these shadows will be low tonal values. This is a conservative "flip" hairdo. The paint was manipulated with both a Number 10 filbert bristle brush and a Number 14 flat bristle brush. Note the softness of the hair at the temples and on the neck. Hair around the face has a very fine texture and blends completely into the skin.

Figure 64. These black, shiny tresses are quick and easy to paint. Don't feel guilty about not taking a long time to do them. They can be done simply in two steps. First lay in the entire hair shape with pure black using a clean brush. Your pigment should be thin but of a consistency that will cover the toned canvas. (Black will only stay pure on a *dry* undertone.) In the second step you can position the lights. They contain two values: Number 5 gray is brushed in around the crown with a Number 10 filbert brush; this is the area of strongest contrast. The soft rolls of hair lower down are brushed in with Number 7 grays with the Number 14 flat brush.

Figure 65. This back view shows a pony tail with an encircling highlight coming sround the skull; it's the area of greatest contrast. Notice the zigzag course of this light. It gives the feeling of hairs grouping themselves into sections. The part is an indefinite, uneven light tone. As the pony tail comes out into the light, it has very subtle highlights that give it shine. It fluffs out in less formality than the hair that hugs the skull. The dip of hairs on the right has a light at the bottom to show its shape.

Figure 66. In comparison to long, casual hair styles, this one is short and sculptured. Although there are many segments which combine highlight, halftone, and shadow, the overall plan of light is strong in front and deep in shadow at the back— even though the hair is light in local color. The problem here is to make all of the curl segments different in pattern and still have the effect of their shape and shininess. It's best not to stress too many of them. Keep each curl simple; most are soft. As you paint each one, keep in mind the large structure and the overall light pattern.

Figure 67. For this almost "watercolor" approach, I started on a bare white canvas. I lay in a Number 3 gray diluted with turpentine; this tone defines the whole head of hair around the tip and the hanging strands on each side of the neck. I denote the highlights by leaving white canvas in these areas. Before the turpentine has evaporated, I drop in the darker hair values with pure black paint around the edge of the head on top and in the back. Around the large highlight on top, I add black paint and also down on the long sections of hair next to the neck. With this method the hair can be completed in one procedure. Not only will the hair be finished, but it will have a desirable softness.

there'll be parts of the hair which fall under other light sources.

When you paint hair, have one solo spotlight which produces lots of "sock" or contrast; then let the rest of your lighting be subordinate to that one. If one strong light is overhead, the area of greatest contrast is usually at the crown where the hair is thinner and lies along a part or circles the cowlick on top.

Two Different Approaches

You'll need the following materials for this project:

10" x 14" canvas board
Numbers 8 and 10 round bristle brushes
Number 14 flat bristle brush
titanium white

Mars black

Let's do a painting of a contemporary hairstyle—long, a little curly at the ends, and dark brown. Its shape will be affected by the crown of the head; then it flows down light around the neck in sections and curls over the shoulders.

There are two ways that you can start painting hair depending on your technique for the whole figure. You can start on white canvas and with a turpentine wash lay in the hair in the manner of a watercolorist—a "one-go" treatment (see Figure 64). The second method is to begin with a toned canvas and work up the hair with an opaque technique, the usual approach when painting with oils. (See the demonstration at the end of this project.)

Overworking

Painting hair can become a problem if it's overworked. Unlike living hair, the look of painted hair isn't improved by brushing and brushing. Unfortunately, the best results with hair sometimes are produced from accidents. These "accidents" are beyond your conscious control, but if you're quick to recognize the "accidents" that look good, you can make the most of them. Remember that hair has two basic characteristics: first, hair has a single area of strong contrast, and secondly, it has alternating patterns of light and shadow. If you establish these two characteristics, your hair will look convincing even without "happy accidents."

Step 1. First I tone my canvas with about a Number 6 or Number 7 gray. For the traditional, opaque oil painting method, I start with thin paint, but not "washy" like the paint used in the "watercolor" technique (see Figure 64). My paint has a creamy texture. I use a Number 10 flat bristle brush and sketch in the main shapes of the whole hair flow. Now I lay in a simplified version of the main lights and shadows. At the far (right) side of her face, the hair edge is going to be light, so I leave a strip of toned canvas there. Next to it, there's a strip of darker values. Next to the profile at the eyes and around the chin and neck the hair is very dark, and I use about a Number 8 gray. On the light (left) side the sections of hair break away at the part and flow downward, with the exception of one strip next to the face which emerges from behind its neighbor. I locate the lightest value on top of her head using a Number 1 gray. Then I establish the alternating light and dark pattern of each hair section.

Step 2. Now I add heavier paint to reiterate what was said in the first step. In this step, background, facial, and body tones are stated. I make the background at the far right darker to bring out the light, transparent edge of the hair on that side. The darkness along the profile and under the chin I strengthen with Number 8 gray. I work the strong highlight at the top into the surrounding tones of the hair. I use whichever brush works best at the moment, the flats or the rounds. In this step some of the larger segments of lights and darks are broken down into smaller patterns of alternating tones. I always try to keep a light patch side by side with a darker one. I paint in the basic face tone, about a Number 2 gray, so that its edges can be blended with those of the hair.

Step 3. The final step is to soften tones and refine the edges. Softening can be done by painting tones into each other or by using a sable brush to feather out the edges. I place a secondary highlight on the clump of hair down in front on the left. I take care that it's not as strong as the light value on top of the head. I always try to keep the tonal ranges *close* (with the exception of the strong "major" highlight). There are a few clean edges at places like the back, in the center, and along the section going up near the face. I keep these at a minimum. For the tips of the hair, like the wisps at the extreme left, I rub the paint with my thumb.

THE FRONT TORSO

The front view of the torso can be visualized as two distinctly separate parts. The upper one is the chest; the lower part is the pelvic area. These are connected by a long abdominal muscle in the front. The sides (flanks) are connected by external oblique muscles which look like nothing more than softly padded flesh. The complete roundness of a chest is hidden in a three-quarter view by the arms which hang at the sides. If the arms are raised, you get a better picture of a cone-shaped chest section. Therefore, I've painted the demonstration at the end of this project in this way. The muscle and bone structure in the front of the torso is similar for both male and female but the chest muscles (pectoralis) disappear into the breast glands on a female (see Figure 68).

Movements of the Torso

A complete torso has restricted movement. It can bend forward; the ribs can expand, and it can arch backward a little and twist slightly. A gracefully curved spine which makes the hip and chest seem to flow into each other when seen from the side is what a painter looks for.

In contrast to studying construction, as we've done with the facial features, painting a torso is easiest if you lay in larger masses, or landmarks, with bold tones. Underlying construction is produced when tones and colors are correctly positioned.

Establishing the Main Shapes

You'll need the following materials for this project:

10" x 14" canvas board
2 Number 8 filbert bristle brushes
2 Number 6 filbert bristle brushes
Number 4 bright bristle brush
titanium white
Mars black

This demonstration of the three-quarter front view of a torso is illuminated in an unusual way by having light come directly from the standpoint of the viewer, or straight on. Early paintings made use of this lighting and in them no attempt was made to get a chiaroscuro effect. Sometimes this is called a "universal light." It's very effective for turning the form, giving it roundness. However, universal light requires a linear painting procedure rather than a tonal technique. It's a more precise technique, one in which colors are not freely manipulated in masses but instead follow a preliminary chalk or charcoal drawing.

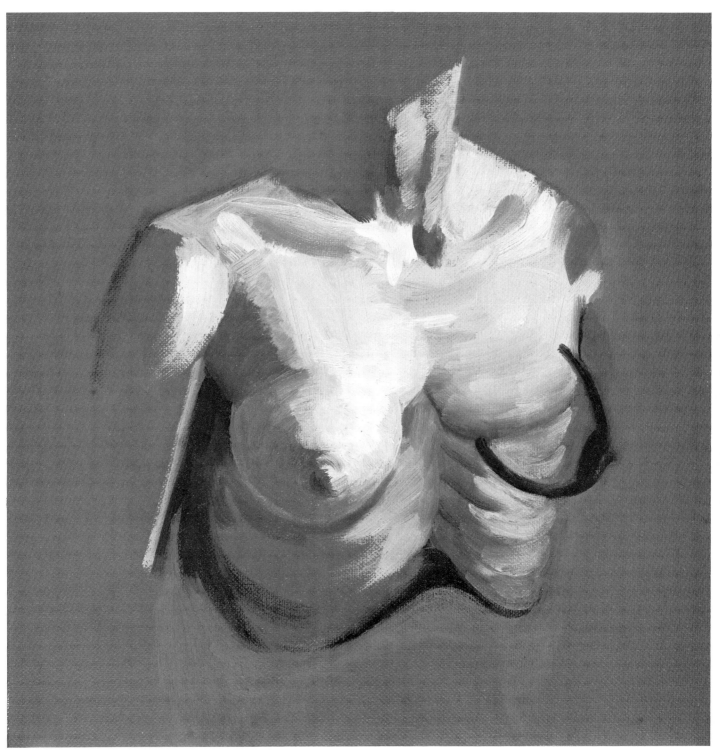

Figure 68. (Left) This view accentuates an abdominal muscle showing its attachment to the arch of the chestbone on top and folding into the tightly stretched ligament across the pubic arch below. The sides of the abdominal muscle step back to smaller planes on each side. This view also shows all of the lower torso wedged in between the hips and thighs. Notice, especially on the shadow side, that each segment of the contour is convex. This is true of all the body's muscle contours. Undertones of light and dark grays began this painting. I used small filbert brushes to pull the tones back and forth into each other, especially down near the hip area on the shadow side.

Figure 69. (Above) In this diagrammatic painting you can see that underneath, a female chest is structured like a male's, the mammary glands of the female grow out from the lower part of the pectoral muscles. It looks as though the chest muscle disappears *into* the gland. Breasts angle slightly outward; the nipples are on the outer corner. To portray this structure, paint a sharp turn for the chest muscle but make the breast turn more gradually from the top around the side—a ball-like shape.

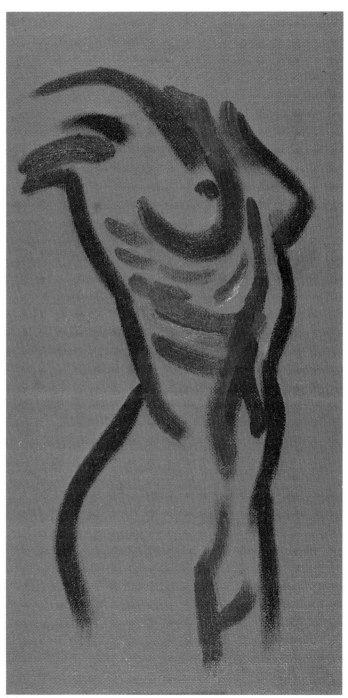

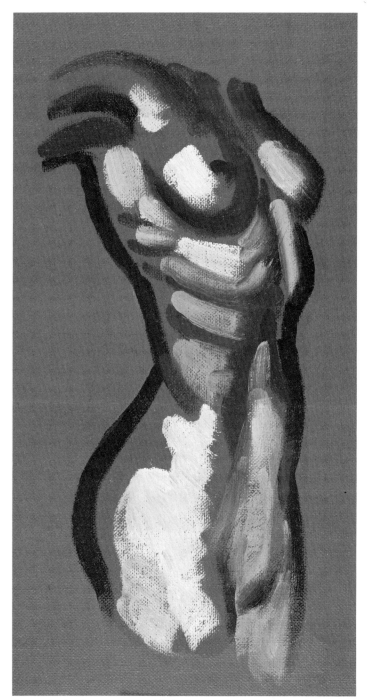

Step 1. Painting on a toned canvas is still the best way to convey the feeling of a lighted subject, especially since this one is lit from straight on. It would look too dark and grim on a white canvas. After carefully establishing proportions with a light chalk drawing, I begin painting in these contours with a Number 4 bright bristle brush. I use a Number 8 gray and slowly paint the contour of the torso with a heavy line. I keep my eyes glued to the outside edge and make it sharp. I don't pay attention to the inside edge. For the outside breast and the arm, I mix a Number 7 gray. I also paint in the areas of marked value change with this tone, like the center line of the chest, the structure of the ribs, and the modulations on the hip and thigh. The big tone under the arm and the loop around the breast are also done with a Number 7 gray.

Step 2. In the first step, I established not only the contours but the dark values. Now it's time to lay in the light tones. For the lightest values I mix some slightly off-white paint. I place this tone for the highlight of the breast, the rib cage, and the big bold light on the hip. With the small amount I have left on my brush, I dab a spot just under the arm where it meets the breast. If you have enough of that off-white left, you can just flick in a tiny bit of gray to darken the off-white one value and use this light gray tone under the arm and for the highlight on the right breast. Using that same tone, I paint down along the abdomen and the thigh. As I do, I let this tone begin to mix with the dark undertones.

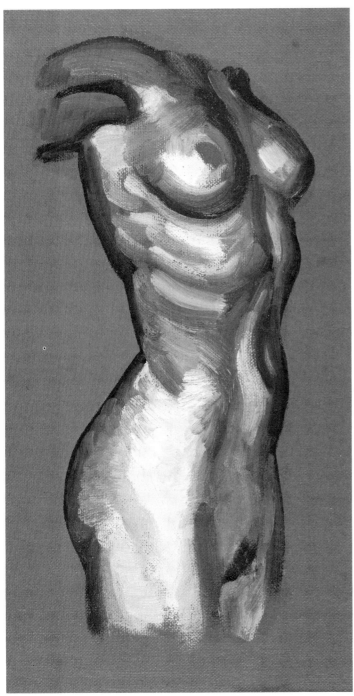

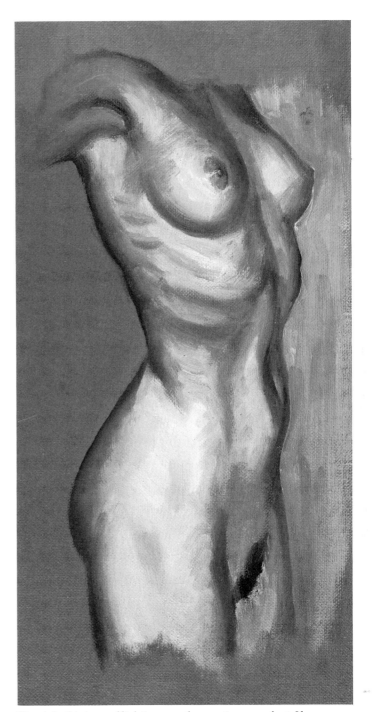

Step 3. Now it's time to add halftones to the three main values: the dark shadow tones, the middle tones (created by the toned canvas), and the highlights. The final painting isn't going to be as dark as the beginning seems to indicate. Some of the dark strokes, like those on the ribs, will be lightened. Why not make them lighter in the first place? I've found that as you're developing your painting in black and white, changes in value tend to get weaker and lost. It's much easier to build up light tones with impasto pigment over *thin* darks, than vice versa. Heavy dark paint over light paint gets muddy and hard to control. I add a halftone to turn the breast into the armpit; the other breast blends with the tone coming down from the neck. Down along the rib cage halftones are painted in the direction of the ribs. Notice that most of the heavy contour line is beginning to be absorbed and lightened in this step.

Step 4. In this type of lighting very few contours are lost. If you want to make the edge stand out more you can cut around it with a lighter background tone, as I've done on the right side. If I want a softer, smoother appearance, I carry the lights right out to the edge, absorbing more of the darks. It's a matter of taste how smooth or slick you want your painting to be. Although I could have used a sable brush, I continue with the bristles, but I wipe them frequently with a paper towel so that my values aren't destroyed. Both ends of the value scale are pulled in; that is, darker tones are lightened somewhat, and light highlights are toned down a bit. However, key tonal areas are left untouched. Notice how dark the pubic area has been left.

Project 9

THE BACK TORSO

When seen from the back, the torso exhibits two basic parts just as it does in the front view. These parts are the chest and pelvis, but they're formed a little differently. From the rear, the chest's upper portion looks wider, flatter, and higher because the shoulder blades and the arms merge, spreading part of the back plane up to the neck and to the outer contours of the arms.

Basic Shapes

The buttocks meet at the center line of the body, so that you lose the effect of having the lower trunk wedged down in between the hips as seen on the front of the torso. The deep furrow of the spinal column at the middle of the body is the result of two heavy tubular muscles, called the sacrospinalis, which connect the top and bottom of the back torso. These are the most obvious muscles lower down. These muscles fasten partly to the sacrum bone which forms a diamond shape above the buttocks; two dimples mark the sacrum's outer limits. This area is pretty flat. In the back view, the ribs sometimes show a little through the thin, flanking latissimus dorsi muscles.

Lighting the Back

You'll need the following materials for this project:

10" x 14" canvas board
2 Number 6 filbert bristle brushes
2 Number 8 filbert bristle brushes
Mars black
titanium white

In contrast to the flat lighting I used for the front torso demonstrations, the light for this straight-on back view is high and to the side. It will serve to show more clearly the particular surface changes of the back.

This painting procedure consists of painting chunky masses of light and dark. It's more an exercise in observation than one of constructing from the inside out. Just imagine yourself putting pieces of a jigsaw puzzle together. The pieces have width and height; they curve, slant, and relate to a flat surface—the canvas. Practice this way of looking at the copy you're using, whether it's a photograph or a live model.

Figure 70. (Right) This three-quarter back view gives you a splendid idea of the way the spinal column runs along the back in a deep ridge. The vertebrae of the spine are visible usually in three spots; the seventh cervical vertebra, in the neck, in the small of the back, and at the sacrum (tail bone). The sacrum is a series of vertebrae that have grown together. I painted the buttocks with circular strokes to give them a ball-like appearance. I sometimes leave the brightest highlights until last. Often a painting that seems to be going dead will suddenly come to life with the addition of final highlights on such areas as the shoulder blades, arms, and buttocks. This is also true of the darkest values which can be reiterated as accents, such as those between the arm and body.

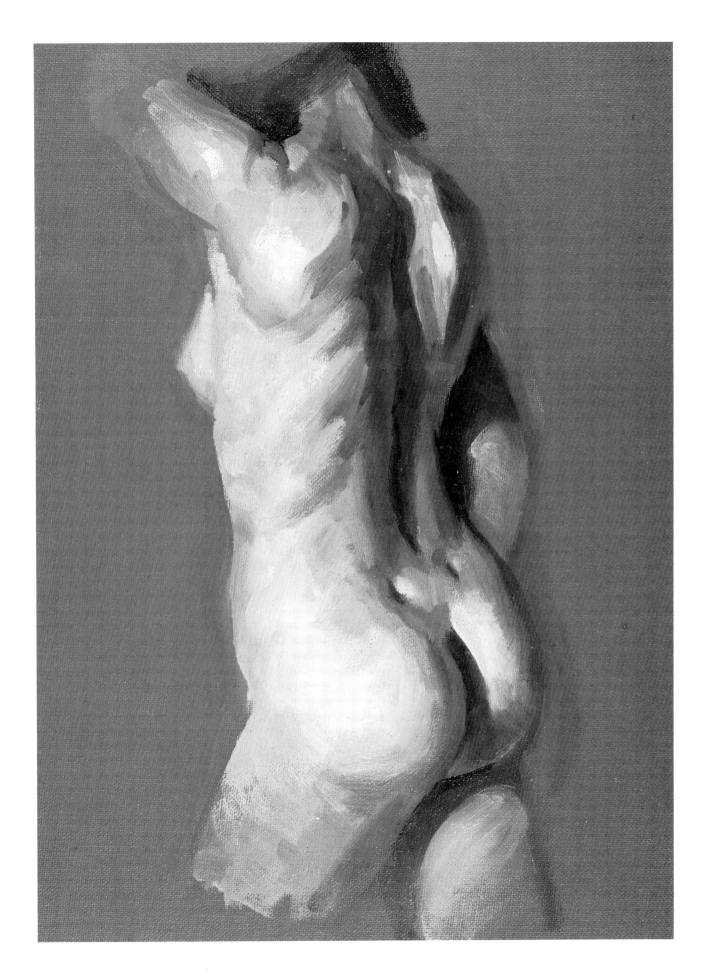

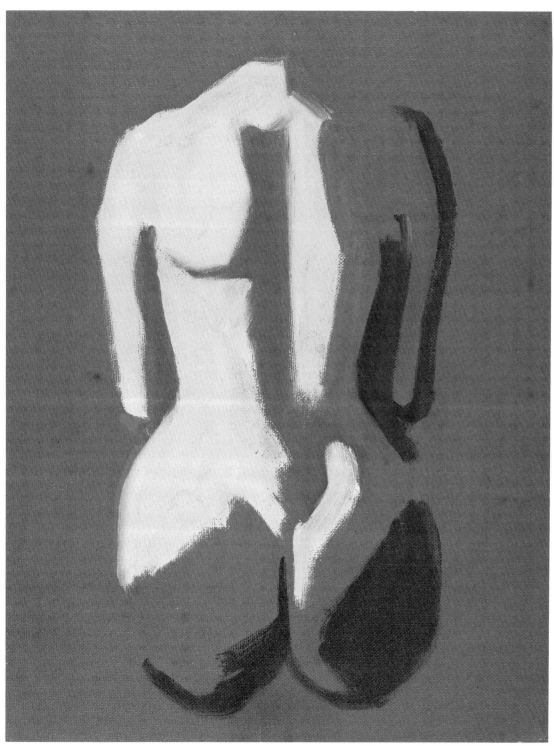

Step 1. By using only two values plus the middle value with which I've already toned the canvas, the light pattern is vividly shown. Some feeling of anatomical construction begins to take shape also. Using a Number 1 gray at the top left, I make the pyramiding neck merge with the shoulder blade and arm. Inside center, I paint a plane slanting out from the spine, which goes down to the waist. I leave a space of toned canvas under the shoulder blade, because it juts out slightly. I include on the opposite side across the sacrum, a patch of light tone where the back turns into the light before it curves down around the hip and buttock. Somewhat like the flat light of Project 8, the arm in shadow has a dark periphery, about a Number 8 gray. This line loops around providing a shadow at the elbow and one next to the body.

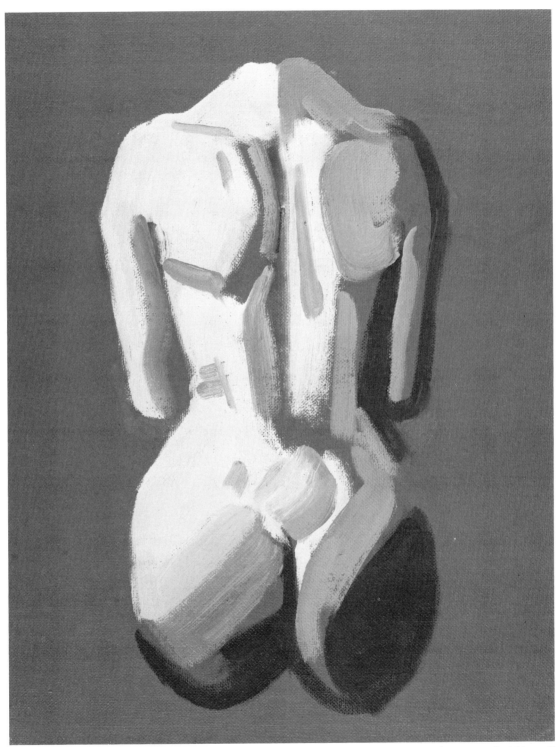

Step 2. This stage is nothing more than an addition of one tone—a Number 4 gray. I add it to all those spots which represent the flat planes of the back. They're turned just enough so that they don't reflect as much light as the highlight areas. These tones are mostly all isolated except in the buttock region where more roundness is the goal. The poster effect is soon lost by introducing halftones which fuse adjacent tones. Keep this poster-like pattern of light and darks as long as possible. It will help you retain the overall important value scheme of your work.

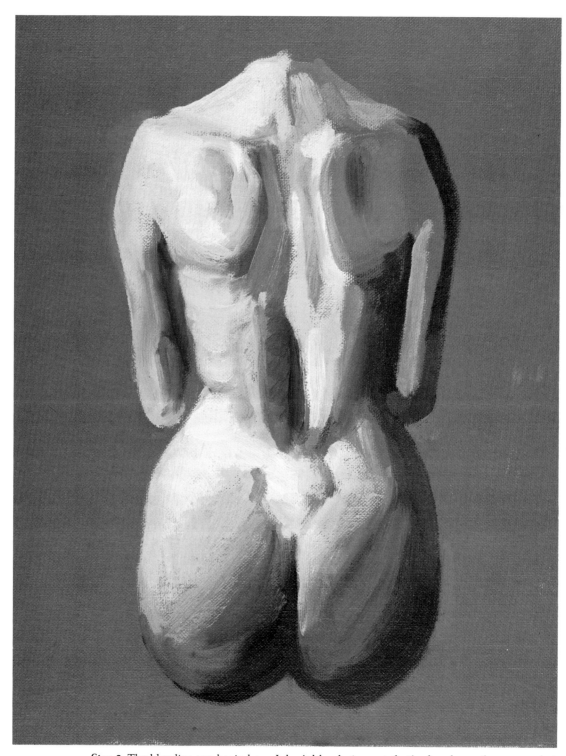

Step 3. The blending can begin here. I don't blend pigment that's already on the canvas, but pick up more paint in the same tones. For example, on the left buttock, I laid undertones on at an angle to represent the light change, but in this step additional tones are crossed over those in the opposite direction. The original light pattern is augmented with in-between tones like those in the furrow of the spine at the waist area. This area is darkened giving some feeling of roundness to that muscle. I add intermediate tones around the rib cage shadows on both sides. Halftones of a Number 2 gray are used to round the light side of the left arm and on top of the left shoulder blade.

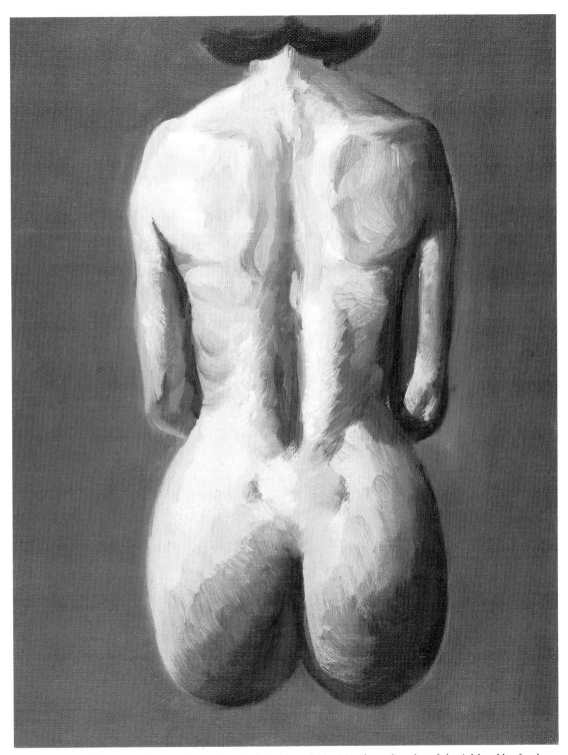

Step 4. I soften and blend the whole back with the Number 6 brushes. I don't blend by feathering the color that's already present, but again, I bring more paint from my palette. Either I brush on additional halftones between two neighboring tones, or I replenish them so they can be worked into each other. All the tones are worked together wet. Notice how I intensify highlight areas on the shoulder, hip, and the right side of the spine with thick deposits of white. I separate the crease of her right arm from her body by defining with halftones the cast shadow thrown on her arm by the torso proper. I repeat, caution is necessary at this stage to preserve the subtle value plan which reveals so much of muscle, structure, and form.

Project 10
THE ARMS

At first glance, arms appear to be two long, round, but otherwise shapeless objects. You wonder how you're going to paint them so they don't just look like sticks. If you scrutinize them more carefully, you'll notice some very subtle curves and indentations. But what do these undulations represent and where, precisely, do you put them? I've found the best way to think of arms is in terms of a series of solid forms. Although the general shape of an arm is somewhat round, tapering gradually to the wrist, a very definite blocky construction exists underneath its deceptive modulating surface.

Basic Shapes

To paint an arm correctly, the solution is to render them somewhat crudely at first, as a series of alternating blocks. Reread the chapter on figure proportions. I've stressed the importance of seeing arms this way, because painting arms can be an annoying problem unless you visualize them in this manner.

You'll need the following materials for this project:

10″ x 14″ canvas board
3 Number 6 filbert brushes
titanium white
Mars black

I've purposely emphasized the muscles of the arm in my demonstration and in the other illustrations to show their construction. Once you've gotten the feel of how the arm is built, you can just *suggest* the variations in muscle shape especially when you paint a female arm. In Figure 71 I've given you two diagrams of the arm—a back view and a front one—which describe the muscle groups and major bone structures. You can refer back to these diagrams if you have trouble with the demonstration.

Keeping Brushes Separate

The hanging arm in the demonstration is in a supinated position—that is, the palm of the hand faces upward when the arm is stretched forward horizontally. Figure 72 is a view of the arm in the other, pronated, position. In this pronated position the palm of the hand is facing downward when the arm is stretched forward horizontally.

The supinated position is a good one to paint. It shows the forms that alternately change direction down the arm's length. I've painted this view of the arm with three brushes: one for the darks, another for the lightest colors, and a third for the intermediate tones. You might think you could do this arm easily with one brush. Yet, you couldn't—not without struggling to keep the values clean. I'd like you to get used to being extravagant with brushes as well as paint.

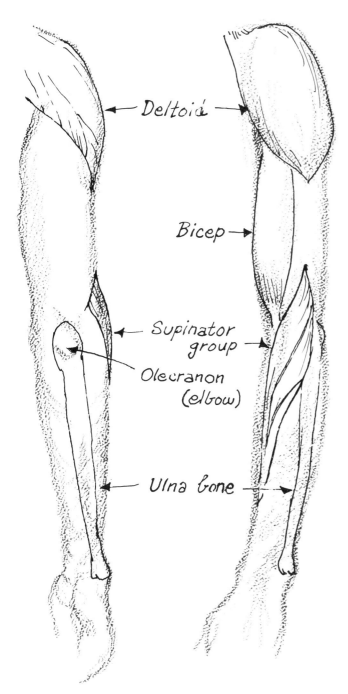

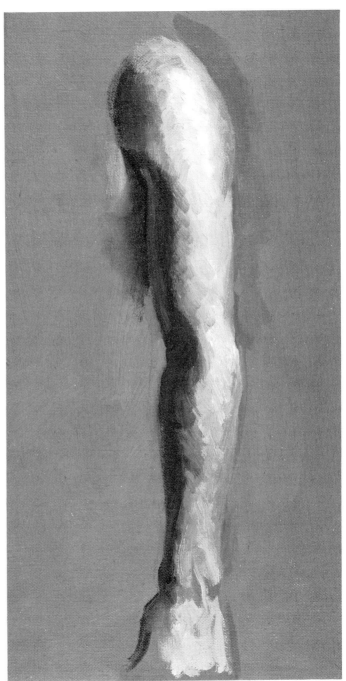

Figure 71. I've drawn two diagrams here: the one on the left shows the back of the arm; the one on the right is front view. Both views show the arm in the pronated position. I've indicated the names of the major bones and muscles. The diagrams are simplified to give you a general conception of the few parts of arm anatomy that I refer to in the demonstration.

Figure 72. The companion to the demonstration painting is this arm in a pronated position. The arm in this position has the most subtle design and is the most difficult to paint. Here the changing forms are mainly two pairs of muscles; each pair faces a different direction. In other words, the deltoid (shoulder muscle) and the supinator group, just below the elbow, have their flat sides facing to the right. The biceps on the upper arm and the lower arm from a center point down have their flat sides facing forward. (This point on the lower arm is shown by a little nick of tone.)

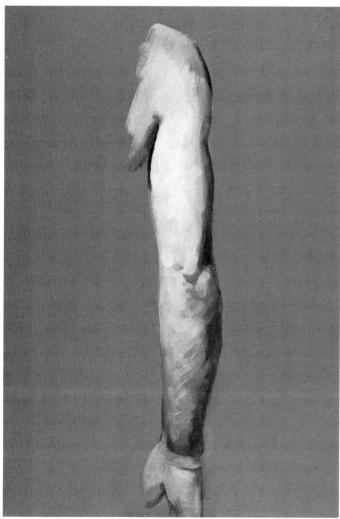

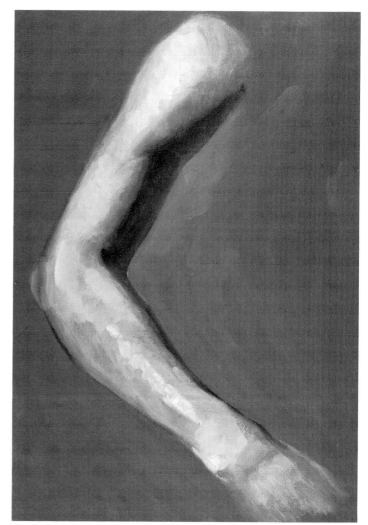

Figure 73. This is a back view of an arm hanging in a pronated position with the palm turned inward. The elbow shows slightly, forming two dimples. The top of the arm is the lightest and gradually darkens toward the lower arm, which is somewhat tawnier in local color. The strokes on the lower arm in this view go around the form in a dipping fashion to give an impression of the lower limb swinging away from the viewer.

Figure 74. Here's a slightly bent arm showing the alternating shapes of the shoulder or deltoid muscle, biceps muscle, flexing muscles in the lower arm, and the more bony structure near the wrist. I painted the dark shadow first; it seems like dark shapes are easier to duplicate than light ones. Notice the gentle curve of the lower arm at the wrist. This action is cancelled somewhat by the bunch of supinator (flexing) muscles, which create that swelling on top of the lower arm near the inner bend of the elbow. They form a curve on their bottom side which leaves the elbow sticking out a little. Notice how the arm becomes flat at the wrist.

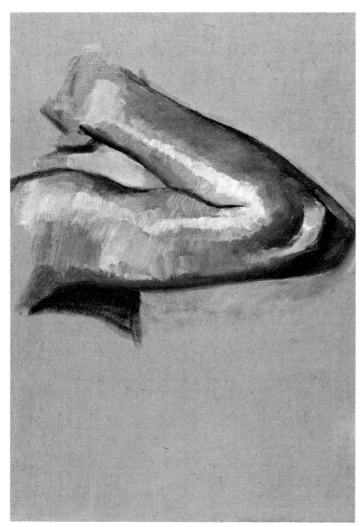

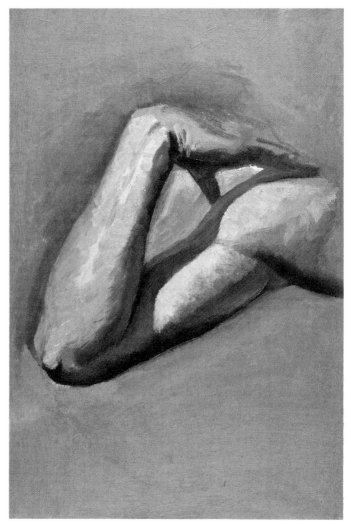

Figure 75. An outside view of a completely flexed arm shows the muscles bulging out at the elbow, pulling away from the bones and forming a bump around the crease where the lower arm bends back onto the upper arm. Next to that bulge is the end of the bone that attaches further up at the shoulder. The olecranon (elbow) bone of the lower arm is at the top of the outer contour of the bend of the arm. I place my brushstrokes across the arm to show the roundness of the flesh and muscle.

Figure 76. On the inside view of a flexed arm, two subcutaneous bones show clearly: the upper end of the ulna, located at the elbow site; and the other end of that ulna bone seen at the wrist. The rest of this arm is soft and fleshy. Again, I use brushstrokes that go across the arm and circle its form.

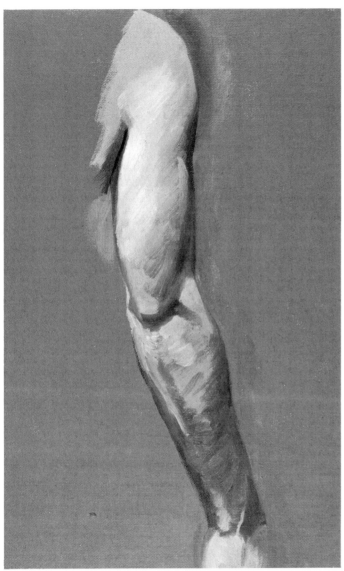

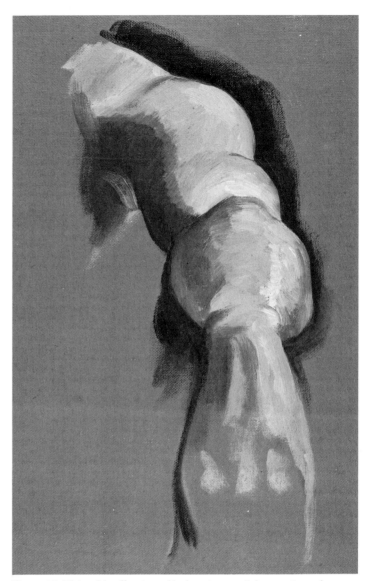

Figure 77. This is the supinated back view (palm turned outward). The back of an upper arm shows a slight swelling in this twisting motion but the main power comes from flexing or supinating muscles that fasten in above the elbow on the outside, curving down and out to a point halfway down the lower limb. This action seems to make the elbow more prominent, but it's actually the effect of the flexing supinator muscles that cause a depression there. You'll notice a shadow running down the lower arm. That is also a depressed effect along the ulna crest. This area is visible in many back views of the arm and should be painted to make the arm more lifelike.

Figure 78. This odd collection of bulges is a straight-on view of an arm resting on a support, such as the arm of a chair. When you're confronted with painting an arm in any foreshortened view, you have to forget about length. In this case, there's a *variety* of overlapping shapes. Starting at the bottom, or foreground, is the hand which covers the end of the forearm (a rectangular shape). Next, you see the forearm which covers up the end of the upper arm (with its rectangular shape standing on end). The upper arm, in turn, overlaps the shoulder muscle. (These last shapes bend in opposite directions from each other.) Although, in physical reality the whole arm actually diminishes in size toward the hand, in this view it appears as though the hand is the largest of units, because it's the part closest to you.

Your opinion of this book would be most helpful to us. Please take a moment to fill out this card.

Title: _____ Author _____

What did you like (or not like)? _____

What did you find most useful? _____

_____ Please initial if you can be quoted _____

Bought at _____ Your profession _____

Would you like a FREE catalog of all our publications? ☐ Yes ☐ No

I am primarily interested in ☐ art instruction ☐ graphic design ☐ architecture/interior design
☐ photography ☐ music

Name _____

Address _____

City/State/Zip _____

BUSINESS REPLY MAIL

FIRST CLASS PERMIT NO. 300 LAKEWOOD, N.J.

Postage will be paid by

Watson-Guptill Publications

1515 Broadway
New York, New York 10109-0025

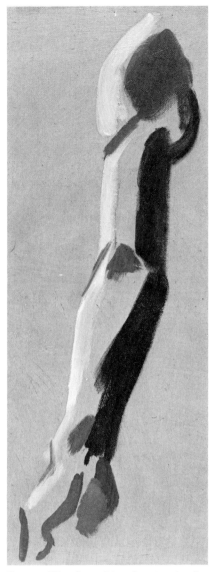 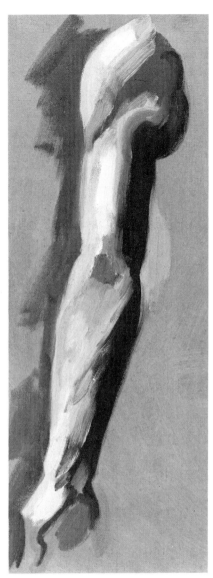 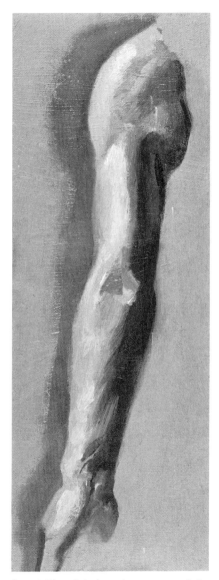

Step 1. The first thing I paint is the shadow on the arm with a diluted dark tone—about a Number 8 gray. On the upper arm along the biceps, the shape of this shadow tone is quite rectangular. It has an abrupt inner edge. This inner shadow edge is sharp around the elbow too; then as the shadow travels down the lower arm, it softens as it turns into the light. For the outside edge of the shadow I use a thin mixture of some light paint (anything that shows on the toned canvas) as a means of roughing in the drawing. Then, with a Number 5 gray I establish the front plane of the deltoid (shoulder muscle), as well as the demarcation of its boundary along the biceps. With the Number 5 gray I also lay in the depression at the elbow joint of the arm, a beginning of flatness at the wrist, and a brief indication of the hand.

Step 2. Now I dip into plenty of paint and use grays that will produce that alternating series of blocks of which the arm is composed. The light hits the top outside of all the muscle forms of the arm which alternately change direction down its length. The shoulder points up and out so the light is on its top ridge. The biceps point forward in the reader's direction, so the outer corner of that long rectangular muscle gets a light. The sharpest turning edge on the lower arm is near the wrist bone. Halftones, or Number 4 grays approximately, are used where the deltoid rolls around to the biceps muscle, then at the bottom of the biceps where it turns under the arm and disappears. The flat part of the lower arm facing you is a halftone composed of a Number 4 gray.

Step 3. Here I darken the strongest light tones somewhat now that the construction of the arm is established. The shoulder tones are pulled together and softened. All of the arm is more precisely shaped. Notice the difference in direction of my brushstrokes. Along the biceps the strokes follow its length. I feel that they impart the steely strength of that particular muscle. On the lower arm there's more of a fleshy softness which can be expressed by angling brushstrokes horizontally across the limb. I add a black accent at the armpit. A noticeable vein crosses the wrist tendon and I use two brushstrokes to indicate it.

Project 11
THE LEGS

Probably the greatest error in painting legs is making them stiff, like the legs of a table. Legs aren't straight! They change direction at the knee. Most people can draw their general shape—their conical look. But the beginner usually fails to establish the line of direction of the legs, which gives them a lifelike quality.

Basic Shapes

Instead of visualizing the legs as a series of blocks, as we did when studying the arms, let's look for the basic line of direction in the legs. The outside contours of the leg have much to do with altering this line of direction. In the front view of the legs, there's an angular configuration; while in the side view, there's a gentle curving path to the legs. Refer back again to the chapter on proportions of the figure.

A leg tapers more dramatically than an arm. The upper arm can be an integral part of the shoulder in certain positions. In the same way the thigh is very much part of a lower torso when the leg is straight down. If the leg is raised, it separates from the hip becoming less a part of the torso. The knee area, called the knee pan, is knobby-looking because of the larger joint, subcutaneous bone ends, and the knee cap. Painting a leg amounts to painting a basic line of direction and then developing all of the masses over that structure.

Foreshortening

You're going to run into foreshortening problems with legs, just as you did when painting arms. You'll have to muster your powers of observation to master this problem. The trouble always starts when you discount what your eyes actually tell you, and, instead, draw from your preconceived ideas of how the leg "should" look. The word "leg" conjures up a vision of its length. A leg painted in a foreshortened position won't have any length, just an illusion of it. Turn to Figures 46 and 47 in the chapter on proportions for some typical leg positions that involve foreshortening.

You'll need the following materials:

10″ x 14″ canvas board
3 Number 6 filbert bristle brushes
Mars black
titanium white

On a toned canvas board I've painted a straight line with a light tone to show the direction line of the leg (see the demonstration at the end of this project). It will angle in toward the center and have a (I hate to use the expression) "dog leg" in it. This angle occurs in the middle and represents the knee pan. In Figure 79 you'll see a more detailed diagram of the leg and knee. In it I've noted the leg's anatomical structure and given you the anatomical names of the various muscles and bones.

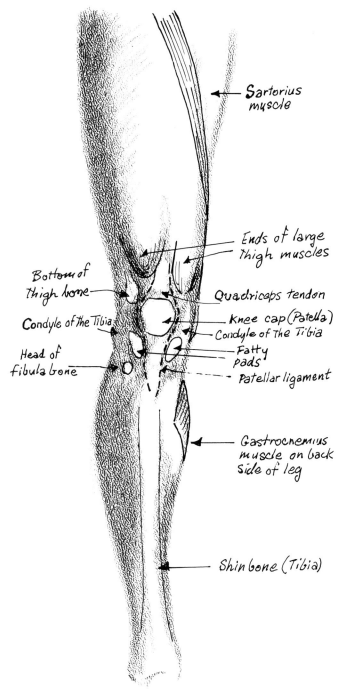

Sartorius muscle

Ends of large thigh muscles

Bottom of thigh bone

Quadriceps tendon

Condyle of the Tibia

Knee cap (Patella)

Condyle of The Tibia

Head of fibula bone

Fatty pads

Patellar ligament

Gastrocnemius muscle on back side of leg

Shin bone (Tibia)

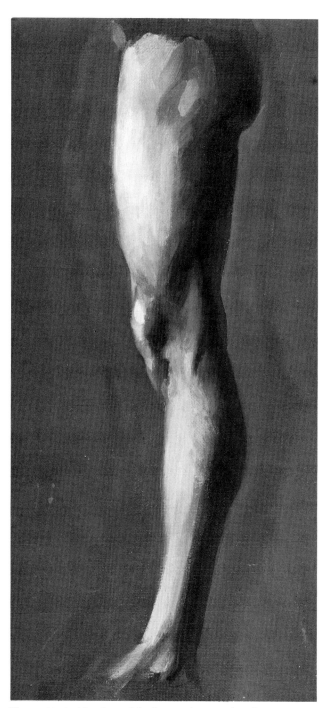

Figure 79. This diagram identifies the anatomical parts of the leg, especially those in and around the knee area. The knee looks more complicated than it really is. Notice how the knee pan moves backward in a direction opposite from that of the thigh thrusting forward.

Figure 80. A side view of the leg can be visualized as a reverse curve. The thigh bone has a gentle arc forward anyway. Coming through the knee pan, that alignment angles backward. Then the direction starts forward again just below the knee to give an appearance of a delicate curve toward the front down to the ankle. This curved look of the lower limb isn't due to bone structure like in the thigh. On the contrary, the tibia, or shin bone, drops straight down. This curve is caused by the smaller bulge of the fatty pad below the knee cap. Sometimes these pads are so large that you can get confused as to which is the knee cap, but the fatty pads are always below it.

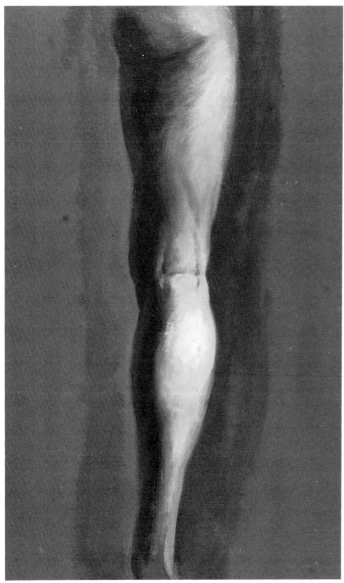

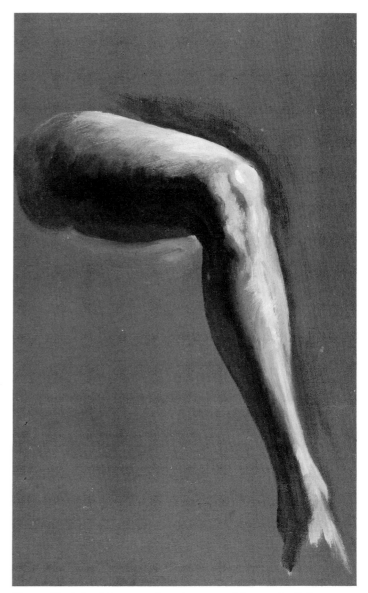

Figure 81. The back view of a leg displays very little of its bone structure when compared with the front view; instead there's more softness and roundness here. The changes in direction are like those seen in a front view, but reversed, of course. The back side of the knee area has an "H" configuration. A wide, bright highlight is painted on the top side of the gastrocnemius muscle. Although this muscle splits in its center, this split is very seldom apparent. At the ankle the inside contour should be higher than the outside one.

Figure 82. A bent leg can almost erase evidence of all the lumps seen in a leg that's completely extended. The knee cap refuses to retreat until the leg is totally flexed. It even stands out more sharply in this position. The condyles (see Figure 79) of the tibia show faintly in this view. Take extra care in denoting the crook of the leg on the underside of the knee. The bend doesn't go into a point; rather, there's a tendon that crosses this joint so that you don't see a concavity there.

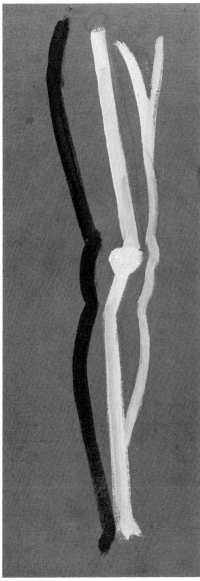 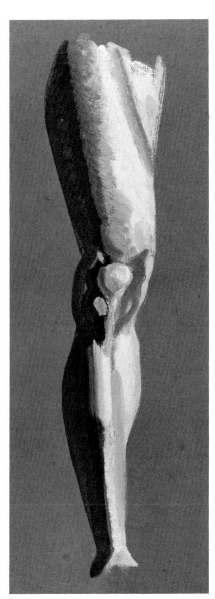 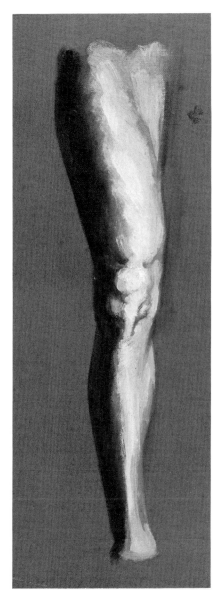

Step 1. Although it's true that you can drop an imaginary plumb line from the center point of the thigh to the center point of the ankle, the action line of the leg changes direction at the knee. The leg's direction changes course again at the lower limb which comes forward—though not as far forward as the thigh. I indicate the knee cap with a large dot. The "Y" on top of the inner contour of the leg shows the crease caused by the sartorius muscle. For the outer contour of the leg I paint a wide line with a Number 7 gray; this is a sweeping general statement that curves around the thigh down to the knee. The outside lower limb is a longer curve than its inside contour. The difference between these outside and inside contours is caused by the gastrocnemius muscle on the back of the leg.

Step 2. Now I lay in the light, middle dark, and shadow tones. These tones follow the changes of direction established in Step 1. The roundness of both the inner thigh and inner lower leg is indicated. In the thigh an indentation is caused by the pull of the sartorius muscle. I depict this muscle with an angling Number 3 gray tone. The lower leg has a Number 2 gray line laying along the light (right) side of the leg to indicate the shin (tibia) bone. I paint the thigh in zigzag strokes to give it a soft, fleshy appearance. The strokes on the lower leg should follow the direction of the shin bone to indicate its hard, flat presence. The knee cap is modeled with a highlight and so is the patellar ligament connecting down below it.

Step 3. This step pulls all the construction elements together into a unified painting. I've slightly overmodeled the knee cap area to emphasize the construction. When you're not doing a study, it would be kinder to simplify this area to keep it from looking like a bag of rocks. Notice how I've done seemingly contradictory things. I've lightened up the very dark shadows and darkened just a bit some of the light areas. I bring the tonal range closer; that is, by modifying the extremes of tone I help to unite the painting. The additon of halftones also produces such an effect, as well as providing the modeling necessary to show form and dimension in the leg.

Project 12
THE HANDS

Hands aren't just beautiful parts of the anatomy; they're also marvelous tools, because of the incredible way they can function. Hands are capable of performing amazing feats of strength in comparison to their size; yet they can achieve pinpoint accuracy with almost any delicate task. The awe these complex instruments inspire may be one reason many people dread the thought of painting hands.

Rather than paint hands that look like welders' gloves or crab claws, some artists will hide them in pockets, behind the figure, or in the grass. Like anything else, if you'll take time to study hands, you needn't dread rendering them. The anatomy of hands is complicated, but you shouldn't have to get too involved in it. If you learn the surface aspects of hands in a few different positions and movements, you'll be able to paint them convincingly.

Three Basic Shapes

It's easier to learn the characteristics of hands if you break them down into basic units or shapes. For instance, you might visualize a hand in three units. One large, solid part is comprised of the palm; another is made up of the fingers; and the third is the thumb with its base. The solid palm is about half the length of the hand. On its back side, using the knuckles as a division, the palm would be less than half this length. There's a short space between the knuckles and the separation of the fingers. The palm side is longer, measuring up to the fingers.

The palm side of the hand lacks the boney appearance of the back, because it consists mainly of pads, or cushions, of fat. The cushions on the fingers have a definite dividing line at the joints. The tips of the fingers seen from this palm side are ball-like.

The fingers have a squarish shape when you view the back of the hand, so you don't want to round off their corners too much. The middle finger is usually the straightest finger; if it curves at all, it does so toward the third finger. However, notice how the other fingers all curve toward the middle one. The little finger seen from the back has more of a bend and inward curve than the others.

The joints of the fingers beginning at the palm knuckles form an arc. At each joint all the way down to the finger tips, this arc widens (see Figure 83). The thumb is a maverick and doesn't follow the line of the fingers. It faces a different direction and moves independently. The base of the thumb forms a triangular attachment to the palm. It sets the thumb out at about a 60° angle to the other fingers.

Movements of the Hands

The palm can move somewhat in a cupping manner. The fingers all have three bones and, of course, are very flexible in curling toward the palm. They can spread a little laterally but have no strength and aren't useful in this movement. However, this spreading and closing of the fingers is important to observe as far as grace and gestures of hands are concerned. The thumb has a movement that's hard to control; most of its power moves in and down toward the palm, and it has only two bones.

You'll need the following materials:

8" x 10" canvas board

Numbers 2 and 8 filbert bristle brushes

2 Number 6 filbert bristle brushes

titanium white

Mars black

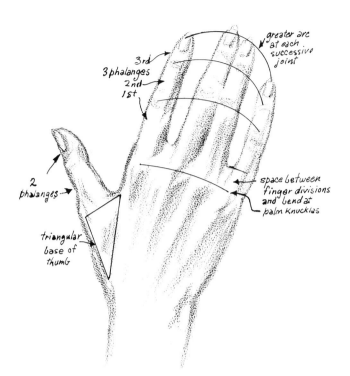

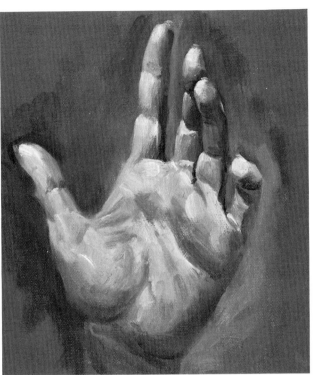

Figure 83. The knuckles on the palm form a slight arc and the joints upward on each finger are proportionately longer so that the arc formed at each set of finger joints is greater than the previous one. Notice how the outer fingers curve toward the middle finger.

Figure 84. The entire base of the thumb appears here as a mound of flesh laying mostly on top of the palm and ending in the palm's center at the lifeline. The small muscles that pull the thumb are visibly stretched. The creases and lines of the palm sweep up toward the first finger. Even though three fingers of this hand curl, in this almost straight-on view, all the fingers bend toward the middle one.

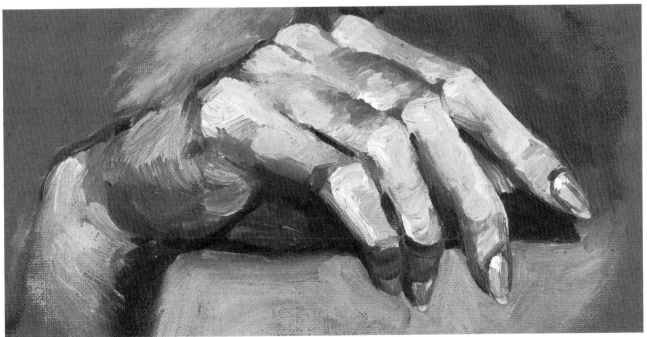

Figure 85. This view shows more dramatically how the tones melt together at the knuckle area, and the plane of the knuckles rises very slightly. In the first phalanges there's a darkening around the top side of the fingers and then a brilliant highlight on the adjoining finger next to that dark tone. The third finger curls under at the same time as it's turning toward the middle finger. There's foreshortening on the solid back of the hand. It has a rounded appearance which I achieve by brushing across its forms.

Step 1. I'm going to paint a back view of the hand using the unit method that I've described. I continue to work on a toned surface and begin by painting the back of the hand as a solid trapezoidal shape. This shape has rounded edges. I use a large filbert brush and a Number 3 gray for it.

Step 2. Using the same Number 3 gray, I paint in the mass of the fingers. If the fingers were closed, I'd paint them as one mass but since the little finger is separated (which is often the case) and has a different curve, I paint a separate mass for it apart from the main finger mass. The rest of the fingers can be painted as one flat tone with tapering, rounded ends. Notice that I've ignored the thumb in this step. I believe it's much easier to get the hand started by leaving the thumb out temporarily.

Step 3. Now I add the thumb and its base with a Number 3 gray tone. In this view the base, or ball, of the thumb doesn't show too much. I attach the thumb to the side of the hand with a flat, triangular configuration. The thumb juts out from this triangular base and has two joints. The first joint is a squarish, straight length; the second joint curves on the upper side but has an angular indentation below. To give the hand depth and substance, I first pick up a generous amount of slightly off-white pigment. The large filbert brush that you've been using will have enough gray in it to tint the pure white. The hand in this pose catches light from the top left. Since the fingers are bending a bit, their two top joints turn into the light, so I put some of the light paint in those areas.

Step 4. Here I add tones that gradually darken as they move toward the thumb; these tones express the camber of the hand's back. A shadow from the hand is cast across the base of the thumb. The dark streaks on the back of the hand are shadows created by tendons which are quite close to the skin's surface. I use about a Number 4 gray for these. I begin depicting the roundness of the wrist area with darker tones. Small dashes of Number 4 tones across the finger joints show the effect of surplus skin that forms the circular patterns there. I divide the three fingers with a heavy dark tone, about a Number 8 gray, but only part way, as you see. With lighter tones I add some roundness to indicate the fingernails.

Step 5. Here by refining the tones I add details. I start with the fingernails, and paint them in with a Number 4 gray. I lighten that tone through the center of the nail with a Number 3 gray. For the shiny highlight on the nail, I load a small filbert brush with white. I just touch one nail, on the middle finger, with a downward stroke. Then I go to the next brightest nail and repeat the procedure without reloading my brush. In this way, the nails will decrease in brightness. I soften the tone dividing the fingers and continue it along their length stopping short of their tips. In this way the effect of the merging fingertips is retained. The general tonal plan of the two upper joints of each finger is kept light, but in along the middle of these joints (or phalanges) there's a very subtle shade, a halftone difference. This halftone imparts a square appearance to the fingers.

THE FEET

So much study is devoted to the rest of the figure that feet are poor neglected orphans. There's so little time left for them. When the moment comes to do a full figure where feet are going to show, how will you do them?

Basic Forms

Steal some time somewhere in your schedule to study feet. They're not difficult to paint; their forms are blocky and simple. For the side and front views the foot can be visualized as an off-center pyramid. The bottom of the foot is an arched platform that flattens when weight is put on it. When the foot is dangling free, or extended, it goes into a deeper arch and "S" curve. Check back to the chapter on figure proportions for more information.

Looking down on the toes from above, they appear to angle off toward the outside; all the toes point toward the middle toe. The foot appears to be clutched at the top between the "jaws" of the end of the leg bone. This definite boundary between the leg and foot is the area where the ankle is located. The ankle can be visualized as a wrench which holds the foot in position. The inside ankle bone (the inner malleolus of the tibia) ends higher up than the outside bone (the outer malleolus of the fibula). This slant from inside to outside never changes.

Painting Toes

The amount of space given to toes is found by first dividing the whole width of the foot into thirds. One third is occupied by the big toe. The two thirds that remain are divided into half for the other toes.

The best way to paint toes is to work up in value from a fairly dark Number 7 gray oil paint. The paths between the toes are "V"-shaped light tones that get whiter at their apex. The toenails are painted dark first with lighter paint worked in later. The final accents are done with black at the bottom of the toes and in between them (see Figure 87).

Nail highlights are painted in a special way. Take a Number 4 filbert bristle brush and lightly dip only its outer edge into white paint. Lay the brush gently in a position horizontal to the canvas where you want the nail and quickly push the brush in a short stroke in the direction of its bristle ends. This is just the opposite of the way you usually stroke with a brush.

The Side View

In the demonstration at the end of this project, I paint a side view of the foot. You'll need the following materials for this project:

8" x 10" canvas board
Number 6 filbert bristle brush
Number 8 filbert bristle brush
Mars black
titanium white

This view is made up partly of angles with some dips and curves. The leg widens at the ankle in this view. In the front view the curve of the foot's arch stops abruptly about the level of the ankle. At the back of the leg, the foot curves down to the heel. There's an angular crease just under the ankle bone, a short forward plane, and then a slanting irregular plane to the toes.

Another plane slopes down to the first bone of the toes to a hump for the joint. Then there's a final drop to the last two toe bones. These are so small that they appear as one unit. In the demonstration, the front and far sides are deliberately put in shadow to show the foot's profile more emphatically.

Figure 86. When the feet are viewed straight-on from the front, you're faced with foreshortening problems. The dimensions of length of the various parts of the foot vanish, and you're left with a series of widened, overlapping forms. This front view of the foot shows how its top plane starts as a narrow form emerging from beneath the grip of the ankle. After a short level distance, this plane widens as it descends to the toes. The large toe here is clearly an adjunct to the foot out at the side. The toes point off slightly to the outside.

Figure 87. With this view you can see the construction of the heel, the Achilles tendon, and the ankle. The Achilles tendon from the gastrocnemius muscle comes clear down to fasten at the heel. It's very narrow and prominent behind the ankle bones. Depressions are formed on each side of it. The heel itself is ball-like. Notice how the inside ankle bone (on the right) is higher than the outside ankle bone (on the left).

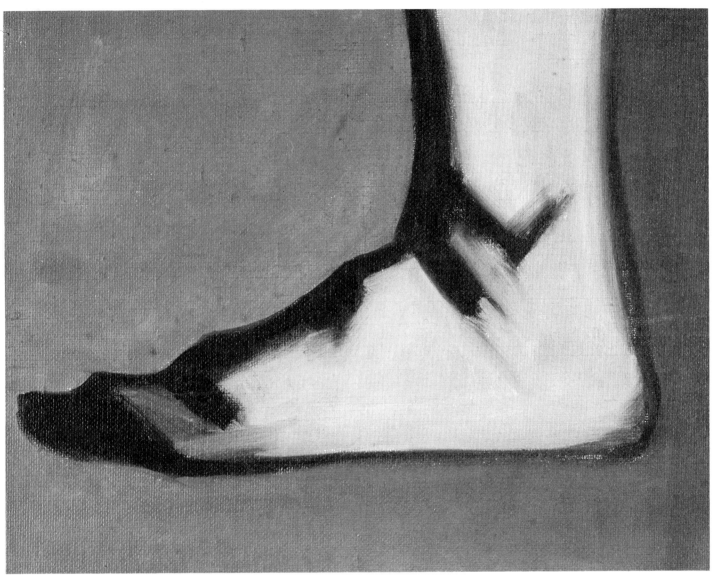

Step 1. On a toned canvas I begin painting with a Number 2 gray. The overall blocky form of the foot, which includes part of the lower leg and ankle. The front and far sides of the foot I deliberately place in shadow to show you the foot's profile more emphatically. For these shadow areas I use a dark Number 8 gray. There's an angular crease causing a shadow just under the ankle bone. Then a short plane moves forward where it joins a slanting irregular plane that ends at the toes. At the toes a flat plane slopes slightly downward to the joint of the first and second phalanges. Then there's the final slanting plane of the last two joints to the tip.

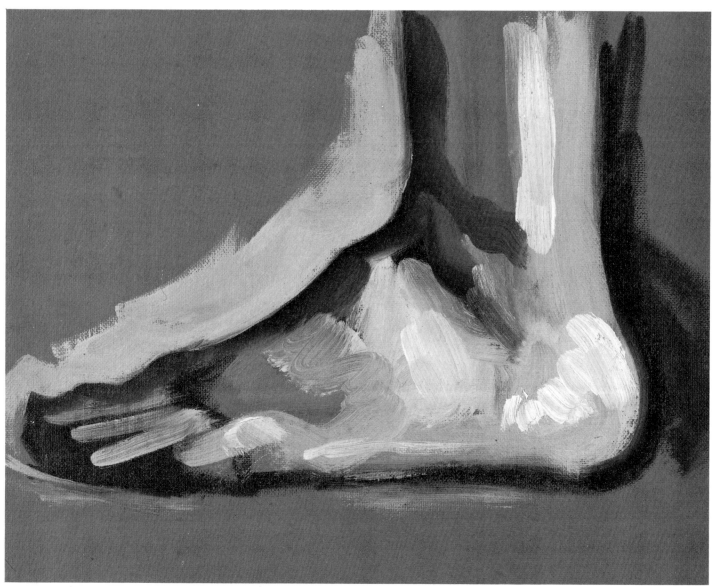

Step 2. I build some bulk into the foot by describing its side planes. I lay in white along the leg bone, on the heel, and then on the main body of the foot (at center). As I paint toward the toes, the tones become less white. I go over the shadow profile with a Number 6 gray. I keep the outside edge of the foot's profile sharp, but I soften the inside one. Transitory values are painted in between the light and shadow sides. I use simple, straight strokes to suggest the toes which appear like steps on this side. Background values are added to set the whole foot firmly on the ground. Next to the top profile of the foot, I use a light, Number 2 gray for the background, while around the heel I use a very dark Number 8 gray.

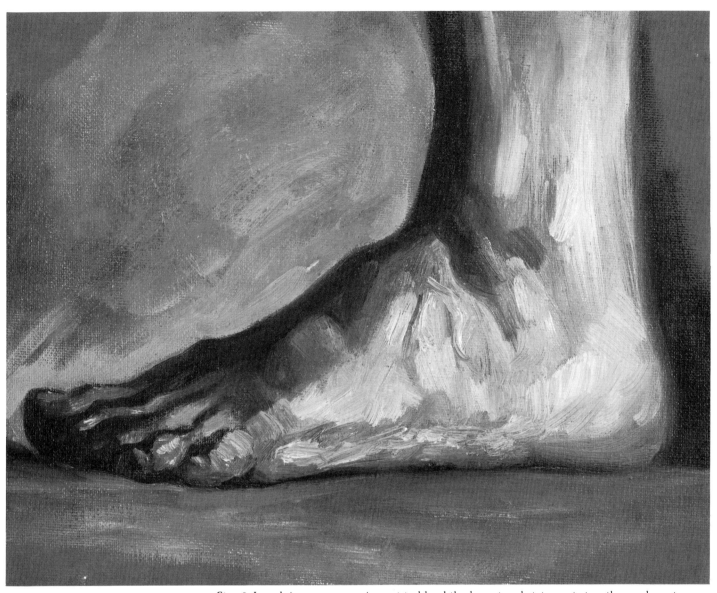

Step 3. I work in even more pigment to blend the large tonal statements together and create halftones which produce modeling. The biggest change is the detail I add to the toes. The toes have a distinctive hump next to the toenails, so the tones I used in Step 2 are altered to this configuration. The alternating strips of tone begin with a difference of one value at the tendons; then the crevices between the toes appear, becoming a lighter value—a Number 3 gray. Small spots of Number 2 gray show in places on the toes. Even on small paintings of feet, the nails in a few places will kick up a tiny highlight or two.

Project 14

THE UPPER
HALF OF
THE FIGURE

In the preceding projects, the groundwork was laid for painting a full figure. You learned how to render all the parts of the human figure in black and white oil paint. Now that you have a good idea of how each separate part is constructed—and how to paint it—you'll have to assemble the pieces so they'll hang together as a convincing figure. With this project we'll also start positioning the figure so that it fits comfortably on the canvas.

Learning to Assemble the Parts

You'll need the following materials for this project:

16″ x 18″ stretched canvas
2 Number 12 filbert bristle brushes
2 Number 6 filbert bristle brushes
2 Number 4 filbert bristle brushes
titanium white
Mars black
turpentine

The canvas that I use in this project is made of medium-rough textured linen which I primed myself. The figure in this demonstration will only be seen from the waist up—half a figure. It will be only *half* as difficult as the complete figure. For a change, let's start on a bare canvas without toning it. I'd like you to paint the first step of this project's demonstration as a simple tonal arrangement instead of a structure. The picture is one of great contrast and deep shadows surrounding the figure. These shad-

ows and contrasting tones make it easy to compose the figure and to construct the various bodily parts.

"Sight Size"

How do you know where to put these shapes? Try to develop a facility for visualizing a picture on a blank canvas. It's a kind of persistence of vision where you look intently at the subject and its environment, then quickly look at the blank canvas and attempt to visualize the subject on the canvas. All drawing or painting is more or less based on this kind of a mental process.

The success of this ability to visualize partly depends on the size that you see your subject to be. Every subject you look at, according to its specific distance from you, has a definite size which you'll automatically use when you try to reproduce this subject on a flat surface. This ability to place the subject at a distance that will make the subject's size conform to the size of your canvas is what I call *sight size*. If you can't move your subject, then you must move your canvas and yourself into different relative positions until you see the subject as being the correct size.

This is a new concept to you, perhaps. It may seem too abstract, but to grow as an artist, you have to keep reaching beyond your present capabilities. It *will* help you to construct the figure if you can also visualize it as a pattern composed of large masses of tone. Initially, I'll just paint the outside shapes in a tonal fashion; then I'll paint the remainder of the figure in a more constructive manner.

Step 1. In this painting, rather than starting with the core of a figure, I tried to visualize the figure as an arrangement of tones. Much of the figure is bathed in light that comes from above, slightly to the left, and almost directly in front of the figure. I see the figure as a study in contrasts; that is, all the light areas are washed out and the extreme dark tones show plainly. These dark tones are found on half of the face and her hair. For the arms and torso I leave mostly bare canvas. I use a wash technique to lay in the hair. To position the figure on the canvas, I wash in the background—all the shapes that surround the figure. I see these shapes as much darker tones than those on the figure itself. These dark shapes that I add in the background describe the figure's contours and are called negative shapes. That is, they're shapes that describe the spaces between forms. By concentrating on and painting these negative shapes, the form of the figure begins to appear.

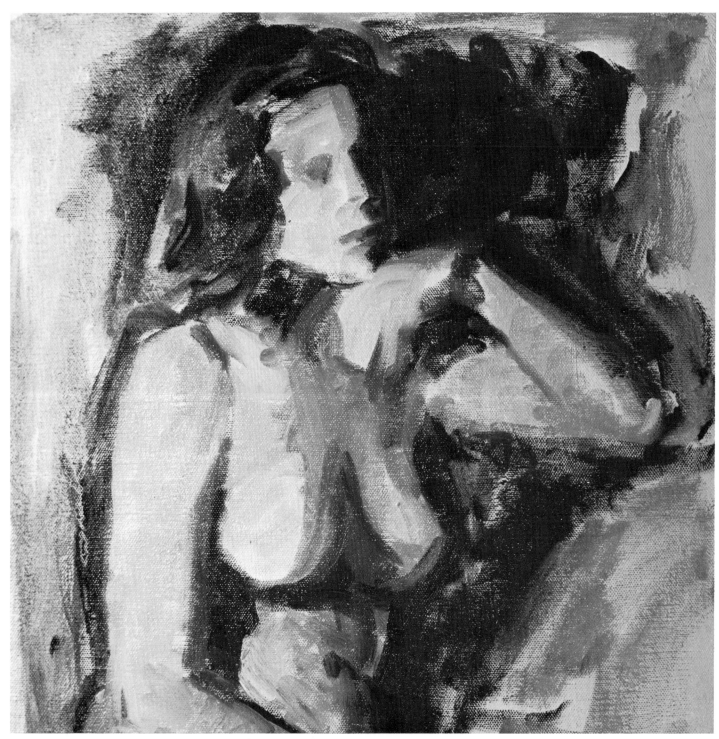

Step 2. Now that I've positioned the figure on the page, the various components can be assembled in the manner of previous projects. I form the oval of the skull by adding halftones. The forehead is faintly darker, because it tilts back and its center is a turning plane. The front plane of the nose joins that center forehead plane and continues into the upper plane of the mouth. I faintly indicate the eye socket. Underneath the socket is a plane that slopes downward. The mouth appears only as a smudge now. Remember that a hand can be painted like a paddle at first, as I've done, by dividing only the most open finger from the rest. The halftone on the chest provides a boundary for the hand shape which, in a sense, is a negative shape! I construct the left arm with a series of twisting units; note how the deltoid muscle on the top of this arm points away from her body. I use a Number 7 gray for it and place it next to the cast shadow on the body which is a Number 8 gray. This shadow forms a boundary for the lower arm and goes across to shape the undersides of the breasts.

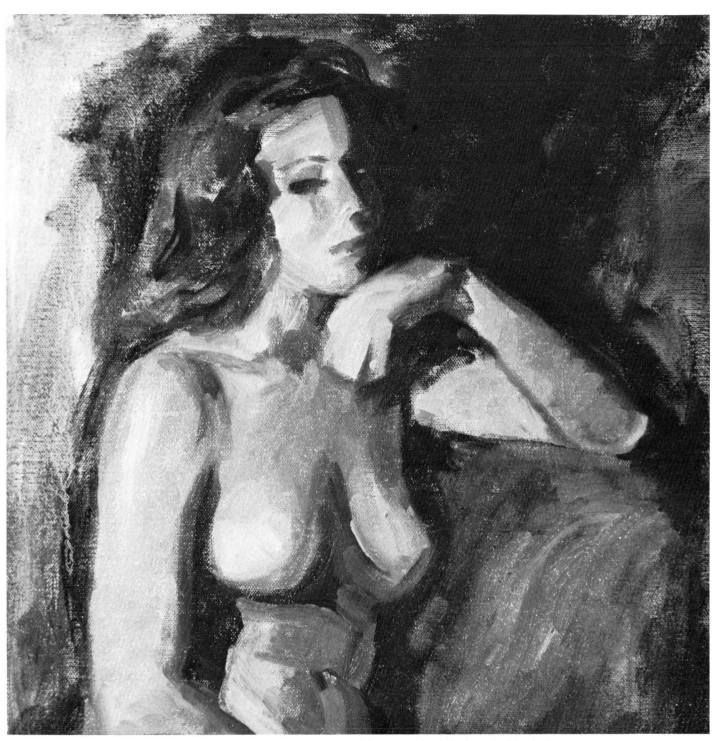

Step 3. Following the original layout wash of the hair, I add a darker tone in the front center and use a little more paint to strengthen the total impression; however, I'm careful not to lose the texture of the first wash, which seems to convey the softness of the hair. The eye is a dark tone which encompasses the iris and lashes. The upper lid is a lighter gray but darker than the edge of the brow bone. It's not too early to add a flick of a light next to the eye at the base of the nose. It's a reference point as well as a key light value. This is also true of the highlight on the left nostril. At one point in the painting, the model's hair had thrown a shadow across her neck (see Step 2), but this shadow cut the head off from the other light areas; so here I pull the hair back, closer to her face, which lets the light in. At this point I lower the top of the left arm somewhat and define the construction of the collarbones and the notch at the pit of the neck.

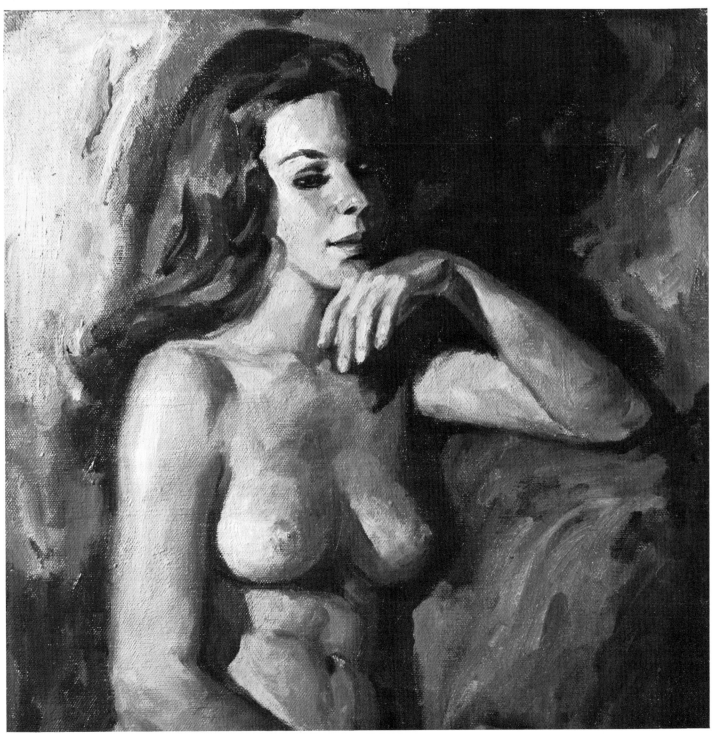

Step 4. I like the patterns and tonal values of the hair, so as I add paint, I take great care not to disturb them. However, I do decide to add more hair down her back and fade it off into the background. The outer corner of her forehead reflects a bright light. That light continues down under the eyebrow. Compare the differences of the eye in this and the previous step. First, I strengthened the round iris with pure black. I add black to the inner corner, place the lashline underneath, and add the shadow of the lashes on the base of the nose. This can be done with a small brush like a Number 1 round bristle or sable. The other eye is a vague smudge with just a spot of Number 5 gray on the lid that happens to catch the light. I add the nostril. I make both lips the same tonal value and separate them with a line that terminates as an accent at their corners. The separation of the fingers begins softly and gets more definite toward their tips. The shadow behind the fingertips is fortunate; it gives me the opportunity to cut in around the fingers and define them.

Project 15

THE STANDING FIGURE

In this project, you're finally going to have a chance to paint the full standing figure. There must be a rhythmic flow to the body to keep the figure from appearing stiff. You must also establish a feeling of balance so that it won't look like it's going to topple over. If you'll refer to the chapter on proportions, you can see how the spine curves gently in a flat "S." The crossbars of the shoulders and hips form right angles to the spine. This fundamental principle should not be tucked away and forgotten. If the posture of the figure is wrong, you may have to go back and examine those basic lines.

You'll need the following materials:

16" x 20" stretched canvas

Numbers 4, 6, and 8 filbert bristle brushes

Number 1 oil sable

Number 14 flat bristle brush

For this demonstration I use medium-textured cotton canvas that's been primed by the manufacturer.

Working From a Charcoal Sketch

When you're a little bit uneasy about starting right off with paint, try doing a charcoal sketch of the figure first. By sketching the figure on your canvas, with charcoal, you can keep erasing until you can actually do the same thing with wet oil paint (when you get braver!). The sketch doesn't have to be shaded too much, especially for a full color painting. With a black and white painting, if you render many of the charcoal tones in the sketch, you'll be able to lay in the same values for most of the paint-

ing. However, a charcoal drawing on canvas is softer and not as "contrasty" as you might want your final black and white painting to be. Therefore, as you're laying in your pigment, you'll have to gradually lower the valu from the middle tone down. Try not to get too hung up on tones; more than anything else, use the drawing as a structural guide. Don't forget to "fix" your drawing with fixative or retouch varnish *before* you begin to paint. Any charcoal that mixes with the pigment obviously will dirty it.

When setting up the drawing, you should concentrate on three points. First, mark off the top and bottom of the figure and establish the correct proportions between these top and bottom marks. Working those proportions out is more difficult when the figure is bent or doubled up, because you can't establish the figure with just a simple geometric shape. Secondly, get the balance of the figure by drawing a perpendicular line from the center of the figure's head to the ball of the weight-bearing foot. Finally, establish the "swing" of the figure, or "action" line (see the chapter on proportions). This action centers on the spine with its characteristic "S" curve. If this line is properly established, your figure will not look stiff.

Connecting Parts of the Body

The procedure for constructing the full figure seen in this demonstration can be found in the steps of the projects on painting the separate parts. Refer to those projects and compare the steps needed to paint various body parts with the ones in this dem-

onstration. Even though the precise position of this figure is not duplicated in those previous demonstrations, nevertheless, they show positions that are near enough to suggest how the body parts in this project are painted. For example, the profile of the head in this demonstration shows the upper face hollowed out for the eye socket (see Project 2). The light sweeping up around the eye above the angular shadow of the jaw shows the point of the cheekbone. Here, too, alternate light and dark strokes illustrate the lips (see (Project 5). The hanging arm is a vivid example of the alternate block formation seen in Project 10. The abdomen is very much like the front torso in Project 8. There's a front view of a straight leg demonstrating how the outside of the thigh aligns with the inside of the ankle (see the chapter on proportions).

Putting these parts together is the most difficult procedure, because all the parts depend on their skeletal joints to keep them in their proper places. Since you can't see these bones, you have to rely on guideposts, or base lines, such as the spine, hip, or shoulder lines. Actually the only connections that I haven't illustrated in paint in earlier demonstrations are the arms to the shoulder, the neck linking the head and torso, the wrist area, and the connection of the legs to the torso. The neck region is covered thoroughly in the chapter on proportions of the figure.

The wrist can be simplified by drawing it as a narrow wedge-shaped block and placing it between the hand and the protuberance of the ulna. The shoulders are actually the deltoid part of the arms; this is especially evident when the arms are hanging down loosely. The legs don't have a very clear demarcation line and seem to merge into the torso. The best way to approach the connection of the hip and shoulder areas is by visualizing them as parallel lines crossing the spine at right angles.

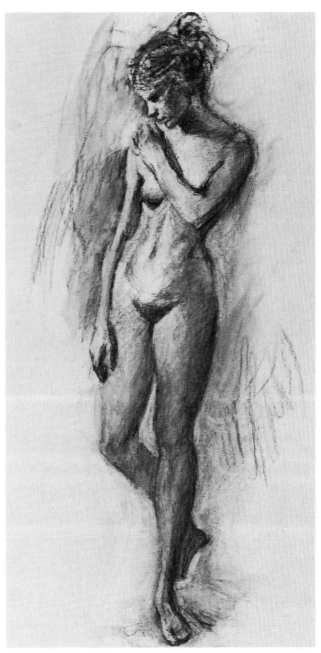

Step 1. I start this painting with a different procedure. I sketch the figure in charcoal directly on the canvas. I spend much more time at this stage than I ordinarily would. This kind of a preparatory step can be a mixed blessing. It will give you confidence that proportion problems have been ironed out. However, your troubles aren't always over, because what happens when the drawing is completely covered with paint? In these progressive steps I start out well (following the drawing) but when the drawing is completely covered, my edges begin creeping back and forth. This demonstration is done on a smooth textured canvas that's been primed. I don't use a tone for this painting and work directly on the white ground.

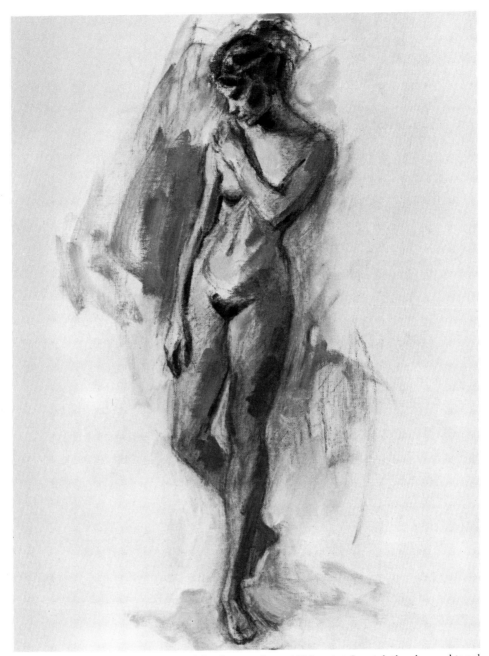

Step 2. I begin painting over some of the drawing here. With paint, I match the charcoal tonal values on the light half of the figure. I make the shadows darker than the charcoal ones because the charcoal on canvas doesn't develop into rich blacks. I paint more flat tones in places on the hair. Notice that the tone on the legs is a darker value and eventually will be even darker. This step consists of spotting in tones over the whole figure.

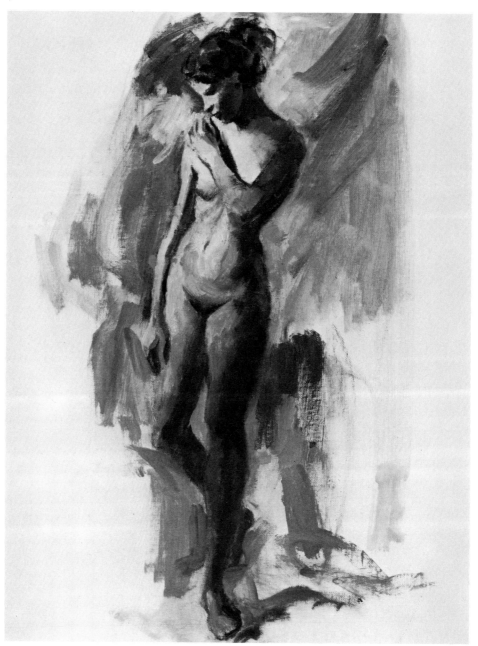

Step 3. Here I cover the drawing completely and also work in a vignette background. The tonal plan is now closer to what I want; it conforms more to the light on the model. This points up the need to use the charcoal drawing more for establishing proportions than for determining tonal qualities. The shadows on the side of the face and neck are darker because the light is the strongest on the face and chest. I sketch in her hair more completely. The whole front of her abdomen is toned down where the light gradually fades off. I use paint strokes which run across the torso to give it a round appearance. On the legs, generally, tones get darker, about a Number 7 value.

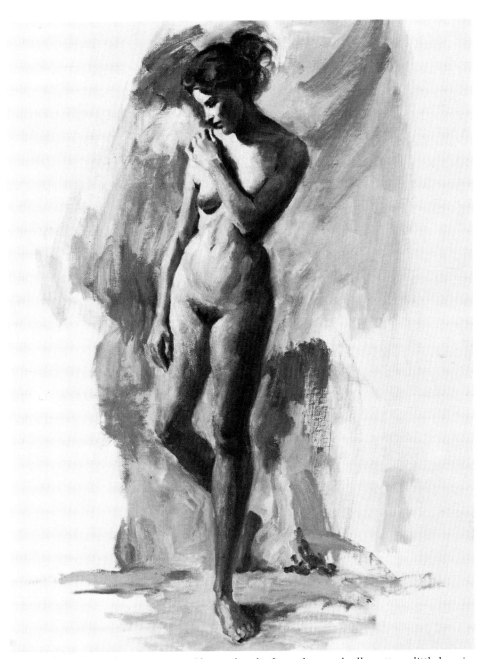

Step 4. Although my drawing is gone, I know that the figure has gradually gotten a little heavier than it should be. At the same time, my values need more definition. I bring the values in the hair closer together by softening them. Since the leg in front bears most of her weight, it tends to thrust her hip upward. In the previous step the whole leg had gotten slack. The shape of the leg should be more angular. I use brushstrokes on the leg and pelvic area that are somewhat diagonal up to the right to purposely enhance this angular feeling. Too much roundness in the abdomen has made the figure look fat. I slim her down by lightening tones at the sides of the abdomen.

Project 16

THE SEATED FIGURE

A sitting position doesn't seem too perplexing until you notice that the limbs aren't in side views but, instead, shoot right out at you. Those limbs are, of course, in perspective. What you're looking at is the contour around the limb and not its length.

Foreshortening Problems

However, that explanation might not help you paint foreshortened limbs. Therefore, try pretending you're painting a patchwork of tones rather than a figure or anything recognizable. Treat the arm as a group of shapes—just shapes. Aren't these shapes simply pieces of different gray tones? Why not concentrate on duplicating the size and shape of those pieces and placing them in proper juxtaposition?

Sometimes it's beneficial to work from photographs. In photographs forms are flattened out on the picture plane where there's no perspective; there's only the illusion of depth caused by a long form being foreshortened.

Using a Grid

When you first begin painting the figure, use a cautious medium like white chalk. You can easily manipulate white chalk, thereby changing figure proportions until you've drawn them correctly. If you're working from a photograph, lay a grid of equal squares over it; that is, draw horizontal and vertical lines on an overlay of acetate or tracing paper and place this over the photograph. Then with chalk divide your canvas into larger squares. Draw in the same number of squares that cover the figure in the photograph. Now draw the main action lines of the figure on your canvas, matching the canvas to the photograph, square by square.

When you're painting from a live model, you can use a sighting frame (Figure 89), which has strings or threads stretched across it to form squares. Always hold it at the same distance when you sight

the model. First look at the model through the squares in the frame. Then draw the model's gesture inside the large squares you've already marked on your canvas, matching square for square between the frame and canvas. Later you should abandon these aids and rely only on your observation.

You'll need the following materials:

16" x 20" canvas
2 Number 12 filbert bristle brushes
2 Number 6 filbert bristle brushes
Number 4 bright bristle brush
Number 10 bright sable brush
Mars black
titanium white

For this demonstration I used smooth linen canvas which I primed myself.

Figure 88. With a piece of chalk, you can draw a grid on your canvas that has the same number of squares as this sighting frame. By viewing the figure through a frame like this one, you can transfer the portion of the figure that you see in each square to the corresponding square on your canvas.

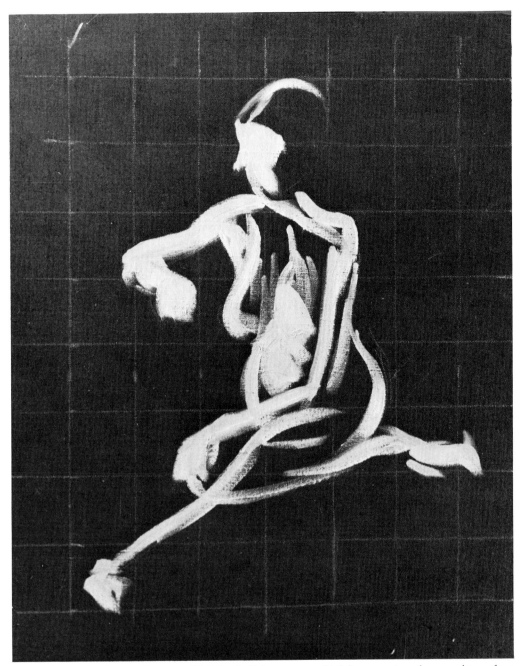

Step 1. On the toned canvas, I lightly chalk in squares which I can use to enlarge and transfer a figure from photographic copy or to help me draw what I see through the sighting frame. Then, I chalk in the figure's gesture. I start the painting with one of the Number 12 bristle brushes. This one will be used exclusively for white and light tones. Over the chalk sketch, I swish in the gesture of the figure with white paint that's diluted with turpentine. I just suggest the "core" or general distribution of the figure. For the back of the head, I leave the toned canvas. Since it's going to be dark anyway—because of the local color of the hair—there's no point in painting it white.

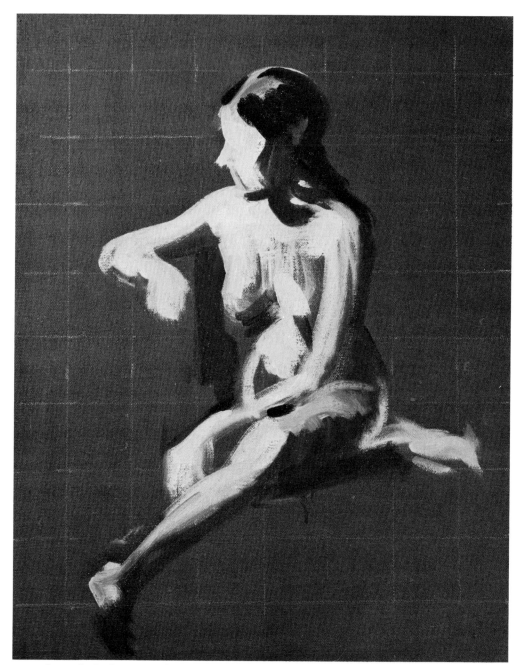

Step 2. In the first step I placed white for the lightest areas; therefore it's necessary to establish the other end of the scale—the dark end. Areas like the crotch, under the leg, the lower foot, and background I paint in pure black with another Number 12 brush. I block in the shadows on the side of the face, the arms, under the breasts, the right hip, and the thigh. I roughly indicate her hair. More light is added to her chest. At this stage, you have three key tones: the white that indicates the gesture of the figure; the blackest spots; and the toned canvas which serves as the middle tone.

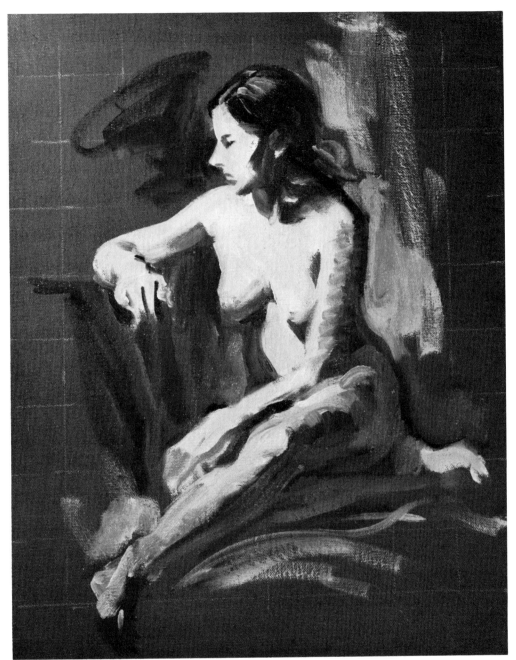

Step 3. From here on, I don't dilute the oil paint with turpentine, and I keep the figure "painty" with sweeping tones. On the foreshortened arms and legs, I brush across the form to give them roundness, especially the thigh. Next, I mix the halftones for the shadows along the bent leg, along the back, the undersides of the arms, under the breasts, the side of the face, on the neck, and under the chin. I use about a Number 6 gray for these halftones. You can start the details of the face, but don't dwell on them now. I rough out the fingers of each hand; the upper one has indications of fingers and a thumb. The lower arm can be done as a solid form for now. I add some angular pieces to the forward foot. The background comes next. I use strokes in the background that reiterate the main thrusts of the body. For example, I use vertical strokes behind the figure's back, while I use some curvy, horizontal strokes for the foreground near the bent leg. I use tones for the background that contrast with the major tonal value of the nearby body area. Close to the dark shoulders and hip of the figure, I use a light tone. Next to the light face and left breast, I use dark tones.

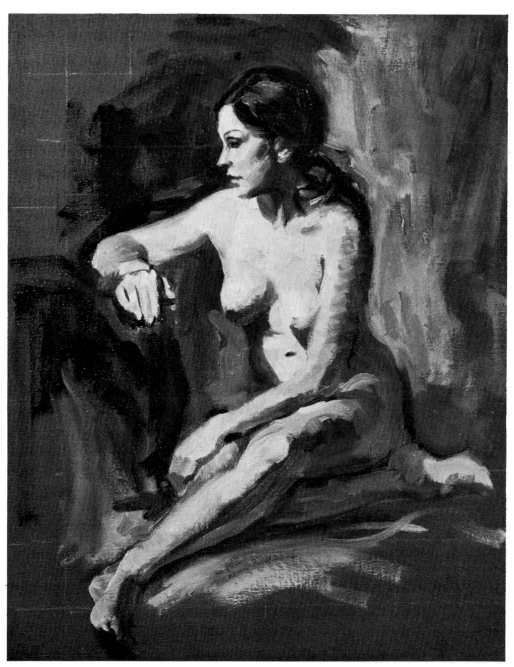

Step 4. The head is shaped out a little more and the spots of sheen are added with highlights, but the largest highlight isn't more than a Number 6 value. I mold the structure of the face by bringing a delicate tone across and down the cheek into the mouth with a Number 6 filbert brush. I stroke a similar tone along the jaw dragging a slight amount of shadow with it. The dark spot of the cheek hollow and the jaw-line shadow are then repainted into those tones. Remember that the strongest light is on the chest. I adjust tones on the breast and arms to conform to this pattern. A dark tone begins around the back side of the upper foreshortened arm and goes over the top of the forearm, getting lighter at the wrist. Notice the bottom edge of the right arm has a very dark, angular bit of tone underneath to suggest the form of the wrist. I paint a short dark stroke for the back of the left hand. A thin black tone cuts in around the lower leg separating it from the surrounding background tone. I paint a Number 8 gray on the top of the foot to show its arch. More background is also added for both contour and contrast to the figure.

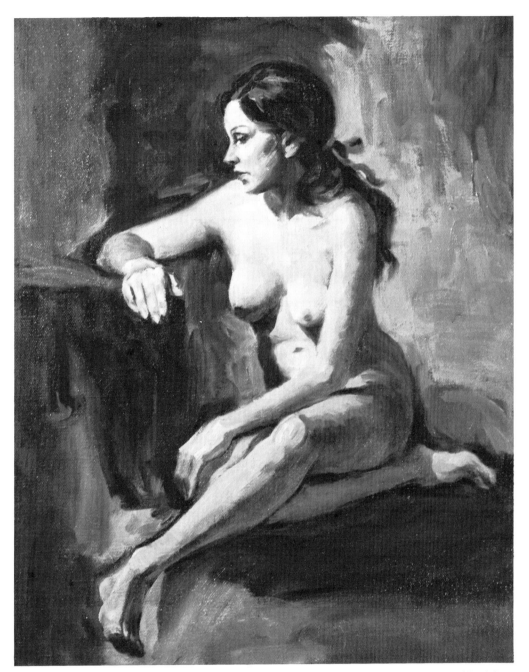

Step 5. More refinement takes place here. The hair on the shoulder was too busy, and both hair and ribbon were too lumped together. I separate them and make the hair a bit longer in back. I soften the halftones and lights on the chest and arms for a more fleshlike quality. I repaint the lower hand a little by adding some dark tone around it, making the wrist smaller and less prominent. The fingers are put in with only faint indications of their separations. All the halftones on the legs are pulled closer together by eliminating the harsh extreme values. The platform on which the figure is seated is painted a Number 8 gray. I finish off the toes on her forward foot by rounding the top of the big toe. Three small, light tones show the separation of the three toes, the little one is out of sight. A few differences in the facial features are noticeable here. I've placed the eyes to look downward; the underside of the nose shows faintly, and the mouth doesn't droop so much. The background helps to contour the distant foot plus that of its outside toes. Notice at this stage I've removed all the chalk lines. I finally add a cast shadow beneath the forward foot. This shadow makes the foot hang free, away from the platform.

Project 17

THE RECLINING FIGURE

Reclining poses test your ability to see the way a familiar volume fills a two-dimensional space. You can get pretty adept at laying out a figure in an upright pose. But when that pose becomes horizontal, you start to flounder. One reason is that people are most accustomed to seeing other humans upright rather than lying down; you get a "feel" for, or intuition about, proportions that way.

Proportions and the Horizontal Pose

There are two common mistakes you're likely to make when painting a horizontal pose. The first is a tendency to make your figure too long. The second is that your figure doesn't seem to lie down. Part of the problem is that you aren't looking across the complete figure to compare highest points along the mounds of flesh. You have your brush in hand, so use it as a sighting device. Hold it so that it lines up with something horizontal near the model. Many times the baseline of the wall or partition behind the model will cut right through a figure and create a perfect horizontal guide. No one ever seems to take advantage of that!

Adjusting Measurements

To adjust the length of the figure, align points that fall directly underneath one another. For instance, the hand or the elbow may lie below the waist, or the knee could be under the midpoint of the other thigh. The chin might be on a line dropped from the shoulder, etc.

You may as well get used to the fact that you can't lie on your side or keep your head tilted while painting the figure. Try to see the pose as masses of tones in a two-dimensional relationship. For the moment don't be hung up on *what* it is you're painting.

You'll need the following materials for this project:

18″ x 24″ canvas

Numbers 6, 8, and 10 bristle brushes

Number 4 oil sable brush

Mars black

titanium white

I'll use a white, untoned, smooth linen canvas which I primed myself for this demonstration of a reclining figure. To launch into this demonstration, use a Number 6 filbert bristle brush and a thinned amount of Number 6 gray. As always, it's important to get off to a good start by properly placing the action and proportions of the figure. This shouldn't be just an outline drawing of the pose, but rather a suggestion of the entire solid form.

Step 1. It's necessary in the initial layout of a reclining figure to determine the horizontal proportions in order to get the figure to lie down properly. The highest parts in this pose are the head and hip which are on the same level. Estimate the hip in about the center, an equal distance from each side of the canvas. A hand and foot, of course, are my outer side limits. The head position is located approximately with relation to the upper hand which I place just inside the edge of the canvas. With a sweeping stroke of Number 6 gray, I brush in a loose sketch of the figure. The undersides of both arms produce a continuous curve. The elbow is at knee level. I sight across the figure with a straight edge and line up as many places as possible.

Step 2. I begin painting the large masses of tone immediately. I unify the figure with a Number 5 gray on all areas that are close to a middle tone, such as the face and neck, the arms, the shadow down the front of the body, and the one on the upper thigh. The hair and background are put in as a Number 8 gray value. It's the photograph that makes them look blacker. I put in rough lines for placement of the facial features, the neck, the arms and the torso. Although much bare white canvas still shows, the highest value (near white) is worked into the forward shoulder and arm.

Step 3. Now I cover most of the bare canvas. I work in the light tones on the top of the figure with bold strokes that are at right angles to the direction of the figure. These strokes add roundness and depth to the forms. The hand on the left is blocked in at first with a large amount of Number 1 gray encompassing the whole form. A flip of darker gray turns the hand back while separating out the thumb. The little finger is cut away from the others and a spot of white near the wrist thrusts it out. The other hand is roughed in differently because the figures are spread out more. The first two fingers and thumb are in the light. With a Number 5 gray I paint a strong highlight on the hair. The model has brown hair which translates into about a Number 7 gray. The reflected light above the right eye sets a key for all the light tones on the face. I darken the neck to push it back under the chin.

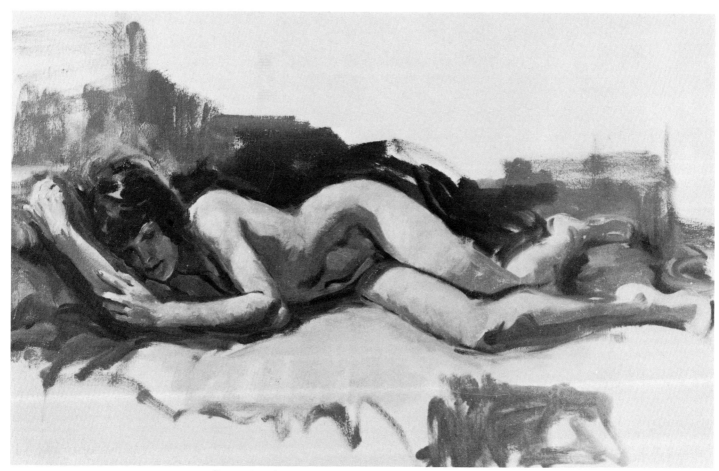

Step 4. A reclining pose is one of the hardest for a model to resume after a break; sometimes they never find precisely their original position. Don't fight it; simply adjust your painting. Here, you can see a change of position by comparing the previous step with this one. Notice where the shoulder and hip are positioned; they've moved up toward the head in this step. This change affected most of that whole side down to the foot. Although the top leg is in the same place, the angle of bend at the knee is different. So is the bend in the arm. While working on the abdomen I put in a reflected light from the drape and a delineation line for later reference.

The fingers of both hands are painted with the edge of the Number 6 filbert bristle brush. The thumb on the lower hand is repainted closer to the fingers.

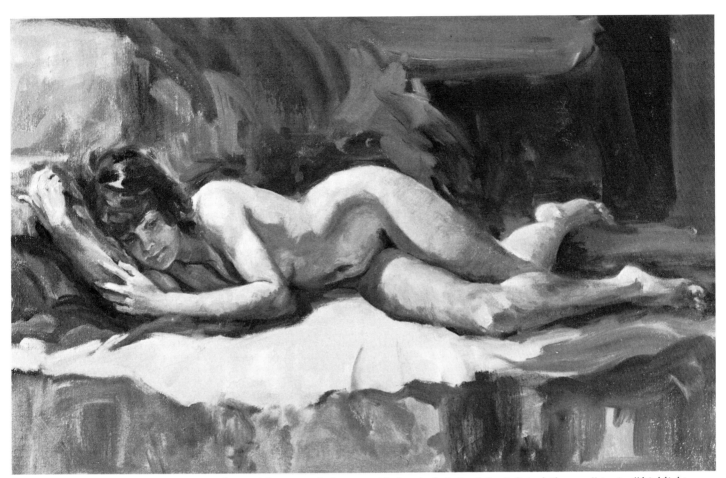

Step 5. A few more dashes are added to the hair, but I don't disturb the one "singing" highlight that I put in back in Step 2. The face gradually develops from larger parts for which I use a Number 6 filbert brush. The smaller details I put in using a Number 4 oil sable. The tonal values of the face fall between a Number 3 and a Number 5 gray, except for the black accents of pupils and lashes. The tonal arrangement on the lips is the opposite of a normal overhead light situation. The upper lip is light; the lower one is dark, and the furrow under the lower lip is light again because of the light reflecting upward. I darken the raised arm and soften the edge to stop the "attention getting" flow of light from her shoulder to her raised hand. This takes away the stiff look that the figure had in Step 4. I've left the breast until now, because it was hardly visible, but here I paint it in. In Step 4 the lower thigh was too straight and unnatural. Here I round it out more next to the drape. Where the thighs meet, there's now a better anatomical line.

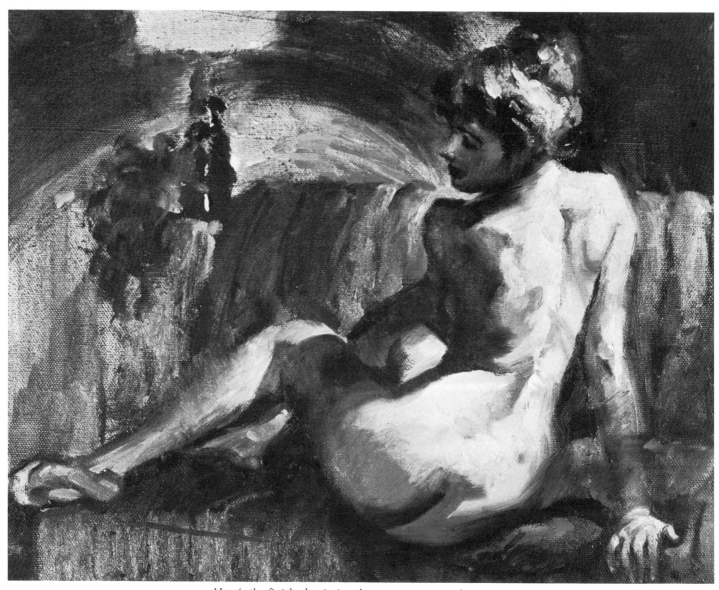

Here's the finished painting that you see me working on in the picture on page 10. I did this 11" x 14" painting on medium textured canvas which I primed in the traditional manner with white lead. I began it with a transparent wash, and as I added heavier paint, I endeavored to keep my brushstrokes "loose" and freewheeling.

COLOR
DEMONSTRATIONS

Project 18

WARM AND COOL COLORS

I know you can't wait to squeeze out some of those lovely colors that have been lying in your paintbox. I've wanted to myself, but believe me, getting a feeling for values first is very important. Your color renderings will be much better for having practiced tonal values in black and white.

Some Characteristics of Color

There's an important characteristic of color—or a phenomenon of light—that you should be aware of before you begin to paint in full color. Certain colors generate feelings of warmth, others feelings of cold. Reds, yellows, oranges, and violets are usually considered *warm colors*. Blues and greens are usually thought of as *cool colors*. However, there are variations even within the two warm and cool categories. That is, a warm color, such as red that has some blue in it, may appear to be a bit cooler than a red that has more orange than blue in it. The same variations hold true for cool colors. A green that has a great deal of yellow mixed in it will appear warmer than one that has more blue in it.

Besides these feelings of "temperature" that colors impart, there's an additional phenomenon of change in distance. The warmest, darkest colors seem to move forward or advance, while cooler, paler tones seem to recede into the distance.

Warm Light and Cool Shadows

In nature warm and cool colors are often found in juxtaposition. Sunlight—especially the hot light of early morning or late afternoon—is warm, while the deep shadows that objects create in such light are cool. Even artificial light tends to be warm. Cool light is unusual; some examples would be a northern light from a blue sky, a light from outside a window at night, or moonlight.

However, even with sunlight there's an exception. On a very bright, hot sunny day, at noon, you'll find that the sunlight seems whiter, while the shadows from the ground appear to be dark and warmer. In fact, this quality of white being cool presents a problem for the painter. When you mix white pigment with a warm color to raise its value (make it lighter in tone) you'll discover that the warm color will get colder. However, take heart! We'll surmount that problem in the two demonstrations at the end of this project.

Local Color

If you could place an object in a setting that was absolutely neutral—without the influence of other colors, lights, and shadows—you would see the true *local color* of an object. However, the local color of an object is always influenced by the light and air or atmosphere in which in exists; this atmosphere creates a wide range of color influences. The painter (if he wishes to produce a realistic representation of the figure) must try to reproduce these color influences on the local color of the figure he's painting.

The local color of human pigmentation has a general hue that's pinkish. Yet this pinkish tone varies, depending upon where it is on the body. A simplified run-down is: head and arms are reddish or brown (getting more sunlight); the chest and breasts are pink and violet; the waist and torso appear yellowish; and the thighs and legs are ruddy leaning toward a purplish cast. I'll be dealing with this local color effect in later color projects.

Color Temperature and the Figure

The first demonstration painting will be a study in warm light and cool shadow—the most common arrangement. I've used smooth linen canvas which I primed myself in both demonstrations. You'll need the following additional materials:

2 16″ x 20″ canvases
Numbers 4, 6, 8, and 12 filbert bristle brushes
Number 2 round bristle or bright sable brushes
Mars red
cobalt blue
burnt umber
titanium white

For the first demonstration, I'll use only two colors: Mars red and cobalt blue. The main difficulty with this painting will be keeping the colors clean, especially the red. Therefore, start cautiously with a drawing to designate where the blue underpainting is going to be. I'll draw in my demonstration figure with charcoal. Other color combinations that would work well in such a two-color painting are: Mars red with "thalo" blue, burnt sienna with thalo blue, and cadmium red with black.

The second demonstration will have cool light and warm shadows. The colors I'll use for it are Mars red and burnt umber, because they're easier to control. They mix together nicely and don't get muddy. This won't be a dramatic cold light and warm shadow effect, such as that produced by moonlight. Rather, this is the type of color pattern you'd see when there was a cool north light with a warm secondary light. This color combination will free you to start the painting in a novel manner. The technique that we'll use allows for a complete mass approach; it's a contrast to the linear way we began the first demonstration. This painting will have a freer flowing look to it—not so tight. Other color combinations could be used for this painting such as: black mixed with white for the cool tones and burnt sienna for the shadows, or ultramarine blue for the light with burnt sienna for the shadows.

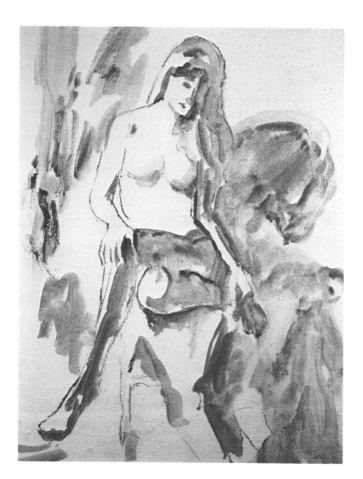

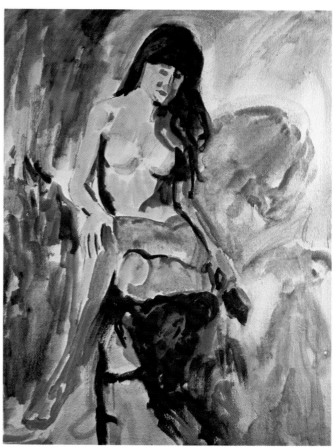

Step 1. Make an outline drawing of the figure with charcoal. I don't usually advocate starting a painting this way. However, it's necessary, because I need to confine the pigment to exact areas right from the start. I use a Number 6 filbert brush and make a thin mixture of cobalt blue and turpentine. With it, I wash in all the areas that are either in shadow on the body or other background shadows and shapes. The light here is coming from the upper left. I deepen the blue where I want the values of the final painting to be dark—for example, on her hair.

Step 2. I use a clean filbert brush and lay in washes of Mars red in the areas that will be bathed in light. Take care that your brush doesn't get into the blue. For now, you can leave the colors slightly separated. If you start painting over the blues, keep wiping your brush. Using pure Mars red, I paint the hair very dark as well as the shadows under the left arm, under the right breast, and the shadow on the right arm. Some of these are warm reddish shadows because they're next to the lights bouncing off the body.

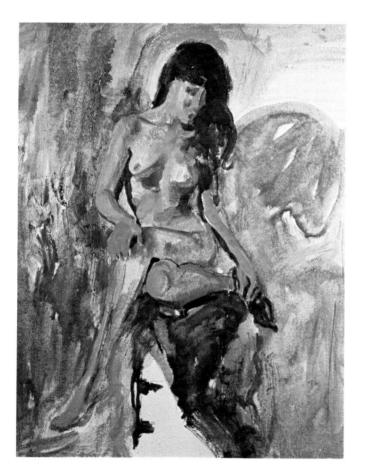

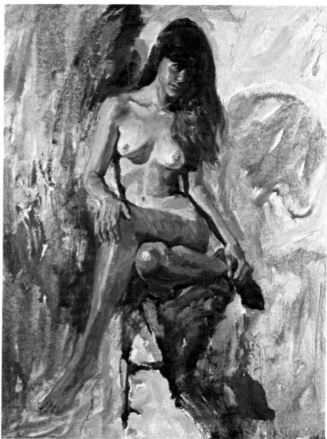

Step 3. Now I begin mixing Mars red with white to achieve the opaque flesh tones. Although white will cool red, it's relatively unimportant here, because the reds are still warmer than the vivid blue shadows. I aim for a roundness and solidity of the torso, the arm, and the head in this stage. I do these areas mostly in red tones except for the small cool shadow on the left shoulder and the breasts. Any mixtures of red and blue should be limited to these areas. If I do any more, the whole thing will get muddy and dirty. On the left breast I achieve a three-dimensional effect by alternating warm and cool colors. The edge of the shadow cast by the breast is cool and gray, because that plane catches the shadows of the room; then the shadow turns pinker because the torso is throwing a hot light upward. Further down on the body, this shadow from the breast gets the full benefit of cold light from overhead and to the left.

Step 4. Here I start using some grayed tones. These are mixtures of almost equal parts of blue, white, and red. They occur in those areas where the plane of the body turns from the light into shadow. The grays are somewhat violet in hue on the top of her legs and on the right arm. The bluest part of the legs are darkened with mostly cobalt and a touch of white and red, depending on the location. I do all the modeling of limbs bearing in mind the direction of the light and using a color that corresponds to that light or shadow. There are many hues that you can get with just two colors: rusty reds, pinks, violets, browns, blacks, blues, and grays. The local color of the skin on the various parts of the body can be simulated with these colors. The chest and breasts are pinker, the shadows of the breasts violet and pale blue, and the face is redder, as are the lower arms and hands. With a purplish tone the legs get darker. These subtle variations in color give a figure a look of flesh and bones—a realistic look.

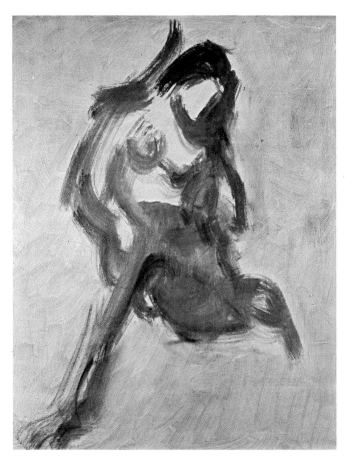

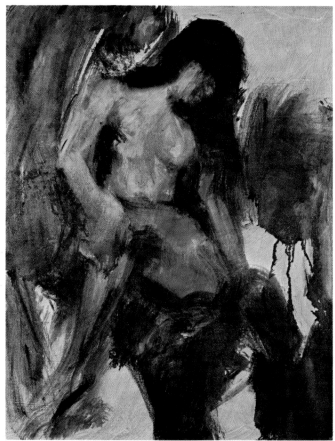

Step 1. I take a piece of paper towel and bunch it into a wad. I place a little turpentine in a shallow dish and dip the towel into the turpentine and then into the Mars red. I start with smears of paint to get the figure's gesture. I start at the top and sweep down around the arm outside, back up the inside, and around the breast. I take another dip for the shoulder and then swing down the thighs and legs. Laying out the figure in this manner, though it's awkward, gives the figure a nice swing, and the figure as a whole will be put together much more accurately.

Step 2. Using the wadded towels, I paint in thinned burnt umber in the left background. I use even more in the right background (the cast shadow). Deeper mixtures of umber begin the drapery of the model stand and the lower right background. I apply a rich degree of umber to the shadows on the hair, the face, and the arm. I shape some of the body by using a piece of clean towel dampened with turpentine. I lift out areas that are to be lighter like the breasts, the neck, the left side of the face, the left arm, and the left hand. If you can still manage to work in this manner, dip into a little color and continue to shape the parts. Working this way keeps you from getting picky and makes you think in terms of the entire figure.

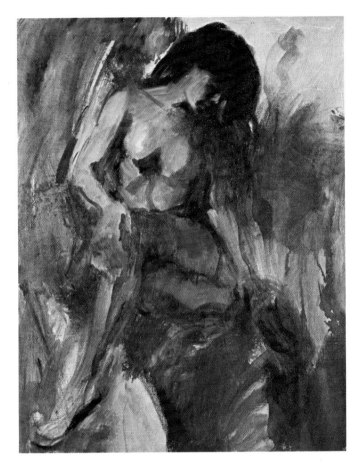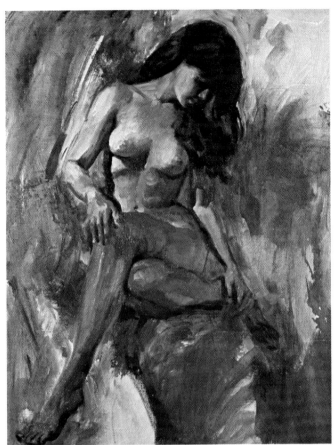

Step 3. Now I add white to the Mars red to create the cooler, violet light areas. (Don't use white in any shadow mixture.) If I need to change values in the shadows, I make sure the color is transparent—a wash. I use the white and red mixture to block in the left side of the face, the nose tip, neck, chest, and arms. I place the lightest value, almost white, on her left breast for a highlight. The features of the face are lost in shadow for the most part. I use small abstract shapes for the parts that catch the light, such as the nose. Light tones above and below the mouth delineate it. The eye is located by the light on the bone of the socket.

Step 4. Most of the finishing on this painting is simple. There are many isolated brushstrokes which I leave unblended, for example, around the neck. Note that on the upper torso the warmer transparent tones aren't covered or disturbed, because they slant away from the light; the whitish violet (or opaque) colors create the planes that face directly into the light. This contrast gives a glow to the figure. However, you can safely mix a tiny amount of white with Mars red for the dark parts on the legs such as: their tops, underneath the bent knee, and on the extended leg. I restate any accents with pure umber and Mars red.

Project 19

TEXTURES AND SUPPORTS

Learning about the warm and cool effects of light in the last project helped to acquaint you with color. However, don't be dismayed if you found it difficult. Painting with two colors is actually more troublesome than painting with a few more, because there are hues you'd like to match but can't find a way to mix them. With only two colors you have to be inventive and simulate a full color effect, or just be content with the warm and cool effect.

In this painting I'll expand the palette with more colors—just two more—to make it a primary color palette. It won't be quite as inhibiting as the one in the last project, even though it's still a limited palette.

Using Masonite

You'll need the following materials for this project:

Masonite (untempered variety)
Numbers 4, 6, and 8 filbert bristle brushes
painting knife
linseed oil
Mars red
cobalt blue
yellow ochre
burnt umber
titanium white
turpentine

There's no reason why you shouldn't have more freedom and a little fun after all the preceding exercises. Using a Masonite hardboard as your surface, rather than canvas, gives you an opportunity to experiment with a different texture and technique. The Masonite should be primed first; for this, I use white acrylic gesso as a ground. If you put the gesso on heavily, interesting textures will develop, and these will show through some of the overpainting. Also the slickness of the board's gesso surface makes the oil paint smear and smudge in interesting patterns according to how you brush the paint on. The polymer gesso is compatible with the oil paint, because the Masonite isn't flexible enough to cause problems that result from the stretching of layers of paint.

Creating a Variety of Textures

Glazing is another fascinating technique to use—either on Masonite board or canvas. Basically, glazing is accomplished by overpainting with a color that's made transparent by greatly diluting it with a medium. The correct way to glaze with oil paint is in stages, after each previous coat has dried. Try some glazing in this project. Block in the figure sketchily with burnt umber to show what the light situation is and to suggest some kind of loose background. Dilute some burnt umber with linseed oil and lay it on as I do in the lower part of the demonstration painting. Lay the Masonite board flat, unless you deliberately want your paint to run. In other areas some of the paint can be brushed on pure and heavy. In still other parts try dropping a *little* bit of turpentine into the paint so that you get a spattered look—as in the upper right background of the demonstration painting.

After the burnt umber dries, start using your other colors, but thin them with turpentine to a transparent consistency. These washes of paint should be used only in the background and foreground of the painting if the figure is done with opaque paint, as it usually is. This will make the painting a combination of transparent and opaque effects.

Sometimes too many textures, or reliance on techniques, can overshadow the total effect of the painting; then the techniques become "tricks." They should just provide accents to your painting. This is a situation where you must be guided by your taste as to how much texture to leave in. In the case of the demonstration painting, I think there's a good balance of textures.

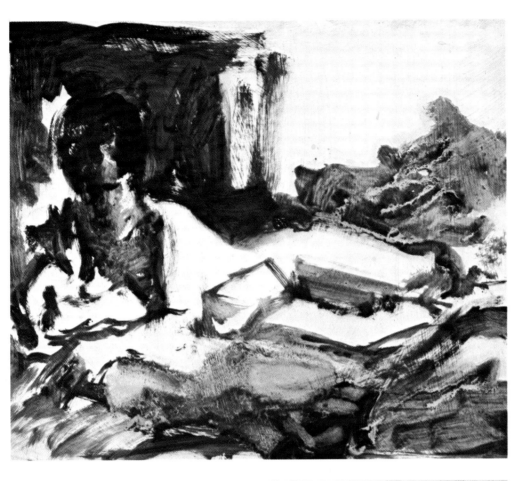

Step 1. I wash the Masonite with ammonia to get off any grease or dirt. After lightly sanding the Masonite, I put on one coat of white acrylic gesso fairly thick. That's enough to cover the board; however, you could put on another coat if you wanted more texture. Using just burnt umber for this step, I paint in the whole figure and some background in a spontaneous, sketchy fashion. I leave bare canvas to represent the light areas of the body. The light is coming from the upper right. Laying the board flat, I then put in more burnt umber diluted with linseed oil around the foreground and the background on the extreme left and center right. This thin paint leaves a nice, smeary look. In a couple of those places I drip a little bit of turpentine into the thin paint. I'm careful about how much I drop; too much will repel the paint. I let this initial step dry completely.

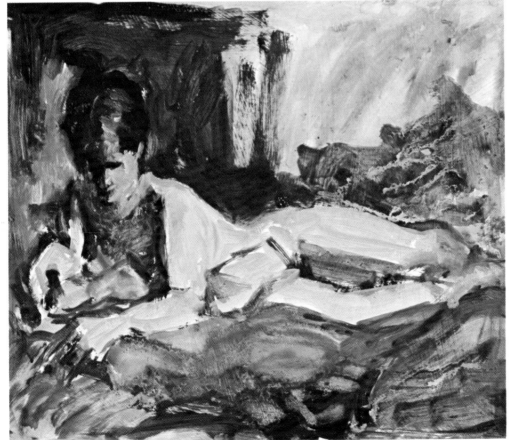

Step 2. I use thin mixtures of turpentine and cobalt blue for the upper right background; I add some white to this mixture in the extreme lower background areas. At the left of her head I paint Mars red thinned with turpentine; then I put in yellow ochre and Mars red over the entire foreground. I mix white with Mars red and lay in all of the light areas of the figure. Notice that in some spots where the mixture isn't heavy enough to cover completely, it mixes with the umber making an interesting violet. I leave this violet tone around her hair and on her shoulder and knee. A little cobalt blue is used to break up the heavy umber color above her right shoulder.

Step 3. For her chest, which is in shadow, I use varying mixtures of the primary colors with white. If you actually mix a Number 5 grayish color—using all of the colors and white—you can use it as base color. With it you can create red or bluish casts depending upon what you need. The upper shadow on the chest is a cooler one because of the cool light coming from above. The foreground is a warm color and causes the breasts and other parts of the body that turn toward it to be warm. For these shadows I use a warm gray-violet. The shadow half of the face and neck turn downward and I use a warm base color to represent them. I paint successively cooler and darker tones for the fingers of the nearest hand; notice that they bend at different joints. The back of the forward hand, rolling toward the ground, needs some orange tones to turn it.

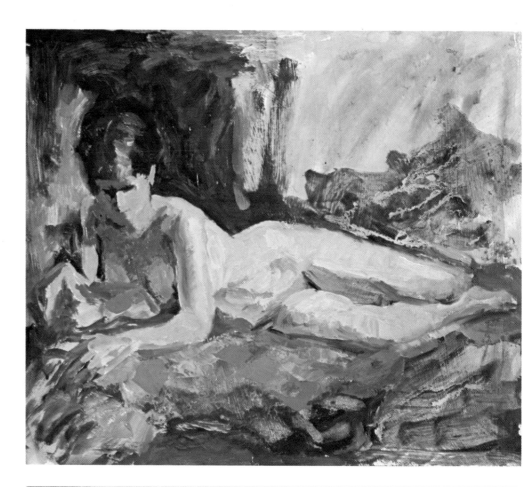

Step 4. In this last stage the figure becomes more rounded and proportioned. The body and legs get pinker and progressively more ruddy from the thighs to the feet. The shadows on the thighs should become grayer as you darken them, otherwise the Mars red alone would make them too hot. The planes of the face that tilt downward, like the chin and lower cheek, have warm shadows; the planes that tilt upward are cool. I keep the features very simple, especially the eyes which I paint in with just umber and blue to get a black mixture for the irises and lashes. I make no attempt to put whites or highlights on such a small head. The nose is a simple geometric structure. Its flat front plane is a reddish color, and its side planes just happen to be the same value and color. The corner of the nose has a highlight running down its ridge. I use mars red and white for the mouth.

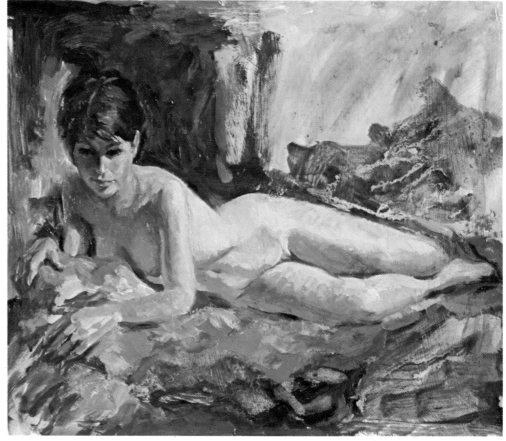

Project 20

FAIR COMPLEXION, BLOND HAIR

Getting a warm, lifelike flesh color—one with oranges and reds—is a problem when the model's skin is especially pale. The rare blond that protects herself from too much sun can have a beautiful quality to her skin. To capture this pale skin tone, you must work with conflicting forces in paint. To make the skin light, you add white, which cools the skin's tone; to give the skin warmth and to bring it back to life, you mix in red, yellow, and orange. Yet these warm colors cause the skin to darken in tone.

To meet this challenge, you'll use a different palette from the one you've been using in previous projects. This palette will give warmth to the skin color, yet it won't make the skin color appear too red.

Learning to Use "High-Keyed" Colors

You'll need the following materials for this project:

16" x 20" canvas

Numbers 4 and 12 round bristle brushes

Numbers 4 and 6 filbert bristle brushes

small painting knife

titanium white
yellow ochre
cadmium yellow light
alizarin crimson
viridian green
cobalt blue
ultramarine blue
burnt sienna
Mars black

I used a smooth textured linen canvas which I primed myself for this figure which is done with "high-keyed" colors. That is, the colors I use here are all light tones, tones that appear on the light or "high" end of the tonal "scale." Work directly on the white canvas for this project. I think as long as you're going to have a high-keyed figure, a dark undertone would only pull your colors down in value. First of all, lay in your figure by using a thin wash of violet (a mixture of alizarin, viridian, and white). By putting in the shadow areas only, you'll have drawn enough of the figure to establish its proportions.

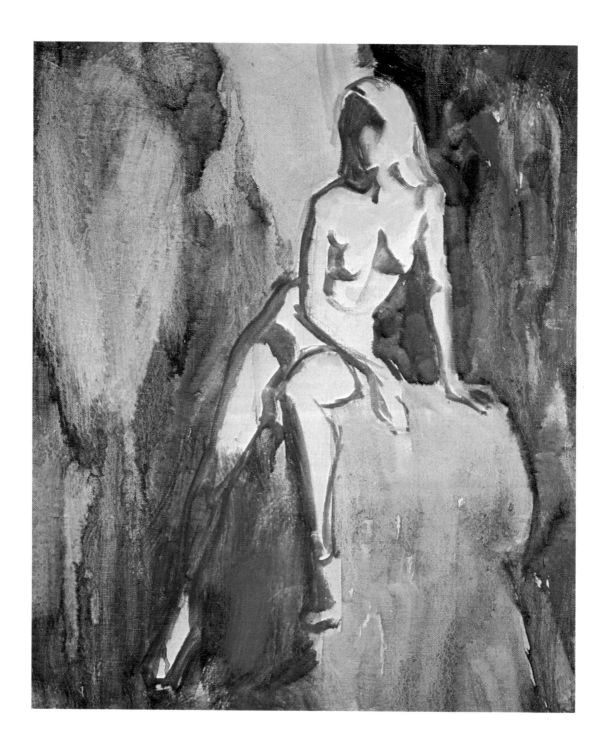

Step 1. To delineate the figure I use a deep violet wash and place the shadows on and around the model. You could also enclose the light side of the figure if you want to delineate it completely. The background describes some of the periphery of the figure. I use lots of turpentine, and I lay the canvas flat when I brush in the colors—alizarin crimson, ultramarine blue, viridian, and black. I use two large brushes: one for the pure alizarin and ultramarine; the other for the viridian and black. I do this so that the colors don't get too mixed. The darkest and most saturated colors I use in the background next to the areas I want to stress. These dark colors "punch out" the light edge of the figure. These rich, cool hues will make the pastel colors on the figure seem very warm by contrast, when actually the colors on the figure will be cool reds and yellows. The streak of light down the drape in front is done with yellow ochre and black. The hair is started with cadmium yellow. Where light directly hits the body on the chest, I use a key color which is a mixture of white, yellow, and alizarin crimson.

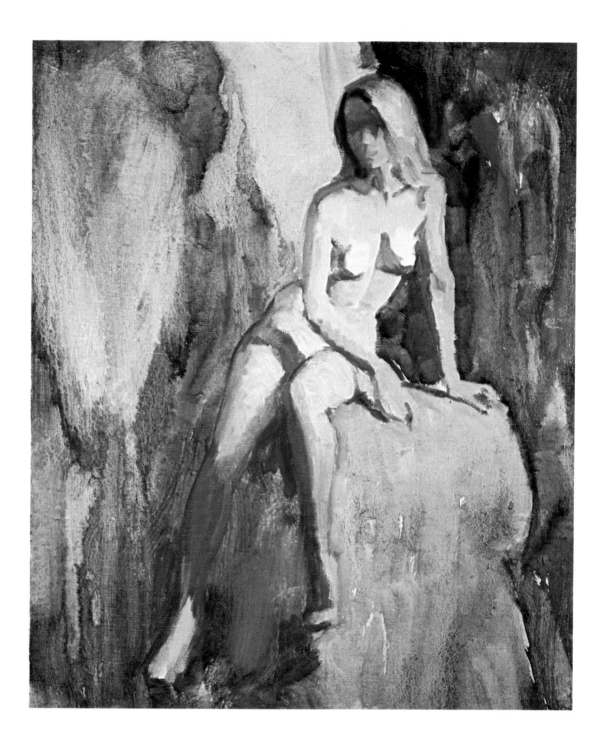

Step 2. By combining white, yellow, and alizarin crimson, I create a basic flesh color. I keep varying the balance of these colors as I pick them up. One stroke I push to the pink side; the next I make slightly more yellowish. They must be the exact value, however. To be an absolute colorist, you should have a mosaic of all kinds of hues. Pale greens, blues, and violets could also be used in the light regions, but this is too difficult to handle at a beginner stage. Combinations of white, alizarin crimson, and now viridian green and yellow ochre will comprise most of the shadow areas. Substitute yellow ochre for cadmium yellow in the shadows because cadmium yellow will make the mixture too greenish. By varying the amounts of those colors, you can get shadow tones that conform to all the various local colors found on the figure. For instance, on the head and shoulder the shadows are less yellow; some are even quite blue. The legs are warmer in tone and the shadows have more yellow ochre and red in the paint.

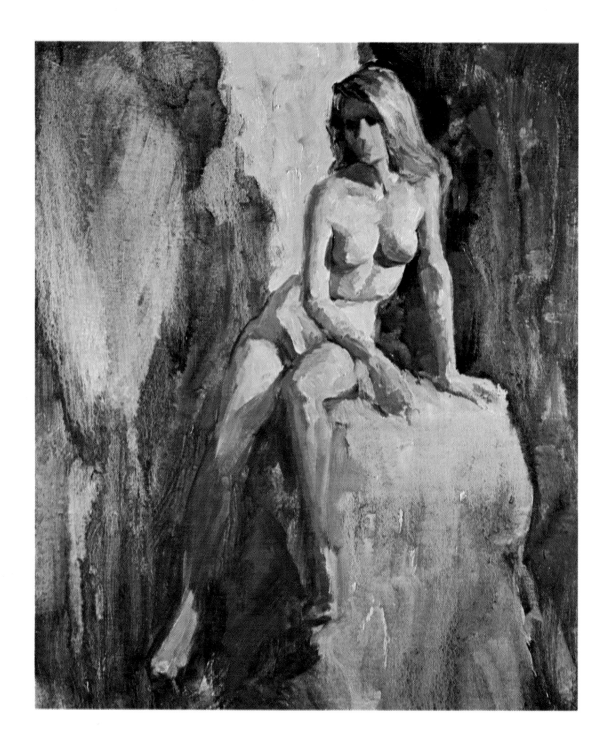

Step 3. The hair has a variety of colors, but it's basically cadmium yellow in the light and yellow ochre in the shadows. The breasts are the lightest and coolest parts of the torso. Leaving bare canvas in the breast area (see Step 2) for a while reminds me of that fact until I'm ready to put on final dabs of paint. The shadows on the breasts are quite cool and bluish or blue-violet. For these shadows I mix a bit of alizarin crimson and viridian with white. Extremities like the arms and hands have a ruddier quality, calling for more alizarin and a bit of yellow ochre. On the arm that rests on the thigh, there's lots of warm light bouncing around, so the turning shadow needs just a little blue. Where the arm and leg meet, you can use a pure alizarin with some burnt sienna in it for the accented line. The lower part of the chest is more yellowish and shaded somewhat; yellow ochre is useful there mixed into the basic, light flesh tone.

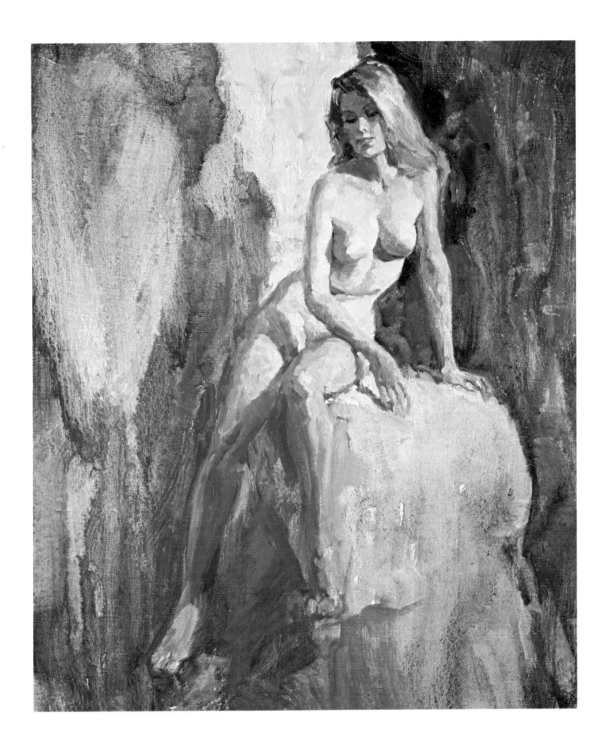

Step 4. In the final step, I merely suggest the model's features. Her downcast eyes are easy to suggest by using nothing more than the lashes. I use black paint, making it a little heavier where the pupils would be. Where the eyeball turns into the corners, I use deep violet. Just above the lashes a dab of blue-violet completes the eyelid. The shadow that shapes the form of the nose and runs across the cheek is lowered a bit because the nose seemed too long. The front plane of the cheek is redder both because of its local color and because it doesn't face the light fully. That plane runs into the mouth for which I use almost pure alizarin. Cadmium yellow is added to the lower lip which makes it brighter and warmer. Small touches of cadmium yellow and white are added as highlights on the nose and chin. The hand on the left is slimmed down with spots of cadmium yellow, viridian green, and more white.

Project 21

FAIR COMPLEXION, RED HAIR

Nature coordinates the colors of hair and skin. As a rule, blonds have light, creamy skin; brunettes have a darker olive skin. Redheaded people tend to have a light freckly skin—one that doesn't tan easily. The basic color of their skin is a cool, illusive pink on most of the body.

Coordinating Hair Color with Complexion

Red hair is a conglomeration of many colors. These colors vary from redhead to redhead. The dominant hues are red, orange, and brown. However, ochre, cool red, and a touch of green may also be present.

You'll need the following palette and materials for this project:

18" x 24" canvas

Numbers 4, 6, and 10 filbert bristle brushes

Number 4 round bristle brush

Number 1 bright sable brush

titanium white

cadmium yellow light

cadmium orange

cadmium red light

alizarin crimson

light red

burnt sienna

viridian green

cobalt blue

Blending Edges

Like the painting of the blond in the previous project, in this demonstration you'll have a problem with getting a high-keyed skin tone. However, this figure's skin tone will be cooler, a more pearly color. Also, in this painting, pay attention to edges that blend together. In the black and white projects, all you had to do was to smudge edges together (even with your finger). With color edges, you have to be certain that they have compatible hues, so that they won't dirty each other. In this demonstration you can see how I coordinate colors at edges. For example, the figure will have some green in the abdomen, so I make the background edge green in that area. Near her back a pure violet works well into the shadowy color found there. The alizarin and brown around the legs mixes nicely with the flesh tones there.

Step 1. On a medium textured white canvas primed with acrylic gesso, I lay out the whole painting—both background and figure. I try to keep the whole painting moving at once. I start with the skin tone which is a diluted mixture of white, light red, a touch of cadmium red light, and yellow ochre. Some of that mixture I scumble into the background. You might feel like you're jumping off the deep end by not drawing out the figure first, but try this method of "instant" painting. The cadmium red keeps the skin mixture lifelike and the yellow ochre gives it just the right "grayness." I use a mixture of burnt sienna and orange to block in her hair. The right hand holding a mirror is done with alizarin plus the flesh mixture. The legs have a richer light red and white hue. The background has many colors present: violet, green, white, and cool red.

Step 2. I fill out the rest of the canvas with color so that no white is left. I bring edges of the figure and background together, putting related colors next to one another. Notice near her lower back the background is a red-violet and the halftone on the body is a grayed red-violet. Likewise, the front torso has a greenish cast which coordinates with the background color in that area. I darken the lower part of her face with a light red and cadmium red combination. The upper arm should be worked into the atmosphere, because it's somewhat in shadow and it's farther back than other parts of the body. I use some of the surrounding cool gray tones and stroke them right over the bottom of this arm. The legs will be reddish brown so a tint of that is laid on now. The mirror is a grayed yellow ochre.

Step 3. The whole picture is enlivened with richer paint in essentially the colors that I first brushed on. Care should be taken here to not *over*-brush edges. Cool nuances on the body are mostly compounds of alizarin, viridian, yellow ochre, and white. In all cases, *all* three colors are used in varying portions. The third color always serves to take the "curse" out of the mixture. The slash down the center of the chest is mostly viridian and yellow ochre. The shadow under the left breast has less yellow in it. The shadow under the right breast is more alizarin and green. The zigzag tone on the abdomen is done with a lot of yellow ochre and viridian. Other grayed areas—under the neck, on the chest, and around the shoulder, and the warm stroke on the front of the abdomen and around the hip—are made with light red and white. I paint the legs with darker combinations of light red and burnt sienna. I do a little more of the drape with cobalt, yellow ochre, and white in different strengths.

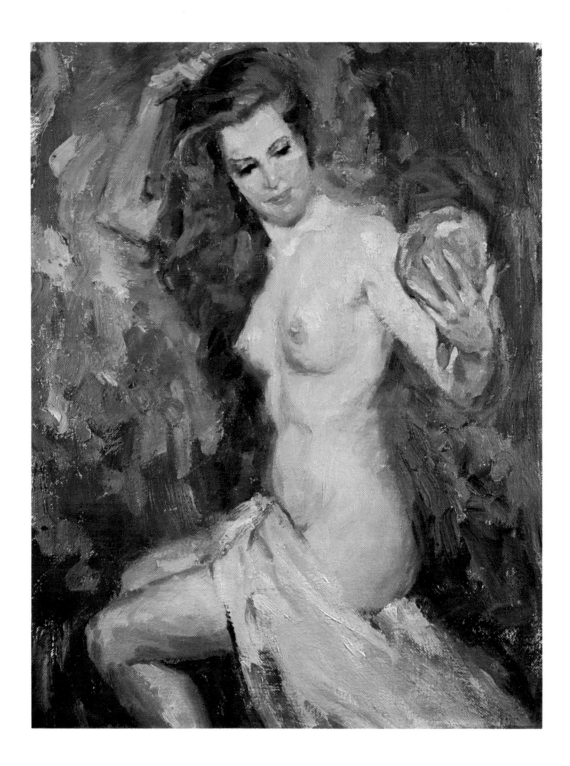

Step 4. In this final step, the position of the head is different, because the first three steps were reconstructed from the final painting. I develop the hair by shifting the amounts of the red, brown, and yellow ochre in the mixtures. I add very little white to most of these. Any white I use will clearly gray the hues, such as the top right of her hair where a lighter tone of alizarin and white comes down to the part. I keep only one highlight on the hair; it curves to the front and is almost pure orange. I use pure alizarin and burnt sienna for accents in the hair. For the high-keyed tones on the breasts, I use pure white tinted with the residue in the brush that I've reserved for the warm flesh colors. The nose and lips I paint with cadmium red, white, and nothing else. The arm brushing the hair is a product of both the background hues and flesh tones brushed in together. In some places I strengthen the periphery of the arm with a line. Any other details I achieve by adding the extremes of tonal values—the highlights and shadows.

ORIENTAL COMPLEXION, BLACK HAIR

Colors such as yellow, black, or red associated with races are not artistic in origin. An Oriental, black, or Indian doesn't possess a skin tone that is one solid color as their racial designations would indicate. You wouldn't paint an Oriental in flat yellow any more than you would paint a white person with pure white. The Oriental has a more subtle and grayed array of colors than the black or Indian who has a myriad of colors present in his skin tones. There's only a slight tinge of yellow to the Oriental complexion.

The strongest influence of yellow shows up on the torso of the Oriental rather than his extremities. The most you should do to indicate Oriental coloring is to use something like yellow ochre as a base in your palette. The problem here is to get just the right subtle touch of yellow, without being obvious about it.

Oriental Body Structure

The anatomical make-up of an Oriental is more characteristic than his skin color. The figure in this demonstration is Japanese. With a person of Japanese extraction you're aware first of his small size. In the details, the head structure is flat across the brow and nose.

Japanese eyes aren't slanted much more than those of the white race. Japanese eyes only *appear* that way because the upper lid is continuous from eyebrow down to lashes, without a fold of skin showing. Refer to Project 3 and notice that the basic construction of the eye shows the outer corner being higher than the tear duct. Caucasian eyes cancel this effect due to the crease arching over the upper lid.

Also, there's a puffiness under the lid of the Oriental eye. the cheekbones can be somewhat prominent on certain Orientals. This plus the flatness across the center of the face makes it hard to turn the facial form as you're accustomed to doing. Of course, Orientals have hair that is black—a blue-black that causes bluish highlights. Oriental eyes are almost totally black so that no pupil color is noticeable.

You'll need the following materials for this project:

16" x 20" canvas
Numbers 4, 6, 8 filbert bristle brushes
titanium white
yellow ochre
alizarin crimson
viridian green
ultramarine blue
burnt umber

The canvas I use in this project is a medium-textured linen which I primed myself. I'll work directly on its white surface without laying in a tone. The lighting isn't quite flat but just enough so that the effect isn't dramatic but rather quiet and subdued. I used a blue daylight bulb in the spotlight to keep the colors from getting too hot.

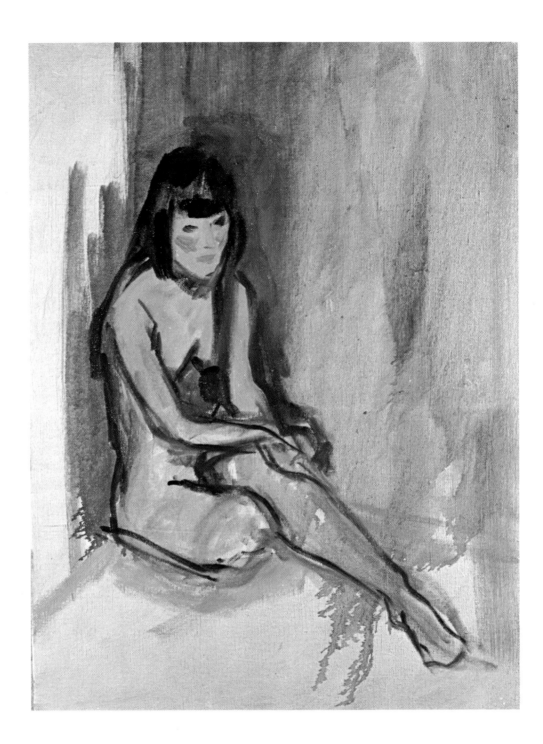

Step 1: First, I wash in some of the larger areas on a medium textured linen canvas which I primed myself. For the background and the figure I use a wash of yellow ochre plus a touch of umber. I hint at some of the figure's form by darkening that color in her middle and around her back. I get some roundness to the head also. I wash a very neutral gray, ultramarine, white, and umber behind her back. A little bit of pink below sets the color of that region. With this kind of light the figure becomes almost linear, so that it's appropriate to enclose it with a heavy line. This approach was discussed in Project 8. I rough in the hair with black made from ultramarine blue and burnt umber. I make the combination lean toward the blue side. I use two dabs of that color for the eyes. I use a little orange (a mixture of alizarin, white, and yellow ochre) to locate her mouth and her cheeks.

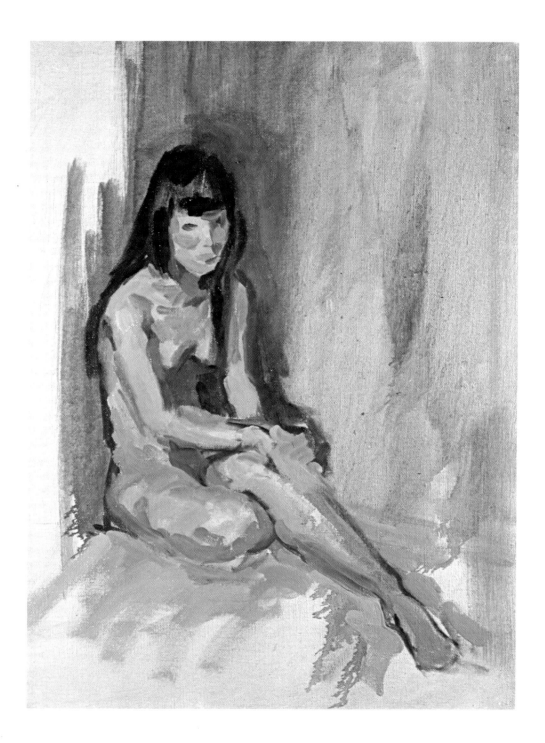

Step 2. Now I model the form with an underpainting of delicate grays. On the palette they're somewhat brighter but when they're put over the yellow ochre wash they appear quite gray such as the grayed red-violet under the chin, along the right arm, next to the left armpit, and under the far breast. The beige tones on the chest are a mixture of yellow ochre, white, and a small amount of blue. This beige is repeated along the top of her thigh. Some of that same color I alter with a bit of alizarin for the underside of the thigh. A high-keyed pink sets the highlight on the left deltoid and knee cap. A similar light on the collarbone will take some of the same pink. I gray that pink with some viridian green and paint the fingers and a spot next to the highlight on the knee and foot. I add still more alizarin and paint along the extended leg where a strong reddishness occurs. While you're still working with the pink colors, use a clean brush and start your mixture for the rug. It's made up of white, alizarin, and some yellow ochre. Some of the edges are still linear, like the arm, but I paint a lighter, greenish beige over the umber lines.

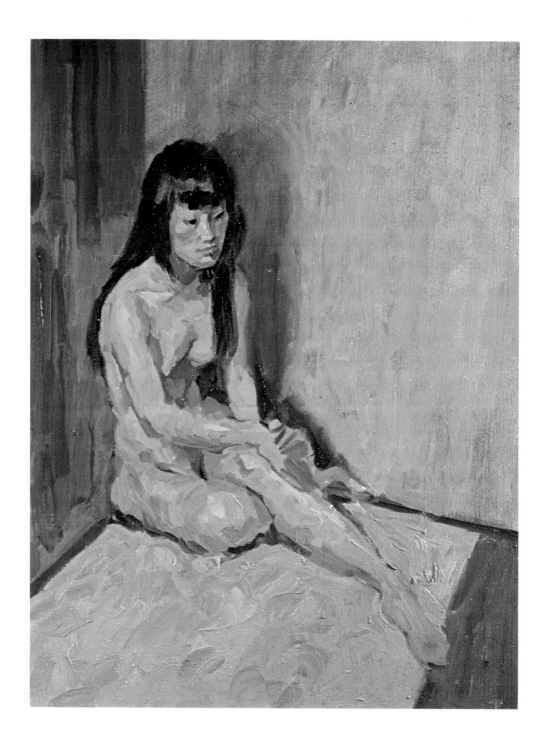

Step 3. As I paint, it seems that I see more color on the model. This is typical; you seem blind to color at first, but the more you look, the more color comes forth. The grayed greens, yellows, and pinks are showing up on the model in places on the chest, back, and thighs. The color progression of a plane in the light is first pink, where the plane catches the most light; yellow, where it starts to turn; then green, as it moves obliquely away from the light. The shadows are generally more violet nearest a light part—like along the breast near the armpit. Those shadows get warm as they move to the right. For example, the shadow on her far hip is quite orange. I paint some of her face and features with a grayed alizarin and white mixture. The model has on green eye shadow which I feel complements the reds, so I paint this color in.

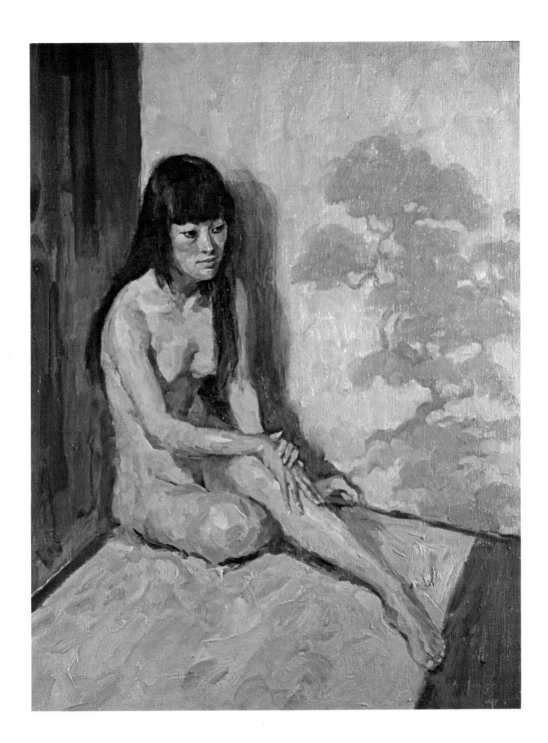

Step 4. Once the color scheme has been set don't deviate by mixing a new and strange color unless you're positive it's a color you've missed. The pretty violet color on the breast, in the cast shadow of the arm, and on the thigh is such a color. Being a direct complement of yellow, it adds vibrancy to other colors. I shape the details of the face, the hands, and the feet with pinks for the lightest areas and yellows for the planes that move away from the light. Because of the florid nature of the head, I use more dark reds in the skin tones. The hands and feet are catching a bouncing cold light so their halftone shadows are greenish (yellow ochre, white and viridian with a little umber). Bluish highlights on the hair give it sheen and color; however, I could see some deep alizarin in there also, probably the scalp showing through. The background, influenced by Japanese architecture and drawings, is formal with divided areas: an ultramarine blue and umber wall to the left, and the alizarin and ochre rug below. I feel the original ochre on the back wall doesn't provide enough contrast, so I paint it over with my version of a Japanese motif.

Project 23

USING
BROKEN
COLOR

One of the desirable qualities of oil is that you can mix lovely grays. However, you have to know when to stop; otherwise your colors become impossible to identify. There are ways to prevent your colors from becoming "muddy." Limit the number of colors that you mix together to three plus white. Stay away from color combinations which are incompatible. Some combinations of warm and cool colors result in a brownish mixture which is repugnant to a colorist.

Another way to prevent muddy, gray colors is to use "broken color," that is colors that aren't too thoroughly mixed. When several colors appear close together, they seem to merge and blend together; you might say that the eye does the mixing. I used some of this technique in Project 20. You can either use pure primary pigments somewhat like pointillism or you can use slightly grayish colors as I do in this project. For more on mixing colors, an excellent book is *Creative Color* by Wendon Blake.

Personal Color Sense

The hues used on nude figures can range from pearly tones, like those painted by Renoir where he used black as a graying agent, to those of Pearlstein, who uses subdued, grayed oranges and tans. Every painter filters his subject through his own consciousness and personal tastes. His choices of color reflect this taste. Yet, color isn't as important as the soundness of the figure's structure which is defined by tonal values.

The figure in this demonstration presents two exercises: the use of broken color and the painting of a figure that's doubled up—a difficult pose to capture.

You'll need the following materials for this project:

18" x 24" canvas
Numbers 4, 6, and 8 filbert bristle brushes
Numbers 4 and 8 round bristle brushes
titanium white
cadmium yellow light
cadmium orange
alizarin crimson
viridian green
burnt sienna
cobalt blue
Mars black

The total shape of the figure is a triangle. Within the larger triangle are two smaller ones. One triangle is formed by the line that runs from shoulder to shoulder with the base of the triangle running from the left to the foot. The other triangle is found at the top of the leg going to the knee and to the foot. Since the figure is going to be a definite geometric shape, other geometric shapes can be added to the composition to complement it.

Step 1. For this painting I use a rough-weave linen canvas that I've primed myself. I only primed it once; this left threads raised up which caught the light in the photographs seen here. I visualize the figure as a triangle. A flatter triangle inside the large one represents the shoulders and arms coming to a point at the bottom right (the foot). The apex of the inner triangle forms the knee between the figure's arms. I use diluted burnt sienna and a Number 4 round brush to sketch these configurations. I add a mirror and a lamp to the right; on the left I'll have some plants.

Step 2. I wash in the background with a large brush, using virdian green and burnt sienna for the plants on the left. I add blue and black in the background near the head and over the right side of the figure. A dark violet color establishes the undersides of the arm and chest, the legs, the arms, and the shadow of the hand. The hair is pure black with some alizarin added to give it more life. The accents and construction lines are alizarin crimson and burnt sienna.

Step 3. In this step I became so engrossed with painting that I developed it too much before taking a picture of it. A lot took place between Step 2 and this one which I'll try to retrace for you. The first step here is to paint the light on her back which is coming from the window. This gives me the lightest tones. I apply two basic "broken colors": a mixture of white, alizarin crimson, and viridian green (in several combinations), and a mixture of white and alizarin, and orange. In the darker shadows, like the cast shadow on the lower leg, I add a small amount of burnt sienna. The lower leg under her arm is mainly viridian and alizarin. That color seems to make the leg stay back, under the figure. The color gets a little warmer on the thigh under the elbow because it gets some orange reflected light from the rug. The breast is pinker but slightly darker, and I use the alizarin, viridian, and white mixture for it. The shadow above the breast is bluish with orange dabs over that. I block in the face with orange, the hot light bouncing off the flesh, or the violet, the light coming from the window.

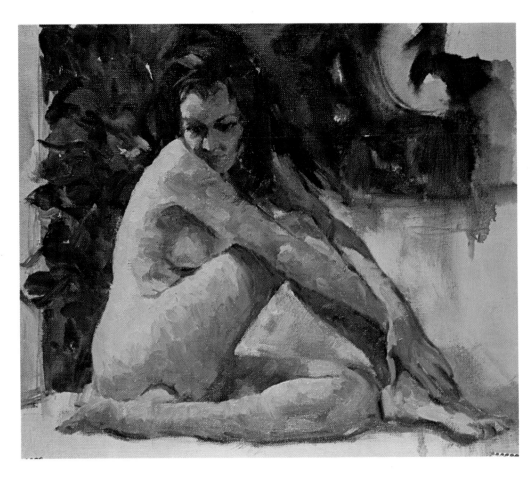

Step 4. The broken color had also broken up the values too much. Therefore, I have to repaint areas, paying close attention to tonal values. For example, I make the left arm look less patchy by eliminating some color. Possibly now I've made it too subtle. I rework the face to establish a better structure more than to improve color. The pupils seemed to be falling out of the eyes and the bridge of the nose was too narrow and too low. The mouth wasn't too definite either, so I carefully refine all these features in this step. However, the major surgery was making the leg and foot beneath her buttock smaller. I made them more anatomically correct, even though they are closest to me and therefore appear larger.

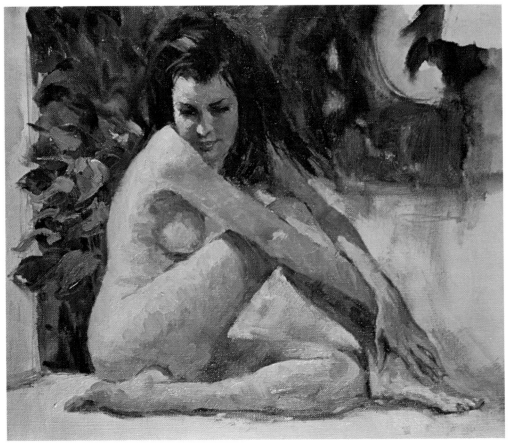

Project 24

PAINTING FROM REFERENCE SOURCES

After you feel you can paint the complete figure, you'll want to incorporate it into a picture. There are different ways to work this out. One, an ideal way, is to have the model in a set complete with all the props so that you paint directly from this arrangement. This is the most satisfactory way to make a picture, because you can stage the model and props in any kind of light or situation that you want. Of course, you'd have to have quite a store of different props, furniture, etc. Painters use their studio furniture to create settings and their old favorite props keep appearing.

Working From Photos and Clippings

Sometimes you'd like to have a certain atmosphere, but you couldn't possibly afford to buy, rent, or borrow the necessary props, so you resort to clippings for copy. Here you have to compromise because you'll never find precisely the clipping you want unless you have an enormous file of pictures and . ometimes not even then—I know!

The third alternative is to "fake" things—paint from your imagination—but you should never do this unless you've had a great deal of experience.

For the painting in this project, I had a clipping that suggested the atmosphere although the model's position had to be altered. I used another photo I'd taken as copy for the figure.

You'll need the following materials:

18" x 24" canvas

4 Number 4 filbert bristle brushes

2 Number 8 filbert bristle brushes

painting knife

layout tissue

white chalk

titanium white

cadmium yellow light

Mars yellow

cadmium orange

cadmium red light

terra rosa

cadmium green

"thalo" green

cobalt blue

burnt sienna deep

raw umber

Transferring Your Drawing

To get the clippings or photos to work together, do a preliminary drawing of the picture on layout tissue. I'd also suggest that you make thumbnail sketches of the color scheme.

The painting for this demonstration is done on a smooth-grade linen canvas that's been primed by the manufacturer. I tone the canvas first with raw umber. To do this, lay your canvas flat. Squeeze a couple of inches of raw umber in the center. Pour a small paint cup of turpentine over that. Take a palette knife and mix the paint and turpentine as you begin to spread it around. To smooth and finish, use a paper towel, going over the paint until it begins to dry. As it drys, the paint will get nice and even. You may have to press in from the back to keep the stretcher edges from showing. This toning should be done at least a day ahead of time so that it will be completely dry when you begin your painting.

Rub white chalk over the back of the tissue of your drawing. Put plenty of it on. Lay the tissue drawing over the dry canvas and tape it in place and trace your drawing. It's a good idea to put a hard surface against the back of the canvas; then you can get enough pressure on your drawing so that the lines will show up on the canvas. If the result is faint, go over the lines that have been transferred onto the canvas with chalk.

Step 1. I get several areas going at once on the figure with white, cadmium red light, cadmium orange, and cadmium yellow. With a separate brush I lay in the yellow-green around the figure. It's a mixture of cadmium yellow plus a touch of "pthalo" green; in some places it's pure cadmium green. You'll discover that pthalo green is a staining pigment. Be wary of it. Your brush will never be white again, even though it can be cleaned. However, it's a valuable color for brilliant greens and yellow-greens. Cadmium green is a very expensive color and is nice for touches. If it's too expensive, you can use pthalo green and cadmium yellow to make almost the same color. The dark shadows are pthalo green, burnt sienna, and sometimes cobalt blue. Around the bedstead the blues predominate, while closer to the figure the brown is stronger. The legs being some distance from the light get darker; for their ruddy color I use a mixture of terra rosa and white. The canvas I use is smooth-textured linen, primed by the manufacturer.

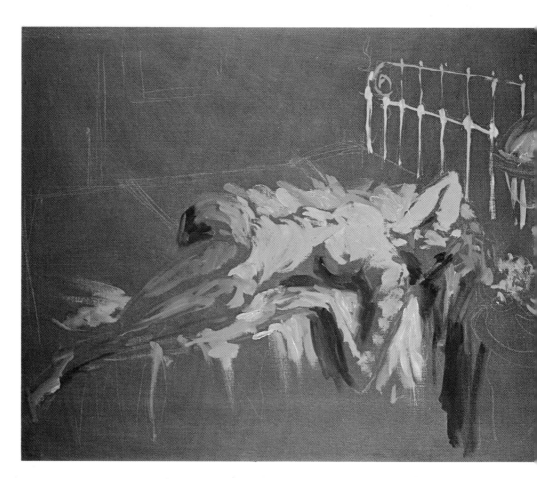

Step 2. I block in the face and hair with warm colors. For instance, the face has more orange than the body. The hair is an arrangement of Mars yellow, terra rosa, and a little burnt sienna. Mars yellow is a color something like yellow ochre; it's slightly greener and isn't as powerful a yellow as ochre. As it gets farther from the light the bedspread is made to look cooler by the addition of green. I model the body with the warm, light colors. For the lightest areas I use white with cadmium yellow or cadmium orange. The body is pinker around the neck and chest, and I use cadmium red and white for these areas. For planes that turn slightly away from the light, I use terra rosa and white. Terra rosa is in the warm family, but the addition of white cools or grays it.

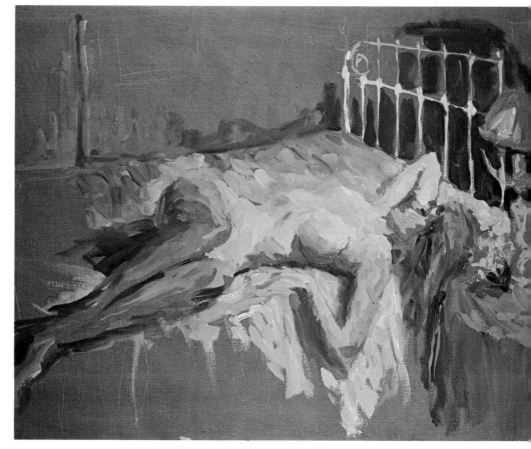

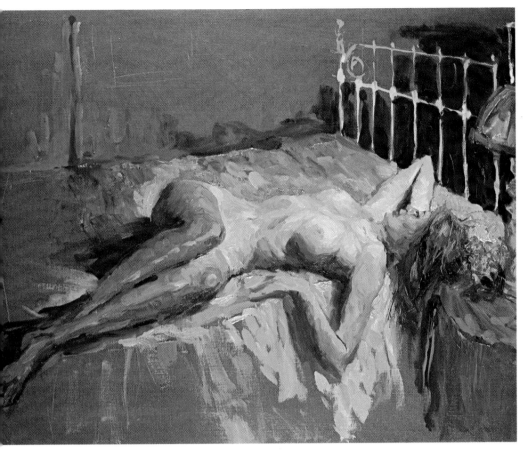

Step 3. In this stage, I finish most of the figure, but I can see a problem looming up. The legs are darker than seems necessary. However, I'll wait until Step 4 to do anything about them. In the meantime I finish the head, the flowers, and arm above. The tones in the background can be elaborated on as much as you like. You may use heavy brushstrokes all over, or in the darker areas you can just be sparse with paint, as I have been. The toned background coming through the bedspread in small bits gives the greens some complementary vibrations. I put a touch or two of the bedspread color on the breasts and sides of the chestcone that face away from the light. The touch of this color on the chest helps its edge to be lost into the background. I finish the face with warm colors. I use cadmium red and orange on the lips, the cheeks, the nose, ear, and under the jaw. I also add these colors to the hair.

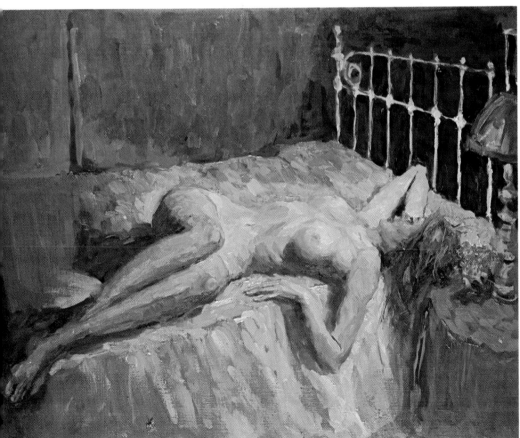

Step 4. I paint over the legs now to lighten them. Even though I was theoretically right about their darker color, it's more suitable in this painting to have them a lighter shade. I use more white and yellow with the terra rosa for them. The shadows on the legs are left as dark as they were originally. Around the knees I add some lights that are quite red. Under the legs I use pure green for vibrancy. I finish the hand with a mixture of white, cadmium red, and terra rosa. The reflected light from the bedspread could conceivably be yellow but I refrain from doing too much of this. A few spots around the hip and the lower thigh have that yellow influence. When you're painting from odd copy, like clippings and black and white photos (such as I've used here), you have to fake the color, of course. You can select the colors on the basis of logic, past experience in painting from life, or your own preference.

This oil sketch was done rapidly on brown wrapping paper mounted on board. The "casual" quality of this painting surface is in keeping with the spontaneity inherent in a quick sketch such as this. The brown paper also provides me with a ground that's already toned.

A FINAL WORD

While painting the demonstrations I've felt the same pressure as I would have if you had been truly looking over my shoulder. I couldn't mull over the next move or set the painting aside for a fresh look at a future time. Besides that, I had to stop at intervals to photograph the different stages. As usual, I wanted to work on the paintings more, make changes, improve them, try for the "masterpiece." Ah, well, perhaps I've given you some help for your masterpiece.

I don't consider the style of painting demonstrated here to be taken as the "final work." You can vary the steps as you see fit once you've mastered the fundamentals.

Some have scoffed at the notion of learning to draw or paint from a book. Yet, having painted each step in this book stroke by stroke, and project by project, I've discovered that I've grown and improved as a painter myself. If you'll actually take the time to do more than simply read an art book—if you use it as an aid to your own study and practice—you can't help but become a better artist.

SUGGESTED READING

Blake, Wendon. *Creative Color.* New York: Watson-Guptill Publications, 1972; London: Pitman Publishing, 1972.

De Ruth, Jan. *Painting the Nude.* New York: Watson-Guptill Publications, 1966.

Farris, Edmond J. *Art Students' Anatomy.* New York: Dover Publications, 1953.

Hogarth, Burne. *Dynamic Anatomy.* New York: Watson-Guptill Publications, 1958.

Mayer, Ralph. *The Artist's Handbook of Materials and Techniques,* 3rd Ed., New York: The Viking Press, 1970.

Richer, Dr. Paul. *Artistic Anatomy.* Trans. and Ed. Robert Beverly Hale. New York: Watson-Guptill Publications, 1972.

Taubes, Frederic. *The Painter's Dictionary of Materials and Methods.* New York: Watson-Guptill Publications, 1971.

Edited by Diane Casella Hines
Designed by James Craig and Robert Fillie
Set in 11 point Elegante